*Tomorrow's Tomorrow*

Joyce A. Ladner received her B.A. in sociology
from Tougaloo College in Mississippi and
her M.A. and Ph.D. from Washington University
in St. Louis. She has been on the faculty
of Southern Illinois University, is a Senior
Research Fellow at the Institute of the Black
World in Atlanta, and has had articles pub-
lished in numerous anthologies and magazines.
In 1970 she received the first Black Woman's
Community Development Foundation Fellowship
to study the African woman's involvement
in nation-building in Tanzania.

*Tomorrow's Tomorrow*
*The Black Woman*

Joyce A. Ladner

Anchor Books
Doubleday & Company, Inc.
Garden City, New York

For my mother, Annie Ruth Perryman,
who taught me what it meant
to become a Black woman,
and my sister, Dorie A. Ladner,
who shared all of the lessons with me.

## Contents

Introduction    1

1   *Yesterday: Black Womanhood in Historical Perspective*    15

2   *Growing Up Black*    55

3   *Racial Oppression and the Black Girl*    77

4   *The Definition of Womanhood*    109

5   *Images of Black Womanhood*    125

6   *Becoming a Woman: Part I*    177

7   *Becoming a Woman: Part II*    235

   *Conclusions*    265

   *Bibliography*    283

   *Index*    291

*Acknowledgments*

Many people have contributed their time, efforts and resources toward making this book possible. This work grew out of a study on "Social and Community Problems in Public Housing Areas," National Institute of Mental Health, Grant No. MH-09189, on which I worked as a research assistant for four years. This research on Black females developed into a doctoral dissertation.

I am deeply indebted to Dr. Lee Rainwater, director of the Pruitt-Igoe housing study, who gave his unselfish time and advice toward my dissertation research. Many of the ideas for this book emanated from my discussions with fellow graduate students Ethel Sawyer, Gwendolyn Jones Magee, and Boone Hammond. To them, I am grateful. I am highly indebted to Dr. Andrew Billingsley and Douglas Davison for their provocative and insightful critiques of the entire manuscript. Dr. Billingsley provided me with many original ideas about the structure and functions of the Black family. Douglas Davison's critique of the white middle-class norm was indispensable for this book. Dr. Alvin Poussaint and Dr. Robert Staples read particular chapters of the work, and have my grateful acknowledgments. My editor, Loretta Barrett, deserves special thanks for her careful editorial comments and insights. Carol Parks at Doubleday caught all of the subtle errors and slight contradictions which allowed me, as an unpublished

author, to feel more secure with my work. She has my special thanks.

Dr. Vincent Harding and members of the Institute of the Black World staff deserve my greatest thanks, for without their concern and support, I would not have had the time to write this book while working as a Senior Research Fellow. I want also to thank the secretarial staff of the Institute for working as a team in the typing of the manuscript. Judy Barton, Tina Harriford, Barbara Knight, Mayme Mitcham and LaSayde Potter typed and proofed the various chapters. I must give special recognition to Adisa Jill Douglass for the long and arduous hours that she put into the typing of the final revised form.

Perhaps this book would never have been written had it not been for the continued pressure and encouragement from my sister, Dorie Ladner, who had more faith in my ability and the need to write it than I did myself. She and my younger sister, Willia Tate, were patient with me, even at 1 A.M., and discussed and debated many of the ideas I attempted to develop in this work. As Black women, they provided me with the most provocative criticisms.

Of course, all responsibility for content and points of view are my own.

*soft: the way her eyes view her children.*

*hard: her hands; a comment on her will.*

*warm: just the way she is, jim!*

*sure: as yesterday, she's tomorrow's tomorrow.*

Don L. Lee, *We Walk the Way of the New World*,
Detroit, Broadside Press, 1970, p. 25.

*Introduction*

It is very difficult to determine whether this book had its beginnings when I was growing up in rural Mississippi and experiencing all the tensions, conflicts, joys, sorrows, warmth, compassion and cruelty that was associated with *becoming a Black woman;* or whether it originated with my graduate school career when I became engaged in research for a doctoral dissertation. I *am* sure that the twenty years I spent being socialized by my family and the broader Black community prior to entering graduate school shaped my perception of life, defined my emotive responses to the world and enhanced my ability to survive in a society that has not made survival for Blacks easy. Therefore, when I decided to engage in research on what approaching womanhood meant to poor Black girls in the city, I brought with me these attitudes, values, beliefs and in effect, a Black perspective. Because of this cultural sensitivity I had to the life-styles of the over one hundred adolescent, preadolescent and adult females I "studied," I had to mediate tensions that existed from day to day between the *reality* and *validity* of their lives *and* the tendency to view it from the *deviant perspective* in accordance with my academic training.

Deviance is the invention of a group that uses its own

standards as the *ideal* by which others are to be judged. Howard Becker states that:

Social groups create deviance by making the rules whose infraction constitutes deviance, and by applying those rules to particular people and labeling them as outsiders. From this point of view, deviance is *not* a quality of the act the person commits, but rather a consequence of the application by others of rules and sanctions to an "offender." The deviant is one to whom that label has successfully been applied; deviant behavior is behavior that people so label.[1]

Other students of social problems have adhered to the same position.[2] Placing Black people in the context of the deviant perspective has been possible because Blacks have not had the necessary power to resist the labels. This power could have come only from the ability to provide the *definitions* of one's past, present and future. Since Blacks have always, until recently, been defined by the majority group, that group's characterization was the one that was predominant.

The preoccupation with *deviancy*, as opposed to *normalcy*, encourages the researcher to limit his scope and ignore some of the most vital elements of the lives of the people he is studying. It has been noted by one sociologist that:

It is probably a fact and one of which some contemporary students of deviance have been cognizant—that the greater portion of the lives of deviant persons or groups is spent in normal, mundane, day-to-day living. In the researcher's focus on deviance and

[1] Howard S. Becker, *The Outsiders*, New York, Free Press, 1963, p. 9.
[2] See the works of Edwin Lemert, *Social Pathology*, New York, McGraw-Hill, 1951; John Kituse, "Societal Reaction to Deviance: Problems of Theory and Method," *Social Problems*, Winter 1962, pp. 247–56; and Frank Tannenbaum, *Crime and the Community*, New York, Columbia University Press, 1938.

this acquisition of the deviant perspective, not only is he likely to overlook these more conventional phenomena, and thus become insensitive to them, but he may in the process overlook that very data which helps to explain that deviance he studies.[3]

Having been equipped with the *deviant perspective* in my academic training, yet lacking strong commitment to it because it conflicted with my objective knowledge and responses to the Black women I was studying, I went into the field equipped with a set of preconceived ideas and labels that I intended to apply to these women. This, of course, meant that I had gone there only to validate and elaborate on what was *alleged to exist*. If I had continued within this context, I would have concluded the same thing that most social scientists who study Black people conclude: that they are pathology-ridden.

However, this role was difficult, if not impossible, for me to play because all of my life experiences invalidated the deviant perspective. As I became more involved with the subjects of this research, I knew that I would not be able to play the role of the dispassionate scientist, whose major objective was to extract certain data from them that would simply be used to *describe* and *theorize* about their conditions. I began to perceive my role as a Black person, with empathy and attachment, and, to a great extent, their day-to-day lives and future destinies became intricately interwoven with my own. This did not occur without a considerable amount of agonizing self-evaluation and conflict over "whose side I was on." On the one hand, I wanted to conduct a study that would allow me to fulfill certain academic requirements, i.e., a doctoral dissertation. On the other hand, I was highly influenced by my *Blackness*—by the fact that I, on many levels, was one of them and had to

[3] Ethel Sawyer, "Some Methodological Problems in Studying Socially Deviant Communities," unpublished paper presented for a Ph.D. Colloquium in the Department of Sociology and Anthropology, Washington University, St. Louis, Missouri, May 9, 1967, p. 4.

deal with their problems on a personal level. I was largely
unable to resolve these strands, this "double conscious-
ness," to which W. E. B. DuBois refers.[4] It is important to
understand that Blacks are at a juncture in history that has
been unprecedented for its necessity to grope with and
clarify and *define* the status of our existence in American
society. Thus, I was unable to resolve the dilemmas I faced
as a Black social scientist because they only symbolized the
larger questions, issues and dilemmas of our times.

Many books have been written about the Black com-
munity[5] but very few have really dealt with the intricate
lives of the people who live there. By and large, they have
attempted to analyze and describe the pathology which
allegedly characterizes the lives of its inhabitants while at
the same time making its residents responsible for its crea-
tion. The unhealthy conditions of the community such as
drug addiction, poverty, crime, dilapidated housing, unem-
ployment and the multitude of problems which charac-
terize it have caused social analysts to see these conditions
as producing millions of "sick" people, many of whom are
given few chances ever to overcome the wretchedness which
clouds their existence. Few authorities on the Black com-
munity have written about the vast amount of strength and
adaptability of the people. They have ignored the fact that
this community is a force which not only acts upon its resi-
dents but which is also acted upon. Black people are in-
volved in a dynamic relationship with their physical and
cultural environment in that they both influence and are
influenced by it. This reciprocal relationship allows them to
exercise a considerable amount of power over their envi-
rons. This also means that they are able to exercise control
over their futures, whereas writers have tended to view the

[4] W. E. B. DuBois, *Souls of Black Folk*, New York, Fawcett
World Library, 1961.
[5] I am using the term "Black community" to refer to what
is traditionally called the "ghetto." I am speaking largely of the
low-income and working-class masses, who comprise the majority
of the Black population in this country.

low-income Black community as an all-pervasive force which is so devastating as to compel its powerless residents to succumb to its pressures. Their power to cope and adapt to a set of unhealthy conditions—not as stereotyped sick people but as normal ones—is a factor which few people seem to accept or even realize. The ways Blacks have adapted to poverty and racism, and yet emerged relatively unscarred, are a peculiar quality which Americans should commend.

The concept of social deviance is quite frequently applied to the values and behavior of Blacks because they represent a departure from the traditional white middle-class norm, along with criminals, homosexuals and prostitutes.

But these middle-class standards should not have been imposed because of the distinctiveness that characterizes the Black life-style, particularly that of the masses.

Most scholars have taken a dim view of any set of distinct life-styles shared by Blacks, and where they were acknowledged to exist, have of course maintained that these forces were negative adaptations to the larger society. There has never been an admission that the Black community is a product of American social policy, *not* the cause of it—the structure of the American social system, through its practices of institutional racism, is designed to create the alleged "pathology" of the community, to perpetuate the "social disorganization" model of Black life. Recently, the Black culture thesis has been granted some legitimization as an explanatory variable for much of the distinctiveness of Black life. As a result of this more positive attitude toward understanding the strengths of life in the Black community, many scholars, policy makers et al. are refocusing their attention and reinterpreting the many aspects of life that comprise the complex existence of American Blacks.

There must be a strong concern with redefining the problem. Instead of future studies being conducted on *problems* of the Black community as represented by the

*deviant perspective*, there must be a redefinition of the *problem as being that of institutional racism*. If the social system is viewed as the *source* of the deviant perspective, then future research must begin to analyze the nature of oppression and the mechanisms by which institutionalized forms of subjugation are initiated and act to maintain the system intact. Thus, studies which have as their focal point the alleged deviant *attitudes* and *behavior* of Blacks are grounded within the racist assumptions and principles that only render Blacks open to further exploitation.

The challenge to social scientists for a redefinition of the basic *problem* has been raised in terms of the "colonial analogy." It has been argued that the relationship between the *researcher* and his *subjects*, by definition, resembles that of the oppressor and the oppressed, because it is the oppressor who defines the problem, the nature of the research and, to some extent, the quality of interaction between him and his subjects. This inability to understand and research the fundamental problem—*neo-colonialism*—prevents most social researchers from being able accurately to observe and analyze Black life and culture and the impact racism and oppression has upon Blacks. Their inability to understand the nature and effects of neo-colonialism in the same manner as Black people is rooted in the inherent bias of the social sciences. The basic concepts and tools of white Western society are permeated by this partiality to the conceptual framework of the oppressor. It is simple enough to say that the difference between the two groups— the oppressor and the oppressed—prevents the former from adequately comprehending the essence of Black life and culture because of a fundamental difference in perceptions, based upon separate histories, life-styles and purposes for being. Simply put, the slave and his master do not view and respond to the world in the same way. The historian Lerone Bennett addresses this problem below:

George Washington and George Washington's slaves lived different realities. And if we extend that insight to all the dimen-

sions of white American history we will realize that blacks lived at a different time and a different reality in this country. And the terrifying implications of all this is that there is another time, another reality, another America. . . .

Bennett states further that:

It is necessary for us to develop a new frame of reference which transcends the limits of white concepts. It is necessary for us to develop a total intellectual offensive against the false universality of white concepts whether they are expressed by William Styron or Daniel Patrick Moynihan. By and large, reality has been conceptualized in terms of the narrow point of view of the small minority of white men who live in Europe and North America. We must abandon the partial frame of reference of our oppressors and create new concepts which will release our reality, which is also the reality of the overwhelming majority of men and women on this globe. We must say to the white world that there are things in the world that are not dreamt of in your history and your sociology and your philosophy.[6]

Currently there are efforts underway to "de-colonize" social research on the *conceptual* and *methodological* levels.[7]

Although I attempted to maintain some degree of objectivity, I soon began to minimize and, very often, negate the importance of being "value-free," because the very selection of the topic itself reflected a bias, i.e., I studied Black women because of my strong interest in the subject.

I decided whose side I was on and resolved within my-

[6] Lerone Bennett, "The Challenge of Blackness," *Black Paper Series*, Institute of the Black World publication, April 1970.

[7] Refer to Robert Blauner, "Internal Colonialism and Ghetto Revolt," *Social Problems*, Vol. 16, No. 4, Spring 1969, pp. 393–408; and see Robert Blauner and David Wellman, "Towards the Decolonization of Social Research," paper delivered at the Workshops on Problems of Research with Low Income and Minority Groups in the United States, sponsored by the National Institute of Child Health and Human Development, March 8–10, 1970.

self that as a Black social scientist I must take a stand and that there could be no value-free sanctuary for me. The controversy over the question of values in social research is addressed by Gouldner:

If sociologists ought not express their personal values in the academic setting, how then are students to be safeguarded against the unwitting influence of these values which shape the sociologist's selection of problems, his preferences for certain hypotheses or conceptual schemes, and his neglect of others? For these are unavoidable and, in this sense, there is and can be no value-free sociology. The only choice is between an expression of one's values as open and honest as it can be, this side of the psychoanalytic couch, and a vain ritual of moral neutrality which, because it invites men to ignore the vulnerability of reason to bias, leaves it at the mercy of irrationality.[8]

I accepted this position as a guiding premise and proceeded to conduct my research with the full knowledge that I could not divorce myself from the problems of these women, nor should I become so engrossed in them that I would lose my original purpose for being in the community.

The words of Kenneth Clark, as he describes the tensions and conflicts he experienced while conducting the research for his classic study of Harlem, *Dark Ghetto*, typify the problems I faced:

I could never be fully detached as a scholar or participant. More than forty years of my life had been lived in Harlem. I started school in Harlem public schools. I first learned about people, about love, about cruelty, about sacrifice, about cowardice, about courage, about bombast in Harlem. For many years before I returned as an "involved observer," Harlem had been my home. My family moved from house to house, and from neighborhood

    [8] Alvin W. Gouldner, "Anti-Minotaur: The Myth of a Value-Free Sociology," *Social Problems*, Winter 1962, pp. 199–213.

to neighborhood within the walls of the ghetto in a desperate attempt to escape its creeping blight. In a very real sense, therefore, *Dark Ghetto* is a summation of my personal lifelong experiences and observations as a prisoner within the ghetto long before I was aware that I was really a prisoner.[9]

The inability to be *objective* about analyzing poverty, racism, disease, self-destruction and the gamut of problems which faced these females only mirrored a broader problem in social research. That is, to what extent should any scientist—white or Black—consider it his duty to be a dispassionate observer and not intervene, when possible, to ameliorate many of the destructive conditions he studies. On many occasions I found myself acting as a counselor, big sister, etc. Certainly the question can be raised as to whether researchers can continue to gather data on impoverished Black communities without addressing these findings to the area of social policy.

This raises another important question, to which I will address myself. That is, many people will read this book because they are seeking answers to the dilemmas and problems facing Black people in general and Black women in particular. A great number of young Black women will expect to find forever sought formulas to give them a new sense of direction as *Black women*. Some Black men will read this work because they are concerned about this new direction and want to become involved in the shaping of this process. Others, of course, will simply be curious to find out what a Black woman has to say about her peers. I expect traditional-type scholars to take great issue with my thesis and many of my formulations because I am consciously attempting to break away from the traditional way in which social science research has analyzed the attitudes and behavior patterns of Blacks. Finally, a small but growing group of scholars will find it refreshing to read a work

[9] Kenneth Clark, *Dark Ghetto*, New York, Harper & Row, 1965, p. xv.

on Black women which does not indict them for all kinds of
alleged social problems, which, if they exist, they did not
create.

All of these are problems and questions which I view
as inescapable for one who decides to attempt to break
that new ground and write about areas of human life in
ways in which they are not ordinarily approached.

There are no standard answers for these dilemmas I
faced, for they are simply microcosms of the larger Black
community. Therefore, this work is not attempting to re-
solve the problems of Black womanhood but to shed light
on them. More than anything else, I feel that it is attempt-
ing to depict what the Black woman's life has been like in
the past, and what barriers she has had to overcome in or-
der to survive, and how she is coping today under the most
strenuous circumstances. Thus, I am simply saying, "This
is what the Black woman was, this is how she has been
solving her problems, and these are ways in which she is
seeking to alter her roles." I am not trying to chart a course
of action for her to follow. This will, in large measure, be
dictated by, and interwoven with, the trends set in that
vast Black American community. My primary concern here
is with depicting the strength of the Black family and Black
girls within the family structure. I will seek to depict the
lives of Black people I knew who were utilizing their scant
resources for survival purposes, but who on the whole were
quite successful with making the necessary adaptive and
creative responses to their oppressed circumstances. I am
also dealing with the somewhat abstract white middle-class
system of values as it affects Blacks. It is hoped that the
problems I encountered with conducting such a study, as
well as the positive approach I was eventually able to take
toward this work, will enable others to be equally as effec-
tive in breaking away from an intellectual tradition which
has existed far too long.

One of the primary preoccupations of every American
adolescent girl, regardless of race and social class back-
ground, is that of eventually becoming a woman. Every

girl looks forward to the time when she will discard the status of child and take on the role of adult, wife and possibly mother.

The official entry into womanhood is usually regarded as that time when she reaches the prescribed legal age (eighteen and sometimes twenty-one), when for the first time she is granted certain legal and other rights and privileges. These rights, such as being allowed to vote, to go to certain "for adults only" events, to join certain social clubs and to obtain certain types of employment, are accompanied by a type of informal understanding that very few privileges, either formal or informal, are to be denied her where age is the primary prerequisite for participation. Entry into womanhood is the point at which she is considered by older adults to be ready to join their ranks because she has gone through the necessary apprenticeship program—the period of adolescence. We can observe differences between racial and social class groups regarding, for instance, the time at which the female is considered to be ready to assume the duties and obligations of womanhood. Becoming a woman in the low-income Black community is somewhat different from the routes followed by the white middle-class girl. The poor Black girl reaches her status of womanhood at an earlier age because of the different prescriptions and expectations of her culture. There is no single set of criteria for becoming a woman in the Black community; each girl is conditioned by a diversity of factors depending primarily upon her opportunities, role models, psychological disposition and the influence of the values, customs and traditions of the Black community. It will be demonstrated that the resources which adolescent girls have at their disposal, combined with the cultural heritage of their communities, are crucial factors in determining what kind of women they become. Structural *and* psychological variables are important as focal points because neither alone is sufficient to explain the many factors involved with psychosocial development. Therefore, the concepts of motivation, roles and role model, identity and socialization, as well as family

income, education, kin and peer group relations are important to consider in the analysis. These diverse factors have rarely been considered as crucial to an analysis of Black womanhood. This situation exists because previous studies have substituted simplistic notions for rigorous multivariate analysis. Here, however, these multiple factors and influences will be analyzed as a "Black cultural" framework which has its own autonomous system of values, behavior, attitudes, sentiments and beliefs.

Another significant dimension to be considered will be the extent to which Black girls are influenced by the distinct culture of their community. Certain historical as well as contemporary variables are very important when describing the young Black woman. Her cultural heritage, I feel, has played a stronger role than has previously been stated by most writers in shaping her into the entity she has become.

Life in the Black community has been conditioned by poverty, discrimination and institutional subordination. It has also been shaped by African cultural survivals. From slavery until the present, many of the African cultural survivals influenced the way Blacks lived, responded to others and, in general, related to their environment. Even after slavery many of these survivals have remained and act to forge a distinct and viable set of cultural adaptive mechanisms because discrimination acted as an agent to perpetuate instead of to destroy the culture.

I will illustrate, through depicting the lives of Black preadolescent and adolescent girls in a big-city slum, how distinct sociohistorical forces have shaped a very positive and practical way of dealing and coping with the world. The values, attitudes, beliefs and behavior emerge from a long tradition, much of which has characterized the Black community from its earliest beginnings in this country.

What is life like in the urban Black community for the "average" girl? How does she define her roles, behaviors, and from whom does she acquire her models for fulfilling what is expected of her? Is there any significant disparity between the resources she has with which to accomplish

her goals in life and the stated aspirations? Is the typical world of the teen-ager in American society shared by the Black girl or does she stand somewhat alone in much of her day-to-day existence?

In an attempt to answer these and other questions, I went to such a community and sought out teen-agers whom I felt could provide me with some insights. I was a research assistant in 1964 on a study of an all-Black low-income housing project of over ten thousand residents in a slum area of St. Louis. (This study was supported by a grant from the National Institute of Mental Health, Grant No. MH-9189, "Social and Community Problems in Public Housing Areas.") It was geographically located near the downtown section of St. Louis, Missouri, and within one of the oldest slum areas of the city. The majority of the females were drawn from the Pruitt-Igoe housing project, although many resided outside the public housing project in substandard private housing.

At that time my curiosity was centered around the various activities in which the girls engaged that frequently produced harmful consequences. Specifically, I attempted to understand how such social problems as pregnancy, premarital sex, school dropout, etc. affected their life chances for success. I also felt, at the time, that a less destructible adaptation could be made to their impoverished environments. However, I was to understand later that perhaps a very healthy and successful adaptation, given their limited resources, had been made by all of these girls to a set of very unhealthy environmental conditions. Therefore, I soon changed my focus and attempted to apply a different perspective to the data.

I spent almost four years interviewing, testing (Thematic Apperception Test), observing and, in general, "hanging out" with these girls. I attempted to establish a strong rapport with all of them by spending a considerable amount of time in their homes with them and their families, at church, parties, dances, in the homes of their friends, shopping, at my apartment and in a variety of other situations. The sample consisted of several peer

groups which over the years changed in number and com-
position. I always endeavored to interview their parents,
and in some cases became close friends of their mothers.
The field work carried me into the community at very un-
regulated hours—weekends, occasional evenings and during
school hours (when I usually talked to their mothers). Al-
though a great portion of the data collected is exploratory
in nature, the majority of it is based on systematic open-
ended interviews that related to (1) life histories and (2)
attitudes and behavior that reflected approaching woman-
hood. During the last year and a half I randomly selected
thirty girls between the ages of thirteen and eighteen and
conducted a systematic investigation that was designed to
test many of my preliminary conclusions drawn from the
exploratory research. All of the interviews and observations
were taped and transcribed. The great majority of the in-
terviews were taped *live*, and will appear as direct quota-
tions throughout this book. (All of the girls have been
given pseudonyms.)

I feel that the data is broad in scope and is applicable
to almost any group of low-income Black teen-age girls
growing up in any American city. The economic, political,
social and racial factors which have produced neo-
colonialism on a national scale operate in Chicago, Rox-
bury, Detroit, Watts, Atlanta—and everywhere else.

The total misrepresentation of the Black community
and the various myths which surround it can be seen in mi-
crocosm in the Black female adolescent. Her growing-up
years reflect the basic quality and character of life in this
environment, as well as anticipations for the future. Be-
cause she is in perhaps the most crucial stage of psycho-
social development, one can capture these crucial forces—
external and internal—which are acting upon her, and
which, more than any other impact, will shape her life-
long adult role. Thus, by understanding the nature and
processes of her development, we can also comprehend the
more intricate elements that characterize the day-to-day
lives of the Black masses.

# Yesterday: Black Womanhood
## in Historical Perspective

Black womanhood has become a popular topic of discussion during the past decade, when social analysts, policy makers, community leaders and others became concerned about the so-called plight of the Black family and sought to intervene in this institution in an effort to "uplift" it from its alleged decay and disorganization. This focus on the Black family and its women began decades ago when E. Franklin Frazier asserted in *The Negro Family in the United States* that the family is matriarchal and disorganized as a result of having inherited the legacy of slavery, and as a result of the mass migration to the cities which causes further disruption. In 1939 Frazier wrote the following:

. . . when one undertakes to envisage the probable course of development of the Negro family in the future, it appears that the travail of civilization is not yet ended. First it appears that the family which evolved within the isolated world of the Negro folks will become increasingly disorganized. Modern means of communication will break down the isolation of the world of black folk, and, as long as the bankrupt system of southern agriculture exists, Negro families will continue to seek a living in the towns and cities of the country. They will crowd the slum areas of southern cities or make their way to northern cities where their family life will become disrupted and their poverty will force them to depend upon charity. . . . the ordeal of civilization

will be less severe if there is a general improvement in the standard of living and racial barriers to employment are broken down. Moreover, the chances for normal family life will be increased if large-scale modern housing facilities are made available for the masses of the Negro population in the cities. Nevertheless, those families which possess some heritage of family life and traditions and education will resist the destructive forces of urban life more successfully than the illiterate Negro folk and in either case their family life will adapt itself to the secular and rational organization of urban life.[1]

During subsequent periods analyses of various aspects of the Black family life were conducted, including the works of Charles S. Johnson (*Growing Up in the Black Belt*), Davis and Dollard (*Children of Bondage*), Drake and Cayton (*Black Metropolis*), Hylan Lewis (*Blackways of Kent*) and others. All of these works generally followed the Frazierian thesis by tacitly comparing the Black family to that of the white middle class, and thereby emphasizing its weaknesses, instead of attempting to understand the nature of its strengths—strengths which emerged and withstood formidable odds against oppression.

All of the classic studies which have investigated Black life and culture have focused on the attitudes and behavior of Blacks. None have dealt with the structural effects of oppression, or with specific ways to change the social system so that it no longer produces its devastating effects on Black people. Because of this faulty conceptualization of the nature of the real problem—oppression as the source— the attitudes and behavior of Blacks became the object of considerable stigmatization because they did not conform to the American *status quo*. The strong resilience and modes of adaptation which Black people developed to combat the forces of poverty and racism, produced by neo-colonialism, were *never* recognized as important areas of intellectual inquiry. Indeed, many students of the Black

[1] E. Franklin Frazier, *The Negro Family in the United States*, Chicago, University of Chicago Press, 1966 edition, pp. 367–68.

life and culture so emphasized the "pathological" that the positive features were virtually unknown. Thus, the dominant trend of thought came to be that which purports that Blacks do not value family life. Dr. Martin Luther King once voiced strong sentiments to the contrary when he said:

. . . for no other group in American life is the matter of family life more important than to the Negro. Our very survival is bound up in it. . . . no one in all history had to fight against so many physical and psychological horrors to have a family life.[2]

The work of Black Sociologist Andrew Billingsley is the first comprehensive study of the Black family that attempts to assess its *strengths* instead of concentrating on its *weaknesses*. His volume, *Black Families in White America*, also places the family in a historical perspective as it relates to the African background, slavery in the Americas, etc.[3]

The Black woman is again emerging as an important figure within the family and community, to be investigated and reinterpreted in light of the foregoing discussion.

Because there has been much controversy and concern over the Black woman, and since there are a great number of misconceptions and myths about who she is, what her functions are and what her relationship to the Black man in fact is, it is necessary that one understand some of the historical background that has shaped her into the entity she has become. It is important to realize that most of the analyses concerned with Black women (largely the poor) are ahistorical and do not attempt to place her in the context of the African background, through slavery and into the modern era. Indeed, scholars generally assume that Blacks were stripped of their heritage during slavery. (This will be discussed more fully below.)

[2] Address delivered at Abbott House, Westchester County, New York, October 29, 1965.

[3] Andrew Billingsley, *Black Families in White America*, Englewood Cliffs, New Jersey, Prentice-Hall, 1968.

It would seem impossible to understand what she is to-
day without having a perspective on what her forebears
were, especially as this relates to the roles, functions and
responsibilities she has traditionally held within the family
unit. This, of course, will involve her relationship to her
husband, children and the extended family. Only by under-
standing these broader sociohistorical factors can we prop-
erly interpret her role today.

There are basically three periods that relate to the Black
woman that will be included in this analysis: (1) the
African background; (2) slavery; and (3) the modern era.
In discussing the Black woman from a historical perspec-
tive, it is important to know that there is no monolithic
concept of *the* Black woman, but that there are many
models of Black womanhood. However, there is a common
denominator, a common strand of history, that charac-
terizes all Black women: *oppression.*[4] Even though many
Black women today consider themselves middle class and
often are socialized in a tradition similar to that of middle-
class white women, the common ancestry and oppressive
conditions under which all Black people have had to live to
varying degrees provide the strong similarities and com-
monalities. Therefore, this chapter will broadly focus on
*the* Black woman, taking into consideration the differences
and similarities that have been mentioned.

THE AFRICAN BACKGROUND

Before Africans were brought to American shores, they had
developed highly complex civilizations along the West
Coast, the area where a considerable amount of slave trad-
ing occurred. The tribal customs and laws for marriage
and the family, property rights, wealth, political institu-
tions and religion revolved around distinct patterns of cul-
ture which had evolved out of the history of the African

---

[4] African women were not shaped by oppression and it was
only after they came to the New World that they had these ex-
periences.

people. The family patterns were viable entities unto themselves and were not influenced by, nor modeled after, the Western tradition of the monogamous unit, and strong protective attitudes toward kinsmen, including the extended family, likewise had their legitimate origin within African societies and were highly functional for her people. John Hope Franklin states that, "At the basis even of economic and political life in Africa was the family, with its inestimable influence over its individual members."[5] The family was extended in form, and acted as a political, economic and religious unit. All of these institutional functions and arrangements took place within the broader extended family presided over by the patriarch. Another writer has noted that, "Although there were various types of states, the fundamental unit politically, . . . was the family. . . . It was a kinship group numbering in the hundreds, but called a family because it was made up of the living descendants of a common ancestor. The dominant figure in this extended community was the patriarch, who exercised a variety of functions. . . ."[6]

A striking feature of precolonial African society was the importance that was attached to the family unit. The extended family was highly structured, with clearly designated roles for its male and female members. Marriage was always considered a ritual that occurred not between two individuals alone, but between all the members of the two extended families. It was a highly sacred ritual that involved bride price and other exchanges of property. Often marriages were arranged by parents of the bride and groom but sometimes by the two consenting partners. The emphasis was placed upon the binding together of two individuals who represented different families, and upon the mutual duties and obligations they were to carry out for each other. The elderly were highly regarded in African society. The

[5] *From Slavery to Freedom*, New York, Alfred A. Knopf, Inc., 1956, p. 28.
[6] Benjamin Quarles, *The Negro in the Making of America*, London, Collier-MacMillan Ltd., 1964, pp. 16–17.

patriarch of the extended family, who was sometimes considered a chief, was usually an elderly man.

Since the families lived in tribes, most of what would now be considered extrafamilial functions were also carried out within the broader extended unit. These included providing for the family's food, clothing, shelter, recreation, religious instruction and education. The family, through the tribe, also engaged in warfare against other hostile tribes. As a social system, the extended family was complete and autonomous. This independence perhaps encouraged the development of close ties between family members and a high regard for the sanctity of the family.

Notably, the roles of women in precolonial Africa were very important ones and quite different from what were considered the duties and obligations of women in Western society. Two of the important roles of African women which were perpetuated during slavery and continue until today are: (1) her economic function; and (2) the close bond she had with her children. Politically, women were very important to the administration of tribal affairs. Since lineage was often matrilineal (descent traced through the female), "Queen Mothers" and "Queen Sisters" assumed highly significant duties in the tribe. For example:

Each major official had a female counterpart known as his "mother," who took precedence over him at court and supervised his work. When officials reported to the King, groups of women were present, whose duty was to remember what had happened.[7]

In attempting to explain the origin of the important roles played by women in precolonial African society, one historian has noted that:

There is a recurring theme in many African legends and mythology of a woman who is the founder or the mother of the tribe

[7] August Meier and Elliott Rudwick, *From Plantation to Ghetto*, New York, Hill and Wang, 1966, p. 14.

*too general
doesn't differentiate between ordinary people
& people assuming special roles*

who is either a queen or the daughter of a king. She is an aristo-
cratic lady who is involved in politics. For example, the creation
myths of the Hausa people in Northern Nigeria or of Niger or
Chad began with a woman who goes out and founds a kingdom.
She is the Black Moses who is leading her people into the prom-
ised land which is an area near the water where communication
is relatively free. She settles down and establishes the traditions
of the people.[8]

It is clear that the roles of women in precolonial West
African societies were very different from those of women
in Western society. Their positions of economic and po-
litical power could also be observed in the family.

One of the ways in which the role of women can be
observed is in her relationship to children. The Queen
Mother or Queen Sister among the Ashanti, who traced
descent matrilineally, placed the woman in the highest
order because of her role as procreator.

Like a mother's control of her children, a queen mother's author-
ity depends on moral rather than legal sanctions and her position
is a symbol of the decisive function of motherhood in the social
system.[9]    *but is this really power?*

Furthermore,

As Ashanti often point out, a person's status, rank and funda-
mental rights stem from his mother, and that is why she is the
most important person in his life.[10]

The relationship between mother and child was important
in all of West Africa. Although there were clearly defined

[8] Marie Perinbaum, lecture delivered at Spelman College,
Spring 1969.
[9] Meyer Fortes, "Kinship and Marriage Among the Ashanti,"
in *African Systems of Kinship and Marriage*, eds. A. R. Radcliffe-
Brown and Daryll Ford, New York, Oxford University Press,
1950.
[10] R. S. Rattray, *Ashanti*, 1923.

roles for adult men and women, with the male taking a
strong role as the patriarch, there were still vital functions
that the mother fulfilled for the children and were re-
served only for her. Thus, "the Ashanti regard the bond
between mother and child as the keystone of all social
relations."[11] Even in the societies where descent was pat-
rilineal or double, there was a high regard for the mother's
function as child bearer and perpetuator of the ancestral
heritage. This emanates from the value that is attached to
the childbearing powers of women. Barren women are
pitied, if not outcasts, even today in much of Africa. Bar-
renness is often considered a legitimate reason for a man
to seek a divorce from his wife. Similarly, women who
bear great numbers of children are accorded high status.[12]
This emphasis upon the woman's role does not underesti-
mate the importance of the male as provider, disciplinar-
ian and teacher. The strong patriarchal figure was of ut-
most importance to the child's rearing, but the day-to-day
contact was primarily with the mother.

Another area of importance with regard to women's
roles in African society was their economic function as
traders in the villages. Meier and Rudwick note that:

Women played an important role in the administration of polit-
ical and economic affairs. . . . They were the chief traders in the
village.[13]

Even in contemporary West African society, women still
fulfill the important economic function as traders. Marie
Perinbaum states:

The West African market woman is an institution in West Africa.
She is the small capitalist, or the entrepreneur, and is sometimes

[11] Fortes, p. 262.
[12] Clark D. Moore and Ann Dunbar, *Africa Yesterday and
Today*, New York, Bantam Books, 1968, p. 33.
[13] P. 14.

one of the major cash winners of the family. She is also the one who brings in the consumer goods.[14]

Melville Herskovits also describes the prominent role that women played as traders in the market, and indicates that some of them became independently wealthy as a result of their endeavors.[15]

These are the traditions and life-styles to which Africans were accustomed. As products of highly complex civilizations, with a high regard for the family—both living and dead—they must have been totally unprepared for the barbaric conditions to which they would be subjected in the New World. From the early seventeenth century to the mid-nineteenth century when slavery ended, approximately forty million Africans were brought to the United States. Historians note that slavery in the United States assumed the most cruel and harsh form, and was designed systematically to dehumanize its captives. All the highly developed institutions which were an integral part of African society were crushed (from their original form) and slaves had to fight to preserve whatever remnants of their civilization they could.

In this cursory view of the Black woman's relationship to the African past one can observe that she was part of a cultural tradition that was very different from that which she was to enter in the New World. Thus:

The Negro who came to the New World varied widely in physical type and ways of life, but there were many common patterns of culture. Whatever the type of state, the varied groups all operated under orderly governments, with established legal codes, and under well-organized social systems. The individual might find it necessary to submerge his will into the collective will, but he shared a deep sense of group identity, a feeling of belonging.[16]

[14] Marie Perinbaum, lecture delivered at Spelman College, Spring 1969.

[15] *The Myth of the Negro Past*, Boston, Beacon Press, 1958 edition, p. 62.

[16] Quarles, pp. 18–19.

The degradation which she suffered in slavery had total effects on all aspects of her life—her identity as a woman and as an African, her relationship and roles with regard to her husband and family, etc.

## SLAVERY

When Africans were sold into slavery they were introduced to an alien culture and an attempt was made to force them to adopt the way of life of Western society. The highly organized social order from which they emerged was considered "barbarous" and "uncivilized" because of the inability of Europeans to understand and appreciate the cultural differences which set them apart from the Africans. Because of the fact that slavery was engaged in for economic reasons, Africans became property and were thus denied the rights of human beings. They were not publicly allowed to practice their native religions, speak their native languages, nor to engage in the numerous other cultural traditions which were characteristic of African society. Obviously the effects were devastating on the family, which, in fact, could not be recognized as the one they had been part of in Africa, notably in its structure. Legal marriage was denied, allowing for the emergence of the ephemeral quality of male-female liaisons. Men were denied the right to fulfill the long-standing tradition of patriarch over the extended family, and women, in effect, became the backbone of the family. Parents were denied the right to exercise authority over their children, an important aspect of African culture. Especially absent was the function of the economic provider, disciplinarian and teacher, which were strong characteristics of the African male. Of considerable importance is the emphasis slaveholders placed upon the legal contract between slave and master as well as the various informal sanctions of slavery. Quarles notes that:

All slaves were inculcated with the idea that the whites ruled from God and that to question this divine right-white theory was to

incur the wrath of heaven, if not to call for a more immediate sign of displeasure here below.[17]

Numerous legal restrictions were enacted to prohibit the slave from exercising his rights as a free person. In spite of these restrictions, there were many outward signs of rebellion against the mores of the slave masters. The structure and processes of slave family life have not been adequately documented because of the scarcity of information recorded by slaves. Yet there is some data concerning the family and, particularly important for the purposes of this analysis, the role of women in slave society.

Most of the accounts of the relationships between slaves and their regard for each other are to be taken from slave narratives and autobiographies of ex-slaves such as Frederick Douglass, Nat Turner and Sojourner Truth. These provide information about the role women in particular played within the family and society. It must be noted that these frequently differ with the analyses and portraits some historians have given. One of the positions that has been advanced by social scientists is that slaves rarely developed strong familial bonds with each other because of the disruptive nature of their family and community life. This position runs counter to the firsthand accounts given by slaves. For it will be observed that the family during slavery, with all its modifications, was a strong unit in that parents were able oftentimes to impart certain values and cultural ethos to their offspring. It appears that whenever it was economically feasible for this family pattern to emerge, parents sought to exert this responsibility. The family was also extended in form whenever it was economically feasible.

Nat Turner, the revolutionary, provides information about his relationship with his parents and grandmother. In his own *Confessions*, he speaks of the religious instruction he received from his grandmother, to whom he was

[17] P. 71.

closely attached, and of the encouragement he received
from his mother and father to become a prophet. He
states:

My father and mother strengthened me in this my first impres-
sion, saying in my presence, I was intended for some great pur-
pose, which they had always thought from certain marks on my
head and breast.[18]

Frederick Douglass, the noted abolitionist, in the *Life and
Times of Frederick Douglass* describes the close relation-
ship he had with his grandmother, who cared for him in
the absence of his mother. Douglass states:

If my poor, dear old grandmother now lives, she lives to remem-
ber and mourn over the loss of children, the loss of grandchil-
dren and the loss of great-grandchildren. . . . My poor old
grandmother, the devoted mother of 12 children is left all
alone. . . .[19]

On one occasion he remembers his own mother, who had
been sold to another plantation, slipping into their home
in the night to see him.

I was grander upon my mother's knee than a king upon
his throne. . . . I dropped off to sleep, and waked in the morn-
ing to find my mother gone. . . . My mother had walked twelve
miles to see me, and had the same distance to travel again be-
fore the morning sunrise.[20]

[18] "The Text of the *Confessions of Nat Turner*, as reported
by Thomas R. Gray, 1831," reprinted in John Henrik Clarke
(editor), *The Confessions of Nat Turner: Ten Black Writers
Respond*, Boston, Beacon Press, 1968, pp. 93–118.
[19] Benjamin Quarles, ed., *Narrative of the Life of Frederick
Douglass, an American Slave, Written by Himself*, Harvard Uni-
versity Press, 1960, pp. 35–36.
[20] Pp. 35–36.

Sojourner Truth, the prophet and leader, who referred to slaves as Africans, provides a vivid account of the trauma her mother suffered when she was separated from her children. Sojourner recounts:

I can remember when I was a little, young girl, how my old mammy would sit out of doors in the evenings and look up at the stars and groan, and I would say, "Mammy, who makes you groan so?" And she would say, "I am groaning to think of my poor children; they do not know where I be and I don't know where they be. I look up at the stars and they look up at the stars!"[21]

When Sojourner's five-year-old son was taken and she was told that he was to be sold into the Deep South (although she was a slave in New York State), she made the statement that she felt as "tall as the world and mighty as the nation," indicating that she had the faith that she and her son would some day be reunited.

Numerous slave narratives provide dramatic accounts of the events surrounding the forced separation between parents and children. The following is one such example.

My brothers and sisters were bid off first, and one by one, while my mother, paralyzed with grief held me by the hand. Her turn came and she was bought by Issac Riley of Montgomery County. Then I was offered. . . . My mother, half distracted with the thought of parting forever from all her children, pushed through the crowd while the bidding for me was going on, to the spot where Riley was standing. She fell at his feet, and clung to his knees, entreating him in tones that a mother could only command, to buy her baby as well as herself, and spare to her one, at least, of her little ones. . . . This man disengaged himself from her with . . . violent blows and kicks. . . . I must have been between five and six years old.[22]

[21] Taken from W. E. B. DuBois, "The Damnation of Women," *Darkwater*, New York, Shocken Books, 1969, p. 179.
[22] Josiah Henson, *Father Henson's Story of His Own Life*, New York, Corinth Books, 1962, pp. 12–13.

Even when separation was apparent, and fathers and mothers found themselves unable to prevent it, there was evident a profound feeling that the family would one day be reunited. Slaves also tried to instill within their children who were being separated from them a sense of morality.

I was about twelve or fourteen years old when I was sold. . . . On the day I left home, everything was sad among the slaves. My mother and father sung and prayed over me and told me how to get along in the world.[23]

This strong bond also transcended actual separation, because when families were not reunited, memories and grief about kinsmen remained strong. Solomon Northup, who spent twelve years as a slave, recalls one such experience.

On my arrival at Bayou Boeuf, I had the pleasure of meeting Eliza, whom I had not seen for several months. . . . She had grown feeble and emaciated, and was still mourning for her children. She asked me if I had forgotten them, and a great many times inquired if I still remembered how handsome little Emily was—how much Randall loved her—and wondered if they were living still, and where the darlings could then be. She had sunk beneath the weight of an excessive grief. Her drooping form and hollow cheeks too plainly indicated that she had well nigh reached the end of her weary road.[24]

Northup's accounts of Eliza's grief demonstrate the mortal psychological wounds she suffered as a result of being separated from her children. It appears that she would almost rather have been dead than to have given them up.

Indeed, some accounts show that mothers chose death for themselves and their children rather than experience

[23] Anonymous, *God Struck Me Dead: Religious Conversion Experiences and Autobiographies of Negro Ex-Slaves*, Nashville, Fisk University Social Sciences Institute, 1945, pp. 161–63.

[24] Solomon Northup, *Twelve Years a Slave*, Baton Rouge, Louisiana State University Press, 1968, p. 77.

the humiliation and torture of slavery, separation and the total denial of their humanity. There is much in the oral history of slavery that speaks about the vast number of captives who jumped overboard en route to the Western Hemisphere, preferring to die rather than become slaves. It is said that others threw their newborns overboard for the same reason. After arriving on the mainland, women sometimes killed their children rather than allow them to grow up in slavery. This highest form of rebellion can be observed in the following oral historical account, taken from a slave narrative.

My mother told me that he [slave master] owned a woman who was the mother of seven children, and when her babies would get about a year or two of age he'd sell them and it would break her heart. She never got to keep them. When her fourth baby was born and was about two months old, she just studied all the time about how she would have to give it up, and one day she said, "I just decided I'm not going to let ol' master sell this baby; he just ain't going to do it." She got up and give it something out of a bottle and pretty soon it was dead.[25]

This example shows the total commitment this mother had to fighting a system which violated what must have been her most sacred principles.

All of these are some of the symbols of the strong bonds that existed between parents and children (notably between mother and child) during slavery and the strong attachment all the family had for each other. Contrary to popular myth, Black parents had a tremendous capacity to express grief when separated from their children. One must also recognize the fact that, because of the inability of slaves to marry legally and have sustained unions, mothers were more often left with the ongoing care of the children, for whatever period they were able to do so. This also

[25] Lou Smith, B. A. Botkin (eds.), *Lay My Burden Down, A Folk History of Slavery*, Chicago, University of Chicago Press, 1945, p. 40.

meant that they served the vital economic function of providers for their families in the absence of a sustained husband-father figure. Staples notes that "only the mother-child bond continually resisted the disruptive effect of economic interests that dictated the sale of fathers away from their families."[26] The institution of slavery only acted to reinforce the close bond that had already existed between mother and child in African society. It could be argued that this strong attachment, although very positive, in many respects probably would not have developed if Africans had been allowed the basic freedoms and liberties of the Europeans who had settled on this continent. This was a necessary adaptation to the system, and without doubt acted to reinforce the subjugation of men to women. It is clear that, within the cultural context of the dominant society, slave women were forced to assume the basic duties and responsibilities toward their families men assumed in the white world. The impact this had on Black men is immeasurable and remnants of this effect can be found today, especially since many of the fundamental conditions are unchanged.

Historians have adequately documented the numerous rebellions/revolts staged by slaves against the social system. The most widely known form of rebellion was the slave revolt but there were a variety of other ways that slaves expressed their indignation, such as the day-to-day feigning of illness or acting "stupid" (recalcitrance). There is little evidence that slaves were a docile, happy lot who without hesitation gave up their African heritage and contented themselves to adapting to whatever life-styles their masters dictated.

The question is often raised as to what was the Black man's role in defending his family against all the ravages and mass assaults of the slave system. It seems to be generally assumed that they did very little, and most often

[26] Robert Staples, "The Myth of the Black Matriarchy," *Black Scholar*, January–February 1970, p. 10.

nothing, to defend their mothers, wives and children. But there are numerous historical accounts of Black men lashing out against slavery because of its inhuman effects upon their families. One notable example is David Walker's *Appeal*, given in 1829.

Now, I ask you, had you not rather be killed than be a slave to a tyrant, who takes the life of your *mother, wife, and dear little children?* Look upon your *mother, wife, and children,* and answer God Almighty; and believe this, that it is no more harm for you to kill a man, who is trying to kill you, than it is for you to take a drink of water when thirsty; in fact, the man who will stand still and let another murder him, is worse than an infidel, and, if he has common sense, ought not to be pitied. (Emphasis added)[27]

One could imagine that Walker voiced the sentiments of the hundreds of thousands of Black men who found themselves unable to protect their mothers, wives and children from the barbarous slave system. Some accounts can be found of Black men who attempted to uphold the system of marriage by defending their wives against the attacks of white men. The following is one such account of a man who described the harsh experiences of his father, who attempted to defend his mother.

His right ear had been cut off close to his head, and he had received a hundred lashes on his back. He had beaten the overseer for a brutal assault on my mother, and this was his punishment. Furious at such treatment, my father became a different man, and was so morose, disobedient, and intractable, that Mr. N. decided to sell him. He accordingly parted with him, not long after, to his son who lived in Alabama; and neither mother nor I ever heard from him again.[28]

[27] Reprinted in Floyd Barbour, *The Black Power Revolt*, Boston, Porter Sargent Publishers, 1968, p. 25.
[28] Frazier, *The Negro Family in the United States*, p. 53.

This severe punishment is a reflection of the problems
Black men encountered when trying to exercise their rights
and obligations to their families. They were harshly dealt
with, sometimes unto death, when doing so. Almost any
compassion expressed by slaves toward each other was
dealt with severely. The following account was taken from
a slave narrative:

They whipped my father 'cause he looked at a slave they killed
and cried.[29]

Slave masters, through their demands for absolute obe-
dience, and reinforced by harsh slave laws, attempted to
crush every symbol of humanity, affection and compassion
within slaves. There were, of course, exceptions among
some slaveholders who attempted to develop a more hu-
mane system.

If slaves revolted against the Western political and cul-
tural system in the ways indicated, there is strong reason
to believe that they, in the process of revolting, attempted
to preserve some of their African traditions. One could
argue that slave revolts (minor and major) were evidence
of a two-pronged attack: (1) against the cruelty of slav-
ery; and (2) against the denial to Blacks of the right to
practice their past cultural traditions, etc. Indeed, both
are closely related. This is not to underestimate the effects
slavery had upon attempting to crush every single remem-
brance of Africa, because the impact was obviously dev-
astating. But one could argue that the oppression forced
some of the native traditions underground. It is also clear
that individual slaves had a strong reaction to slavery and
the denial of Africans in this country to relate to the na-
tive customs. Sojourner Truth's reference to Blacks as
Africans is a notable example. It is most clear, however,
that slavery forged many distinct adaptations and acted

[29] Roberta Manson, Library of Congress, taken from Julius
Lester, *To Be a Slave*, New York, Dial Press, 1968, p. 33.

to create a unique set of behavior patterns, attitudes and values—a Black culture—that are more American than African. Yet it would be in error to say that all of the African heritage was destroyed during slavery, because we have observed certain conditions that encouraged the perpetuation of African traditions related to the family. Immediately we can recognize the effects oppression had and subsequent adaptations it caused in the sharp change in status of Black men, who were strong patriarchs in African society and mere subhumans in America, with none of the rights and privileges of American household heads. There are numerous other changes that affected the roles of men and women, such as the inability to marry legally and have children within the Western societal framework, and the undue hardships women experienced with being *forced* very often to accept total responsibility for their families.

A multiplicity of factors acted to mold the Black family —notably slavery. It is too simple an explanation to attribute all of the behavior characteristics of the family during slavery to either *Africanisms* or to the *series of adaptations that Blacks were forced to make to the social system*. On this point, Herskovits states that:

Slavery did not cause the "maternal" family; but it tended to continue certain elements in the cultural endowment brought to the New World by the Negroes. The feeling between mother and child was reinforced when the father was sold away from the rest of the family; where he was not, he continued life in a way that tended to consolidate the obligations assumed by him in the integrated societies of Africa as these obligations were shaped to fit the monogamic, paternalistic pattern of the white masters.

The economic, political and social institutions to which Africans had to relate during slavery provided the opportunity for the survival of many of the African traditions. The woman continued to play important functions within the family with regard to the welfare of children as well

as in the economic sphere. This allowed for the strengthening of her role as an independent figure within the family; in the New World her role as an economic provider only assumed a different form. However, the demands in slave society were more acute than those she had experienced in Africa because of the mandatory status that was applied.

That the plantation system did not differentiate between the sexes in exploiting slave labor, tended, again, to reinforce the tradition of the part played by women in the tribal economics.[30]

As already stated, had there not been a continuing need for Black women to continue to fulfill these functions their roles would probably have been little different from those of most white women, whose statuses were economically secure.

Today a popular debate revolves around whether or not American Blacks possess a distinct cultural heritage that is a hybrid of the culture developed during slavery and certain remnants of African culture that were preserved. E. Franklin Frazier argues in *The Negro Family in the United States* that slavery and the Middle Passage destroyed all remnants of African culture:

Probably never before in history has a people been so nearly completely stripped of its social heritage as the Negroes who were brought to America. Other conquered races have continued to worship their household gods within the intimate circle of their kinsmen. But American slavery destroyed household gods and dissolved the bonds of sympathy and affection between men of the same blood and household. Old men and women might have brooded over memories of their African homeland, but they could not change the world about them. Through force of circumstances, they had to acquire a new language, adopt new habits of labor, and take over, however imperfectly, the folkways of the American environment. Their children, who knew only the

[30] Herskovits, p. 181.

American environment, soon forgot the few memories that had been passed on to them and developed motivations and modes of behavior in harmony with the New World. Their children's children have often recalled with skepticism the fragments of stories concerning Africa which have been preserved in their families. *But, of the habits and customs, as well as the hopes and fears that characterized the life of their forebearers in Africa, nothing remains.* (Emphasis added)[31]

In his perceptive analysis, Melville Herskovits polemicizes Frazier in *The Myth of the Negro Past* and argues that many "Africanisms" survived slavery and are to be observed in the contemporary life-styles of Blacks, including the family, religion, music, dance, the arts, etc. The debate continues today among scholars such as Nathan Glazer and Daniel P. Moynihan, who assert that, "It is not possible for Negroes to view themselves as other ethnic groups viewed themselves because . . . the Negro is only an American and nothing else. He has no values and culture to guard and protect."[32] Some Black intellectuals have argued that Blacks in American society are an African people, and that few of the continuities between Africa and America have been broken.[33] Others propose that Black culture is authentic. Charles Keil, whose study of Black blues singers demonstrates the distinctiveness of the "soul ideology" and its peculiarity to the Black experience, is one of the chief proponents of this thesis.

Like it or not, . . . a Negro culture exists, and its existence ought to be recognized by all concerned, no matter what their policy or proposed solutions to the American dilemmas.[34]

[31] P. 15.
[32] *Beyond the Melting Pot*, Cambridge, M.I.T. Press, 1963, p. 53.
[33] abd-L Hakimu Ibn Alkalimat, "The Ideology of Black Social Science," *Black Scholar*, December 1969, pp. 28–35.
[34] Charles Keil, *Urban Blues*, Chicago, University of Chicago Press, 1966, pp. 191–92.

Robert Blauner asserts that the peculiar historical experiences of Blacks allowed for the development of a distinctive Negro lower-class life-style, although compared to the cultures of other ethnic minorities it is relatively weak.[35] It is very easy to concentrate on the thesis that Blacks were denied their heritage because it allows for the perpetuation of various myths regarding the inferiority of Black people. Herskovits states:

The myth of the Negro past is one of the principal supports of race prejudice in this country. Unrecognized in its efficacy, it rationalizes discrimination in everyday contact between Negroes and whites, influences the shaping of policy where Negroes are concerned, and affects the trends of research by scholars whose theoretical approach, methods, and systems of thought presented to students are in harmony with it.[36]

It seems more difficult to recognize the unique heritage of Blacks because most of the current historical documentations present a stereotyped portrait of the servile slave personality, as well as the "disorganized" family structure. One is forced to perceive Black people today in a more positive manner if recognition is given to the rich cultural tradition from which Blacks emerged. Such an analysis would put Black people close to the same context in which the European immigrants to this country have been placed —immigrants who have been allowed to be assimilated into the mainstream of the society, and whose cultural heritages are highly respected.

Much of the heritage of slavery was passed on to Blacks in the modern era. The basic economic inequities and racial discrimination in all walks of life prevented the majority of the Black population from entering the mainstream and competing in an open society. Therefore, some

[35] Robert Blauner, "Negro Culture: Myth or Reality," *Black Experience: The Transformation of Activism*, Trans-action publication, 1970.
[36] P. 1.

of the problems Black women faced during slavery, notably those of providing the economic sustenance for the family in the absence of a strong male provider, the maintenance of the extended family and the close ties between mother and children, are also characteristics today.

So Black people had no choice but to develop their own distinctive culture with some elements from the old and some from the new and many innovative adaptations. It was necessary to develop this Black culture in order to survive, to communicate and to give meaning to life. For culture is the very way of life of a people.

The debate over the retention of Africanisms and the controversy over whether either a total Black social system or a Black subculture exists has only relative importance. There are both sharp discontinuities and strong uniformities between Africa and the New World (the United States and the Caribbeans), and the principal factor among these should be an understanding of the political context of the Black family all over the world. The Black families in Africa, the Caribbeans and the United States have all been strongly influenced by the effects of neo-colonialism, and thus have suffered similar problems emanating from racism and poverty.

Numerous studies have been conducted on the Black family in the Caribbeans and all of them provide a considerable amount of information about the way in which the continuities between Africa and this part of the New World have been maintained, although these assumptions are only implicit in most of these investigations.[37]

[37] Edith Clarke (*My Mother Who Fathered Me*, London, George Allen and Unwin Ltd., 1957), R. T. Smith (*The Negro Family in British Guiana*, New York, Grove Press, Inc., 1956), M. G. Smith (*The Plural Society in the British West Indies*, Berkeley, University of California Press, 1965), Judith Blake (*Family Structure in Jamaica*, New York, Free Press, 1961), William Goode ("Illegitimacy in the Caribbean Social Structure," *American Sociological Review*, XXV, February 1960, pp. 21–30), Hyman Rodman ("Marital Relationships in a Trinidad Village," *Marriage and Family Living*, XXIII, May 1969, p. 170; "Lower-

One can recognize the similarities that exist between the Caribbean society and the broader Black community in the United States, although the interpretations that researchers have provided vary widely. Blake argues, for example, that lower-class family relations are merely deviations from the traditional Western social system instead of being representative of a distinct culture. This position was challenged by Braithwaite, Rodman et al., who assert that this seemingly disorganized culture is a normal and legitimate one for its adherents.

It is generally recognized that the institution of slavery was less severe in this part of the New World than in the United States, which accounted for, among other things, a higher retention of African culture. Melville Herskovits' pioneering efforts in studying the continuities are perhaps still considered the foremost work in this field, although other scholars have challenged many of Herskovits' assumptions. Hannerz says:

Noting the strong bond between mother and children in black American households, and the weak and marginal relationship of the husband and father to this household nucleus, Herskovits related this to West African polygyny where he held that the male naturally was somewhat peripheral to each group of mother and children. West African women are also traditionally rather independent economically, a fact which could contribute to keeping the husband-wife relationship rather weak. West Africans had an idea of the conjugal relationship as relatively weak, and

class Attitudes Toward 'Deviant' Family Patterns, a Cross Cultural Study," *Journal of Marriage and the Family*, May 1969, pp. 315–21; and "The Lower Class Value Stretch," *Social Forces*, XLII, December 1963, pp. 205–15), Lloyd Braithwaite ("Sociology and Demographic Research in the Caribbean," *Social and Economic Studies*, VI, Jamaica, University College of the West Indies) and F. M. Henriquez (*Family and Colour in Jamaica*, London, Eyre and Spottiswoode, 1953)—all these scholars have provided penetrating insights into the family structure of West Indians.

when taken into slavery in the Americas they brought this idea along.[38]

A position that is somewhat different from both Herskovits and E. Franklin Frazier's "culturally stripped" thesis is held by M. G. Smith, who maintains that in the West Indies many of the cultural adaptations to the slave system which developed are still transmitted because of their functional value, and other family forms that are closer to the dominant society have developed out of the contemporary social context because certain conditions have been conducive to their emergence.[39]

An understanding of the Caribbean family structure provides the broader perspective that is needed to interpret the common sociohistorical experiences of Blacks in the Americas. Such an analysis also generates a proper political context in which to analyze and propose solutions to the problems of the Black family in all of the New World.

THE BLACK WOMAN TODAY

Black women in contemporary American society have been influenced by the conditions which characterize the history of Black people in Africa and the New World. The "matriarchy" has become a popular symbol that is used by many to describe Black womanhood, although this label is probably most often invalid. Today Black women play highly functional and sometimes autonomous roles within the family and society because the same economic and social conditions which allowed for the emergence of a female-dominated society during slavery still perpetuate this type of family structure. The female-headed household is assumed to be the predominant family form al-

[38] Ulf Hannerz, *Soulside: Inquiries into Ghetto Culture and Community*, New York, Columbia University Press, 1969, p. 72.

[39] See Ulf Hannerz, *Soulside*, pp. 71–76, for a full discussion of the various schools of thought on the Black family in the New World.

though less than one quarter of all Black families in the United States are headed by a woman.[40] (In 1965, 21 per cent of the families were female-headed.) The popular Moynihan report (*The Negro Family: The Case for National Action*) aroused national fervor in 1965, when its author asserted that the Black family had reached a stage of breakdown because of the high percentage of female-headed households. Little consideration was given to the fact that this almost one fourth broken families included those ruptured by death, desertion, separation, divorce, as well as a perhaps higher percentage of common-law arrangements which are not considered in the marriage statistics as a legitimate form. Another consideration is that the very close conjugal relationship that, ideally, comes with legal marriages is not as strongly a part of the traditions of poor Black people. Legal marriage is a decided choice, but not necessarily the unquestionable preference for all adult males and females.

Given the highly unsuitable conditions to which the Black family has been subjected, one would expect the number of female-headed households to be considerably higher. On this point, Erik Erikson asks the question:

Why do we hear so much about the absent father and so little about the present father—although the majority of fathers are present? Why do we hear so little about the presence of the mother and what she has achieved against staggering odds? If it were not for the magnificent strength of low-income Negro mothers, surely the family would have disintegrated by now. Why is so little said about the strengths of low-income families, and so much about their weaknesses?[41]

[40] Social scientists rarely use multivariate analysis when analyzing female-headed households. Some follow the common stereotype which holds that the most common cause for female-headed households is desertion. Yet family "experts" are all too willing to analyze all possible causes for the rupture of white families, including death, divorce, etc.

[41] Erik Erikson, "The Concept of Identity in Race Relations: Notes and Queries," *Daedalus*, Winter 1966, pp. 145–71.

It has been argued that the so-called matriarchy is a myth because the Black family and the Black woman have never functioned in the manner in which proponents of the matriarchy thesis propose. The matriarchy has been defined as:

. . . a society in which some, if not all, of the legal powers relating to the ordering and governing of the family-power over property, over inheritance, over marriage, over the house are lodged in women rather than men.[42]

The standards which have been applied to the so-called Black matriarchy depart markedly from this definition. In fact, it has been suggested that no matriarchy (defined as a society ruled by women) is known to exist in any part of the world.[43]

The highly functional role that the Black female has historically played has caused her to be erroneously stereotyped as a matriarchate, and this label has been quite injurious to Black women and men. It has caused a considerable amount of frustration and emasculation within Black men because it implies that they are incapable of fulfilling the responsibilities for the care and protection of their families. It has also caused certain added responsibilities to be placed on the shoulders of the Black woman because the larger societal expectation of her was in conformance with this stereotyped conception.

In recent years the Black woman has almost become a romantic, legendary figure in this society because the vast conceptions of her as a person are largely dictated by these stereotypes. The idea that she is almost superhuman, capable of assuming all major responsibilities for sustaining herself and her family through harsh economic and social conditions has been projected in much of the popular

[42] Margaret Mead, *Male and Female,* New York, William Morrow and Co., 1949, p. 301.
[43] William Goode, *The Family,* New Jersey, Prentice-Hall, Inc., 1964, p. 14.

literature as well as the academic research. Implicit in the popular conceptualization of Black womanhood on all fronts is that she is felt to be stronger than other women, and certainly stronger than Black men. It is ironic that as the Black woman was romanticized for her so-called superior strength, at the same time she was criticized because she was labeled as a perpetuator of "bastardization" and the Black man was systematically excluded from meaningful participation in the society.

The dualism which characterizes the way in which the Black woman is perceived by the dominant society (the towering pillar of strength and an "immoral" person who cannot approximate the white woman, who has become the adorned symbol of femininity in American society) is responsible for many of the conflicts and problems she must endure. She has been forced to accept the images of what the larger society says a woman should be but at the same time accept the fact that in spite of how she strives to approximate these models, she can never reach the pedestal upon which white women have been put. Until recently this was the source of a considerable amount of anxiety in many Black women, but the new thrust toward Black consciousness and Black identity have allowed for the development of an internal set of standards by which many Black women have begun to judge themselves. Therefore, the conflict which was caused because of the incongruity between white versus Black identification models has lessened, and white conceptions of womanhood have ceased to have the same relevance they once had. In many cases, there has been an outright rejection of the standards of womanhood created by the dominant society. This can be observed in the area of make-up and wearing apparel (natural hair styles and African garb), as well as in the rejection of the more fundamental values that govern the dominant society's family life (monogamy and a high value for having children in wedlock).

The conceptions and expectations that the larger society holds about the Black woman have a strong impact on

the entire Black community, and notably affect her relationship with Black men. A popular theme projected by social scientists and in the popular literature is that Black men have been psychologically castrated because of the strong role Black women play in the home and community. Moreover, it is often assumed that the male's inability to function as the larger society expects him to is more a function of his having been emasculated by the woman than the society. Although the scars of emasculation probably penetrated the Black man more deeply than the injustices inflicted upon the woman, there has, however, been an overemphasis upon the degree to which the Black man has been damaged. Some writers on the subject would have us believe that the damage done is irreparable.[44] They also refuse to place the responsibility on the racist society, but rather insist that it is caused by the so-called domineering wife and/or mother. Few will accept the theory that much of the damage is done outside the male-female relationship and that it is within the home that his failure is reinforced because it is there that he is reminded of his inability to function as a productive member of the society *and* to his fullest capacity in his home. One writer has suggested that this alleged conflict between Blacks has been deliberately advanced:

It has been functional for the white ruling class, through its ideological apparatus, to create internal antagonisms in the black community between black men and women to divide them and to ward off effective attacks on the external system or white racism. It is a mere manifestation of the divide-and-conquer strategy, used by most ruling classes through the annals of man, to continue the exploitation of an oppressed group.[45]

This position is quite relevant to many young Black men and women who tend to view frustrations and tensions

[44] William Grier and Price Cobbs, *Black Rage*, New York, Basic Books, 1968.
[45] Robert Staples, "The Myth of the Black Matriarchy," *The Black Scholar*, January–February 1970, p. 15.

in their relationships as having originated internally rather than to the external forces which have historically impinged upon them.

The theory of Black male emasculation has been advanced strongest by social and behavioral scientists who do not have a reasonable understanding of the intricate male-female relationship, and by those who, by popularizing the male subordination thesis, could continue systematically to exclude him from equal participation in the society. Many Black men have never experienced the type of emasculation that is described in sociological and psychiatric journals. The problem that an increasing number of Black scholars (and Black people in general) have with accepting the emasculation thesis in its fullest extension is that it does not allow for an understanding of the more complex and intricate relationship that is shared by the Black man and woman. Thus, what appears on the surface to be female dominance is not necessarily dominance. Men can be very supportive and, indeed, dominant in relationships with women without the couple becoming legally married (as has historically been evident in common-law marriages) and without being the *absolute* chief providers. What one observes in the economic arrangements within the low-income Black family, with the female very often accepting a great amount of responsibility for the sustenance of the unit, cannot be judged within the same context as the traditional monogamous unit. The adaptations which are necessary for the family to make if it is to survive allow for an alteration of the larger society's rules and, most importantly, the creation of an alternative mode of action that is more functional for the particular circumstances. Therefore, it would follow that Black men who find themselves unable to meet all the established requirements for the chief family provider would not necessarily suffer the same effects of inadequacy, etc., that middleclass white men experience, because their lives are defined by a different set of norms.

Another consideration is that in many Black homes

where the husband and wife are present, women appear to
be carrying the major responsibility for the family unit
and the man seems to be a shadow in the background.
However, his shadow does not mean that he is non-
assertive. Oftentimes he makes decisions in the household
that are entrusted to his wife for implementation. In still
other families, the wife does indeed make most of the de-
cisions but with the tacit, sometimes explicit, and always
understood permission of the man. His is the ultimate
authority and he can exercise it when he wishes or feels
impelled to do so. In other situations where women are
heads of their household and have boyfriends, it is often
he who plays a stronger supportive role than is traditionally
held to be the case. Schulz maintains that ". . . the lower-
class Negro man contributes to the welfare of his woman
more than is commonly acknowledged, and plays an im-
portant role of surrogate to her children."[46]

The Black woman often relies upon her boyfriend's
judgment in making decisions that affect her family. It is
he who provides her with the emotional and physical
security and encouragement to continue to project herself
as a strong woman who, by necessity, must shoulder

[46] David Schulz, *Coming Up Black, Patterns of Ghetto So-
cialization*, Englewood Cliffs, New Jersey, Prentice-Hall, 1969,
p. 137. Schulz calls the boyfriend a quasi-father and asserts that
the distinguishing characteristics are: (1) He supports the family
regularly over long periods of time. . . . (2) His concern extends
directly to her children as well. He will give them allowances or
spending money, attempt more or less successfully to discipline
them and take them out to the park, to the movies or to other
places for entertainment. (3) He frequently visits the family dur-
ing the week, and may or may not reside with them . . .
usually not. The relationship is not ordinarily conducted clan-
destinely, but in full knowledge of kin on both sides—particularly
the parents, if they reside in the same city with the couple. In
return for this he receives (1) his meals . . . ; (2) washing and
ironing; (3) sexual satisfaction; and (4) *familial companionship*.
In short, he seems to be bargaining for more than just a woman
in seeking intimacy in the context of a family. (Ibid.)

certain responsibilities—responsibilities that he is very often not allowed to carry.

One author has noted that:

> If one listens to low-income Negro females and observes their behavior at close range, it becomes apparent that somehow the news of their victory over the male hasn't come through to them either. If women are the dominant sex among low-income Negroes, the women do not know it. On that score, one of them remarked, "I've heard a lot of women wish they were men but I never heard no man wish he was a woman."[47]

The problem is that there has been a confusion of the terms *dominant* and *strong*. All dominant people must necessarily be strong but all strong people are not necessarily dominant. Much of this misconception comes from the fact that women in American society are held to be the *passive* sex, but the majority of Black women have, perhaps, never fit this model, and have been liberated from many of the constraints the society has traditionally imposed on women. Although this emerged from forced circumstances, it has nevertheless allowed the Black woman the kind of emotional well-being that Women's Liberation groups are calling for.

We know so little about the quality of interpersonal relationships between Black males and females. What really goes on between the two individuals is largely unknown because most of the studies which have been conducted on Black families, with emphasis on the adult relationship, have been overriden with clichés and superficiality.

Beneath the so-called matriarchal society exist close bonds between male and female, and very often strong mutual respect in spite of the male's economic instability, etc. It could indeed be argued that much of the "strength" of the Black woman comes as a result of the sustained

[47] Elizabeth Herzog, "About the Poor: Some Facts and Some Fictions," Washington, *Government Printing Office*, 1968, p. 12.

support she receives through her male partner. Very often it is he who, although economically insecure, provides her with the emotional support that allows her to continue to deal with the harsh realities of her existence. In the absence of monetary incentives and support, Black men indeed fill the void in other ways. A very good example of the kind of relationship which is being described is that which exists between the female who depends upon public assistance for the support of her family and her male partner who is unskilled or semiskilled and consequently only erratically employed. In research that this writer conducted with women who supported their families on Aid to Dependent Children allowances in a St. Louis housing project, there was not a single case in which these women rejected their unemployed husbands and boyfriends solely because of the economic factor.[48] This does not mean that unemployed husbands did not introduce tensions within the family. Some Black women do, in fact, reject their spouses because they cannot provide for them. Many others, while not totally rejecting them, find it difficult to maintain harmonious relations with a husband or boyfriend who cannot support his family. Such a man also experiences severe emotional and physical hardships with the knowledge that the society has institutionally subordinated him and *refused* to allow him to fulfill those responsibilities which he has set for himself (in addition to those which society has designated for him). Although an employed spouse was highly desirable, the man with a stable source of income was a rare commodity because of the high male unemployment rate. Many women risked losing their welfare allowances by maintaining close associations with their spouse (who no longer lived in the home) or their boyfriend. In no case did they attempt to live up to the absurd welfare laws by breaking the bonds

[48] During the time the study was conducted, the Missouri Welfare Department forbade the husband to live in the home, and women who received ADC allowances were not allowed legitimately to have boyfriends.

they had with men, but rather there was always present a conscious effort to manipulate the rules to fit their situation. Each couple devised ways to avoid being caught by the Welfare Department caseworker. In many cases the Black man who has been forced to abandon his family so they may receive public assistance (owing to his economic instability) remains close to his wife (or girl friend) and there is a congenial relationship between father and children.[49] They do not view their relationships with each other in the same manner in which legislators and policy makers do—who refuse to support what they consider "immoral" women. It is ironic that the society places a high value on close family bonds but at the same time refuses to provide financial support (welfare) to low-income Black families who attempt to maintain these bonds. It must be noted that Black women who must depend upon charity for their economic sustenance do not place the blame on their spouses for their condition so much as they do on the racist society which, they understand, has organized itself to subordinate their men's obligations and responsibilities. It does sometimes occur, of course, that Black women succumb to the views of their men that are expressed by white society. They are thus doubly victimized.

Ultimately, Blacks understand that there are certain prescriptions that the dominant society has set for them to live by that, if necessary, must be ignored because of their invalidity. Thus, it is considered more valuable to have a man around the house to give one the support and strength to continue to deal with the day-to-day problems than it is to live fastidiously by the illegitimate rules and laws the society attempts to force them to live by. Black families are more often measured against the white ideal than the white reality. They should be measured against neither, of course, but against their own reality that is

[49] Patricia McBroom, "The Black Matriarchy; Healthy or Pathological?" *Science News*, Vol. 94, October 19, 1968, p. 394.

created out of their own history. One must recognize the
blatant contradiction within a society which sanctions the
monogamous unit as the only legitimate one, while si-
multaneously institutionally and systematically organizing
for the destruction of this unit among people who must
depend upon charity. It is no accident that almost 25 per
cent of the Black families in the United States are female-
headed. This is not to underestimate the tensions that
exist because of unemployment, because the family is ob-
viously strongly affected by the male's inability to provide
adequately for its needs. The values of the mainstream
comprise one set of standards by which people judge them-
selves, and failure to live up to these often causes tension
and pressures within the family which has to live in the
larger society, and to some extent live by many of its rules.
But contrary to popular thinking, this is not the only set
of norms that is used to determine behavior because the
reality of the situation is that they cannot be applied in a
context lacking the other essential ingredients that are
necessary for the behavior to occur. That reality is the one
which is probably predominant.

The two basic aspects which characterized the roles of
Black women in Africa and during slavery—the semi-
independent economic function and the close bond that
existed between her and her children—are two of the vari-
ables which apply to the masses of Black women today,
particularly low-income women. The major impediment to
the Black family's survival is poverty. According to the
poverty index of the Social Security Administration, 12
per cent of the white families and 48 per cent of the non-
white families with children under eighteen in 1964
could be categorized as poor.[50] Today, it is estimated that
14 per cent of Black children in America (as opposed to
2 per cent of white children) must depend upon Aid for

[50] Mollie Orshansky, "Who's Who Among the Poor: A De-
mographic View of Poverty," *Social Security Bulletin*, Vol. 28,
No. 7, July 1965, p. 332.

Dependent Children for their support. Eight per cent of
white children receive public assistance at some time in
their lives, as opposed to 56 per cent of Black children.[51]
This also means that the majority of such families are
female-headed. Even for Black women who are employed
year round, the average annual earnings are only $3487,
which places them at the bottom of the pay scale—below
white women, whose average annual income is $4,580.[52]
The jobless rate for Black women is 6.7 per cent, against
4.2 per cent for Black men; 3.6 per cent for white women
and 2 per cent for white men. Where Black families are
headed by women, the chances are that the family will
be living in poverty. In the under $2000–$4000 range,
women head more than half these households.[53] The im-
plication to be drawn from these statistics is that, relative
to the contemporary situation of this very wealthy society,
Black women and the Black family must still face the same
economic instability they experienced in previous periods.
This means that the fundamental structure of the Black
family, in relative terms, has not radically changed. Fami-
lies which are forced to exist in poverty are obviously de-
nied the *quality* life which is conducive to adequate
development. Moreover, poverty-stricken families with fe-
male heads usually suffer many severe hardships because
of the inability of women to provide the same resources
that men can. Although the objective conditions have
changed considerably, the fact remains that Black women
still occupy subjugated statuses that prevent them from
competing effectively in the larger society, and must con-
tinue many of the traditions that were borne out of eco-

[51] Daniel Patrick Moynihan, *The Negro Family: The Case
for National Action*, Government Printing Office, March 1967
(reprinted in Lee Rainwater and William Yancey, *The Moynihan
Report and the Politics of Controversy*, Cambridge, M.I.T. Press,
1967, p. 12).
[52] U. S. Department of Commerce, Bureau of the Census,
CPR:-60, No. 66.
[53] Cf. Sylvia Porter, "Negro Women and Poverty," San Fran-
cisco *Chronicle*, August 5, 1969, p. 48.

nomic instability and racism, which were a part of their ancestors' set of experiences. The transmission of these values, beliefs and traditions is very often reinforced because the external conditions are still conducive to their perpetuation.

It should be clearly emphasized that the Black community in the United States is a vast one with all the distinguishing social class groups, religious denominations, professional interests and the entire range of differentiating criteria that is used to describe any other ethnic group in this society. Therefore, the "Black bourgeoisie," which E. Franklin Frazier described,[54] and the "Black Anglo-Saxon," which was the subject of Nathan Hare's analysis,[55] are prototypes within this vast community, although comprising only a small segment. Much of what has been described about the interpersonal relationships between Black women and men, about the socialization experiences of impoverished Black children and, indeed, about the self-conceptions of Black women does not apply to a small segment of the population. This group has been cast into a somewhat different mold because they were able to escape the economic conditions which produce many of the problems that affect the family. Therefore, they have reared their children in two-parent households, provided them with a quality education and fulfilled the other duties and responsibilities to their families that the dominant society expects. This pattern had its origin during slavery when small numbers of the privileged class of slaves (usually mulattoes and often the sons and daughters of plantation owners) were allowed to assimilate many of the values of the slave master, were provided with education, were granted manumission, and became members of the small Black middle class. It must be noted that these privileged Blacks numbered very few persons, and did not represent

[54] E. Franklin Frazier, *Black Bourgeoisie*, New York, Free Press, 1955.
[55] Nathan Hare, *Black Anglo-Saxons*, New York, Marzani and Munsell Publishers, 1965.

the masses of slaves, and although they established their own traditions through the generations, they have probably never had a very strong impact on the masses of the Black population at any point in history. Another factor to be considered is that in spite of their relatively high socio-economic statuses, they were still strongly affected by racial oppression; hence, they shared that common experience with the masses.

Another segment of the Black population that does not experience the poverty described earlier in this chapter is that group which does not depend upon any form of public assistance for its livelihood but yet is not a part of the middle class. This group, largely working class, has managed to move up the socioeconomic scale and occupy positions in the skilled labor force. The relative economic advantage they have over Blacks below the poverty line allows for the development of economic stability because they are more capable of withstanding many of the pressures that are brought to bear by the larger society. Some of the advantages of economic stability that these families hold are the ability to meet the rent payments, or to purchase modest homes, to enjoy decent food and clothing, to provide recreational activities for the children (summer camp, etc.), to save for their children's college education and to enjoy a few modest luxuries such as summer vacations from time to time. Many such family heads were once indigent but managed to escape the intergenerational persistence of poverty through education, skilled occupations and decrease in family size.[56] These families are able to provide much of the quality life to their offspring that they never had. It is not at all uncommon to discover adults who were reared on plantations in the rural South who now own their homes and are able to afford college educations for their children. This rapid intergenerational mobility has produced a fairly large stable

[56] For a full discussion of intergenerational patterns of poverty see Louis Kriesberg, *Mothers in Poverty: A Study of Fatherless Families*, Chicago, Aldine Publishing Co., 1970, pp. 167–95.

working class that will not suffer the same inequities as the generation preceding them.

The economically stable working-class family is one which has been shaped, to some extent, by the strong influences to conform to certain societal expectations. Because of the structure of the society, people are forced to conform to certain middle-class norms if they are allowed to "improve" themselves. Basically, people can conform and thereby rise up in the class structure, or remain in poverty. However, all conformers do not make it out of poverty. Institutional racism forces conformity to or adoption of certain middle-class norms, and it is these, combined with the economic advantage, that allows for this type of family structure.

In spite of the relatively high socioeconomic statuses of the Black middle and working classes, they are still strongly affected by oppression. Hence, they share a common experience with the indigent. It is this commonality—racial oppression—that serves as a medium of identification for all Black people in the United States. Therefore, I am suggesting that race barriers have transcended class, education, occupation and religious influences, and the distinctions that can be made among Blacks along class lines have become far less relevant.

From the foregoing discussion, two things seem apparent. First, the culture of the Black community represents an autonomous social system that departs markedly from the dominant middle class. Certain Africanisms (the strong semi-independent economic function and the close relationship between mother and children) have been perpetuated and function to reinforce contemporary attitudes and behavior. Secondly, Black people have used various modes of adaptations to racism and poverty—to neo-colonialism—growing out of slavery which, again, forged a distinctiveness to the character of life that the majority of Blacks shared. Both of these causal factors have contributed to the shaping of Black females. Against this background, preadolescent and adolescent girls are social-

ized into the cultural milieu. It is within this setting that they learn the rules of the Black community that have been passed on from one generation to the next for becoming a woman. A great portion of what they learn is transmitted through the customs and traditions of their community in a very informal sense. The extended family, including aunts and grandmothers, often serves as strong a function in preparing young girls for womanhood as do their mothers and fathers.

What then do the sociohistorical traditions of the Black community do to mold girls into women? How do contemporary circumstances and events play important roles in preparing them to fulfill the expectations of their community and the larger society?

## Growing Up Black

The life of the young girl in the Black lower class is con-
ditioned by the community's traditions, values, beliefs and,
in sum, its culture. Thus, Black child socialization must
necessarily be different from that of children reared in the
white middle-class tradition, because of the sociohistorical
differences that exist between the two groups. It is also
vastly different for the life of a girl growing up in the white
lower class. For race is a much more powerful variable in
this society than social class. It also differs to a great ex-
tent from the Black middle class, whose child-rearing
practices are often similar to those of the white middle
class, but yet dissimilar in the sense that Black parents
can never give their children the *ultimate* protection from
racism which white parents exercise. Perhaps the most de-
cisive factor that influences the child-rearing patterns of
the Black lower class relates to the oppression that even its
children must endure and learn to deal with. Unlike the
white middle-class child, Black children must also be sub-
jected to the second-class citizenship of their elders. The
consequences are manifested in a variety of ways. When
one speaks of childhood in the lower-class Black com-
munity, it relates to a different phenomenon than what
is typically held to be the standard norm in American
society. Childhood must be influenced by one's social class
and racial background as well as by other factors such as

nationality and religion. The type of childhood that is
held to be the American norm is peculiar to this society.
Philippe Aries observes that the childhood that is charac-
teristic of a great many Western societies was unheard of
from the Middle Ages to the seventeenth century. It was
only in the seventeenth century that parents became con-
cerned with providing a certain kind of educative resource
to children in the preparation for their future roles as
adults. Childhood was sharply demarcated from adulthood
and a long period of socialization and preparation for
the adult world came into being. This had a greater influ-
ence on the middle classes, who began providing formal
education for their children, than on the lower classes,
whose children had to work for the maintenance of the
family.[1] This was also the situation with children who
worked in sweatshops in the same manner as adults in
eighteenth- and nineteenth-century Europe before child-
labor laws were enacted. The same, of course, was true for
the United States from 1870 to about 1910, when children
did not have the protection of child-labor laws.

Lower-class Black children have received less of the pro-
tection from these laws, and have been the least likely
group of children in the United States to benefit from the
general concern with child protection. The socioeconomic
status of the Black family has always been such that the
income of its children often served a vital need. One only
needs to take a cursory view of the biographies of many
prominent Black people, who describe their impoverished
childhood and the economic contributions they had to
make to their family's subsistence, to understand how
economic instability, produced by racism, influenced their
development as children. Booker T. Washington, the
noted Black educator who was born a slave, recalls the

[1] Philippe Aries, *Centuries of Childhood: A Social History of
Family Life*, New York, Random House, 1962.

time when he was forced to move from the world of child-
hood to that of adulthood:

Though I was a mere child, my stepfather put me and my
brother at work in one of the [salt] furnaces. Often I began work
as early as four o'clock in the morning.[2]

Frederick Douglass also speaks of his childhood as a slave,
and the harsh, cruel and inhuman existence he was forced
to experience.

I suffered much from hunger, but much more from cold. In hot-
test summer and coldest winter, I was kept almost naked—no
shoes, no stockings, no jacket, no trousers, nothing on but a
coarse tow linen shirt, reaching only to my knees. I had no bed.
. . . I must have perished with cold, but that, the coldest nights,
I used to steal a bag which was used for carrying corn to the mill.
I would crawl into this bag, and there sleep on the cold, damp,
clay floor.[3]

Understandably the lives of Washington, Frederick Doug-
lass and other great statesmen of this period would be
greatly influenced by slavery. However, the pattern of
Black child development in subsequent periods of history
was equally influenced by the societal oppression against
Black people. Thus, Richard Wright's *Black Boy* and
Claude Brown's *Manchild in the Promised Land* address
the same problems of child development that is explicit
in the lives of Douglass and Washington.

The standard conception of the "protected, carefree,
and non-responsible" child has never been possible for the
majority of Black children. Parents are unable to offer this
protection and comfort to their children because of their
own vulnerability to the discriminative practices of the

[2] Booker T. Washington, *Up from Slavery*, New York, Bantam
Books, Inc., 1963 edition, p. 18.
[3] Taken from *Growing Up Black*, Jay David (ed.), New York,
Pocket Books edition, 1969, p. 95.

larger society. The consequences of the powerlessness of
Black parents and their inability to adhere to the stand-
ard child-rearing norm necessitated that they devise their
own patterns of child socialization. These patterns were
primarily predicated upon the principle that children in
the Black community must be taught to survive in a hostile
society. Various mechanisms were created for dealing with
the strategy of survival. Robert Coles writes:

If the Negro child's life is one of having to learn how to con-
front a future of unrelenting harassment, his intimidated parents
must prepare him for it. They must teach their child a variety of
maneuvers and postures to cope with his baffling lot. By seven or
eight most Negro children know the score, and I have seen them
draw only faintly disguised pictures of the harsh future awaiting
them.[4]

The fact that a parent has to deal openly with this question
with his young child probably raises the level of the re-
lationship between parent and child to a more mature one.
It also forces an openness and honesty between parent and
child on the subject of the external hostile forces that are
absolutely necessary. Moreover, the self-defensive mecha-
nisms that are an integral part of the child-rearing process
act to protect the child against external as well as internal
forces. When a parent berates his child for not defending
himself on the playground when attacked by his peers, he
is likely to use the same defensive tactics in this situation
that he would use against white racists who would launch
a similar attack. Black children are, therefore, more totally
responsible for their own protection than their middle-
class counterparts, especially white. The responsibility they
are forced to exercise also lends itself to a deeper involve-
ment with shaping their futures, and ultimately to render-
ing more control over their destinies. Almost by default,

[4] Robert Coles, *Children of Crisis*, New York, Little Brown,
1964, p. 322.

these children are forced to become a vital part of the creative process that determines what kind of individuals they are to become. It is the contention of some behavioral scientists that chronological age probably has little to do with one's maturity when other factors operate in such a forceful way as to be the major determinants of the course an individual's life is to take. Robert Coles provides a perceptive analysis of this aspect of Black childhood in *Children of Crisis:*

Is a sixteen-year-old [Negro] boy who has lived in stark, unremitting poverty, worked since eight, earned a living since fourteen, married at fifteen, and is soon to be a father, a "child"?[5]

The "adult" responsibility that Coles describes, although less the situation with Black adolescents today than in previous historical periods, is still a very prevalent occurrence. In traditional analysis, the lot of Black children, being "denied" a comforting and protected childhood, is viewed as a negative experience. It falls within the realm of behavior that produces "social problems" and "disorganization" for its participants and the society. However, if the same phenomenon is viewed within the context of its strengths and positive symbols, we can observe the development of maturity and other creative resources that enhance one's ability to be an active agent in the society, instead of a passive recipient. This is the role that poor Black children play in this society.

There is a great need for a new perspective and definition on what childhood means in America and what consequences for particular types of behavior should be viewed as healthy and which ones as pathological. Such a reinterpretation should enable social and behavioral analysts to view the Black child, whose life has often been an unrelenting series of harsh experiences, as a more emotionally stable and well-integrated personality than his

[5] p. 319.

white middle-class counterparts, whose protected, sheltered lives are representations of the most fragile personality the society could produce. More simply, a new interpretation of emotional strength and productivity is needed in analyzing socialization patterns and consequences of Black children.

It is within this perspective that the early patterns of learning of preadolescent lower-class girls, growing up in the inner city, will be analyzed.

The young Black girl growing up in this environment becomes consciously socialized into the role of womanhood when she is about seven or eight years old. Human socialization is the period when the individual learns specific forms of behavior through interacting with others in her environment in order to facilitate effective functioning within the social group. It assumes different forms and follows different patterns from one culture or society to another. Different patterns of child rearing, for example, can be observed among various social classes and ethnic groups within a society.[6]

In the Black community the primary agents of socialization for the preadolescent girl are her immediate and extended family. Although she spends more time with her nuclear family, it is often members of the extended family, including aunts and uncles, grandparents, cousins and others, who serve this vital function as well. Frequently, girls spend all of their growing-up years in the care of extended kin. Grandmothers act as permanent baby sitters while the actual parents are away working, and when the absence of parents is more permanent. Often children are "given" to their grandparents, who rear them to adulthood. The influence of the extended family upon the socialization of the young Black girl is often very strong. Many children normally grow up in a three-generation household and they absorb the influences of grandmother and grandfather as well as mother and father.

[6] Allison Davis, *Social Class Influences upon Learning*, Cambridge, Harvard University Press, 1962.

Another important agent of socialization for the young Black girl is the peer group. During preadolescence girls become strong participants in peer group activities. When the child goes to school her reference group expands from being primarily that of the parents and the extended kin to include her peers. Frequently this process of expansion occurs before school age because the child is often exposed to other children in her age category in a meaningful way. It becomes very important for her to judge and be judged by other children her age. The family begins to slowly lose its position of primary importance. It is also during the preadolescent developmental phase that the Black child begins to engage in conflicts with her family. Her self-assertiveness becomes more pronounced because of the decrease in dependency on the family. What was once taken for granted because of its authoritativeness becomes questioned because one's peers might not agree as to its appropriateness.

As they (ages five to twelve) enter into this psychosocial developmental phase, their lives become attuned to how they should begin to relate to each other and to those around them as aspirant women. Although preadolescent Black girls are very much involved in play activities, sibling rivalry, school and a host of other preoccupations that characterize children in other social, ethnic and racial groups, there is a strong cultural phenomenon directed toward sharpening roles. It is not very easy to articulate what womanhood means to eight-, nine- and ten-year-old girls. Part of the problem is that they do not yet know how to articulate it, but their behaviors are dramatic representations of it. At the age when girls outside this community are playing with dolls and engaging in all of those activities which reflect childhood, girls within its borders are often unable to experience this complete cycle. The societal canon of "childhood" is often unobserved to varying degrees because it is a luxury which many parents cannot afford. Parents in the Black community are often unable to protect their young children from harsh social forces,

which protection would ensure that they grow up in this "safe period" emerging relatively unscarred.

In the community in which this study took place, the adult population often envisioned their community as one which had its share of "troubles"—troubles which hindered them from exercising the necessary parental controls over their children's behavior. There is a noticeable absence of formal and informal regulations in the community which would help to counter the socially unapproved behavior. For example, an eight-year-old girl has a good chance of being exposed to rape and violence (such a case will be discussed below) and neither parents nor community leaders have the power to eliminate this antisocial behavior. The community power base still lies outside its borders. In a similar manner, many children are forced to go hungry, without shoes and clothing and an adequate home to live in because of the powerlessness of their parents.

One of the consequences of these pervasive community influences upon the child is that they superimpose emotional precocity on the girl that often exceeds her chronological years. This precocity often enables her to enter networks of individuals and situations wherein traditionally unaccepted behavior for her age group takes place. For example, the thirteen-year-old who can pass for sixteen or seventeen in certain circles not only becomes exposed to but often takes part in behavior that would normally be beyond her range of experience and therefore beyond her capability to manage herself adequately. Among the pre-adolescents in this study, many of them exhibited behavior patterns and knowledge of "worldly" events that exceeded their years. It was often remarkable to observe these children handle stressful situations with a fair amount of capability.

One of the common themes they relate to is violence, to which they are often exposed. When these children are either witnesses or victims of aggressive activity (or potential victims), they react in a manner of intense fright and displeasure as children elsewhere. However, a differ-

ence which is of importance with these children is that they have been educated by older children and adults as to the nature and possible consequences of such aggressive activity. This enables them to, in some ways, defend themselves against antisocial behavior more vigorously than would the child who has not had either vicarious or personal experience with these overt acts.

Rose, an eight-year-old, tearfully described how she had "escaped" the advances of the "rape man" (a middle-aged man who had the reputation for being a child molester) by running through an alley near her home. In this situation Rose expressed both fright and joy about the encounter: She stated that she was frightened when it happened because she knew what he intended to do to her, but was exhilarated that she had been able to maneuver her way out of the situation. A similar occurrence was that of Kim, a ten-year-old, who describes her distress in the following manner:

Interviewer: Are you afraid of men?

Kim: Yes ma'am. They hang out on the streets drinking and the police come by shooting at them and running. One Sunday I went to a girl friend of my sister's house. Her name was Mary. A man came in this store. His name was Johnny and he had been stabbed . . . in the stomach. It was New Year's Eve. . . . I got scared and started crying. Then the police came by . . . his wife ran out of the store crying and she took her baby with her. The next evening their house caught on fire. . . . [It was set] by the same man who had stabbed Johnny because they didn't like him.

Most of these children could relate directly to some form of violence. They all knew someone who had been involved in it and at least one had experienced rape.

One could say that the mature knowledge they have about antisocial behavior and their abilities to cope with it are symbols of strength that the "protected" child does

not share. On the other hand, one of the greatest tragedies
is that some parents are often unable to exercise more
than minimal control over this rapid developmental
process.

Girls growing up in the inner cities in many ways are
like their counterparts in other social class, racial and
ethnic groups. They share the same concerns, fears, joys
and questing ventures as other children. Their preoccupa-
tion with youthfulness is present although situations and
events often occur which force them to think and act more
grown-up than they are. They share the concerns with
boys, peers, games and other play activities as do children
in other communities. However, there are other concerns
that are thrust upon the young girl through environmental
circumstances. Often, a purely childhood experience in the
impoverished Black community is considered a luxury.
Childhood implies that one grows up in a relatively insu-
lated environment, a protectiveness that keeps her from
being exposed to certain facets of grown-up life and the
responsibilities that are considered adult. Many parents
grew up without the luxuries of the childhood that they
are trying to give their children. One mother, who had a
sixteen-year-old daughter and a fourteen-year-old son, ex-
plained to me why she was so strict on her children, and
why she *nurtured* them through a prolonged period of
childhood, when compared with most of their peers.

I had such a short childhood that I wanted my children to have
a childhood; not to rush them into being grown people before
their time. . . . I had my first boy when I was fifteen years old,
nine days before I was sixteen. So that is one thing I wanted to
get my daughter through.

The Black child is often forced into "grown-up" activities
before he becomes legally an adult. This is the theme of
the explosive autobiography of Claude Brown, who de-
scribes the social, political and economic conditions in
Harlem that prevented him and his peers from ever know-

ing what it meant to be a child in the *traditional* sense. An excerpt taken from this work provides an illustration of this point. Reno, a friend of Claude's, is speaking to Claude:

Man, Sonny, they ain't got no kids in Harlem. I ain't never seen any. I've seen some really small people actin' like kids. They were too small to be grown, and they might've looked like kids, but they don't have any kids in Harlem, because nobody has time for a childhood. Man, do you ever remember bein' a kid, Sonny? Damn, you lucky. I ain't never been a kid, man. I don't ever remember bein' happy and not scared. I don't know what happened, Man, but I think I missed out on that childhood thing, because I don't ever recall bein' a kid.[7]

The absence of childhood that Reno speaks of is present, to varying degrees, with many preadolescents in the Black community. Some children grow up without the traditional childhood, as described by Reno, and others are given some of the "happiness and protection from fear" that Reno never experienced. Although the experiences are harsh and oftentimes *cruel*, children do develop a great amount of strength and adaptability that enables them to adjust to and cope with the world. The strong personality which emerges is to be viewed as positive because it enhances the child's chances for survival. The childhoods of Kim, whose life has been very similar to Reno's, and Beth, whose parents insulated her from the outside world, are two polar examples.

THE CASE OF KIM

When I first met Kim she was ten years old. She lived in a two-bedroom apartment in the housing project with her mother, two older sisters (eleven and sixteen), younger brother (one) and niece (one). Her father had, according

[7] Claude Brown, *Manchild in the Promised Land*, New American Library, Inc., 1966, p. 295.

to Mrs. Marshall, "gotten tired and just walked away" several years earlier. The family was now supported by Aid to Dependent Children welfare. As a fifth grader, Kim's activities were geared toward her peer group, of which she was the undisputed leader. Most of her time was spent outside the home. As soon as she returned from school each day, she immediately went outside to play until late at night. In the summer she was gone from sunup to sundown. Her mother rarely attempted to prevent her from spending long hours away from home. She and her friends played in other buildings in the housing project, on the project grounds, and often wandered long distances from her home. On occasion she pointed out to me that she had no particular time to be home and was sometimes chased in the building by the housing project security police near midnight. Although Kim was a charming and well-mannered child, she often engaged in "grown-up" activities with her peers. She "played house," played the "dirty dozens," cursed and occasionally imitated sex play with her twelve-year-old boyfriend. Frequently, she also had to baby-sit with the two one-year-olds while their parents were away, help her mother prepare meals, clean house and face the bill collectors when her mother was in hiding because she didn't have the money.

Kim's behavior was similar to that of her mother and sixteen-year-old sister. She laughed about the same things they considered funny and despaired when they did. Her vocabulary was that of her mother. At age ten, she had decided that "men are no good," a sentiment often expressed by her mother, whose husband had deserted her "when things got too rough." Kim had the same attitude toward her mother's boyfriend because he could never stay with them beyond a certain point. He had to go home to his wife.

Earlier in Kim's life, her mother had probably exercised a great amount of control over her activities, but one got the impression now that Mrs. Marshall had grown tired and was unable to express the same amount of concern

over Kim's whereabouts as she had when Kim was much younger. Consequently, Mrs. Marshall's discipline over Kim was erratic. Sometimes when she was not in by 11 P.M. she would whip her when she came home, and at other times, she seemed far removed from it. The burden of trying to "make ends meet" with an inadequate welfare allowance took precedent over a preoccupation with her ten-year-old's whereabouts at all times. Mrs. Marshall's sixteen-year-old daughter had given birth to a child at fourteen, and was to become pregnant again at sixteen. She had held high hopes for Elizabeth, but had also reconciled herself to the fact that her resources for rearing her daughters in the desired fashion were too sparse. She could, therefore, only hope for the best. Her second oldest child, Judy, often played hooky from school, talked back to her mother and had taken to smoking. Mrs. Marshall's problems were many. Exercising discipline over Kim was to be counted among the others. The case of Beth, however, is very different.

BETH

Beth, at age nine, lived in the housing project with her mother and father and four sisters and brothers. They lived in a neat apartment that was decorated in lively colors and with fairly good furniture. Her father worked as a skilled laborer in a factory and her mother, on a part-time basis, worked as a cook in a restaurant. Beth was the second oldest child, and was a close companion of her fourteen-year-old sister. The two of them, in spite of the age difference, shared secrets, went places together (although their parents rarely allowed them to associate with other children except in their own home or under the close supervision of an adult of whom they approved) and viewed each other as close peers. The entire family was a close one and they engaged in frequent outings together, family discussions on issues which the kids raised, etc. Mrs. Robinson was always anxious to involve herself in the lives

of her children, particularly her two older daughters, and at age thirty-five (approximately) she was able to understand their day-to-day concerns and problems almost as though they were her very own. Mr. Robinson also played a strong role in the lives of his children, and was as concerned about the problems of his daughters as he was with providing the proper image for his sons (the other three children in the family were boys). However, because of his heavy work schedule which kept him away from home for long hours, he was unable to spend the amount of time with his family that he preferred. Thus, much of the day-to-day guidance and socialization was imparted by Mrs. Robinson. Perhaps for this reason, she was prone to be very strict on her children, especially the two girls. She often described the "troubles" she was afraid they would encounter if she became too lenient and allowed them to "hang out" with the other children in the neighborhood. At one point she told me that she did not feel that Beth was better than her friends, but she could not trust them and their influences upon her because they might unintentionally lead her astray.

Beth was a bright and articulate girl who was always exuberant and easily met challenges from her peers. Whenever I observed her among her peers, she was very creative and the undisputed leader of the group. Her young girl friends looked up to her and sought her childish advice on their problems. She was very mature for her age. Yet the overprotectiveness her mother provided from the outside world seemed to have curbed much of her initiative and creativity. In her mother's presence she rarely spoke to me about any topic without alluding to the fact that "But Mother doesn't feel this way about it," or "Mother said we should do this. . . ." Although she is very close to her mother and father, there are still tensions, which seem to mount from day to day, that border on her insulated home environment and the more mundane involvement with her peers. In Beth we see a young girl coming of age in the Black community whose life is so insulated that she

is in the process of developing a reticence and naïveté about life that might prevent her from effectively coping with the harsh realities of her community, should it ever become necessary to do so.

In Kim and Beth, we see two prototypes in the Black community. Kim represents one of the many children whose parents despaired and long since stopped trying to offer the protectiveness afforded other children because they knew they were fighting an uphill battle they would probably lose. They learned not to fight for the unattainable, but they always reserve a gleam of hope that fate will eventually act in their behalf. On the contrary, Beth is one of the many girls whose parents have consciously decided to insulate them because that is the only possible hope, they feel, for coming through the childhood experience relatively unscarred. Beth's mother reasoned that there were too many "bad" people in the streets to allow Beth out there. She could not trust Beth or the "bad" people, so her alternative was always to keep her within specified limits. Mrs. Robinson's recognition of her powerlessness to cope with the environmental conditions is perhaps the only effective strategy of which she is aware. She confided that her experience in the streets as a growing youngster had led her to believe that her children could not adequately handle themselves when confronted by what is out there. On the other hand, this alternative has probably stifled Beth somewhat and rendered her ineffective in dealing with traumatic events. Both girls' childhoods can be considered different from those experienced by middle-class children. Whether little protection (as in Kim's case) or an abundance of protection (as in Beth's case) can be offered is one of the key factors in determining the extent to which Black girls in this kind of environment can expect a relatively restricted, secure life.

These two separate case studies do not cover the entire range of *models*, but represent what I found to be two polarities. Many parents, of course, combine some of the significant elements of both childhood experiences, while

others devise even more creative ways of socializing their
children for adult roles.

PEER GROUP AND EXTENDED FAMILY

The Black child in this environment is almost born into
a strong society of peers who, throughout preadolescence,
exert strong influence over their lives. As the child ap-
proaches kindergarten age she is exposed to other children
on a regular basis. Sometimes the interaction occurs earlier
because some parents allow their three- and four-year-olds
to spend an almost unrestricted amount of time playing
in the buildings and outside with other children in their
age group. Frequently, in this community older siblings
supervised the play activities of younger sisters and broth-
ers, and sometimes parents conducted the supervision.
The early exposure and intimate contact (extended) with
other children one's own age allowed for the facilitation of
the learning process of certain types of behaviors. The child
was no longer under the constant care and influence of
parents and extended kin, but of other children his own
age. The influence peers exert over each other is remark-
able. The formation of attitudes, ideas, behaviors and
values can be recognized in the preadolescent as having
been a direct result of peer group influence.

One of the reasons peers influence each other so strongly
is because they spend so much time together. Mothers and
fathers in the Black community are often forced to leave
the child in the hands of older sisters and brothers, neigh-
borhood children or alone because they are unable to af-
ford regular baby sitters or nursery school. Grandparents
and other elderly women often baby-sit with preschool-age
children for a nominal fee from the child's parents, and
sometimes no payment is involved. In the housing project
a number of elderly women earned much of their income
from baby-sitting with several children while their parents
worked. In such situations, the children are kept indoors
a large portion of the time but usually spend some time

outside with the baby sitter. Usually the baby sitter sits
with a group of her friends on a bench on the project
grounds and talks with them while the children play within
a reasonable distance. The children usually do not stray
very far from her, and when they do, they are promptly
brought back to the area to which they have been re-
stricted. The supervision of these children is usually quite
good. They are fed reguarly, they take naps and are often
taught games and other play activities by the elderly per-
son, depending upon the degree to which she is able to
engage in such things. Grandmothers often live in the
homes of their children and grandchildren. Here they prob-
ably exercise more influence over the behavior of the child
than do the parents because of the continuous involvement
with them. They not only take care of them in the absence
of the parents but the process continues even when the
parents return home. Occasionally the child becomes con-
fused about whom he should relate to and be supervised by
as the authority figure. If there is some disagreement be-
tween the parent and grandparent over the child's be-
havior, he is prone to take sides with the one he favors.

There were five children, the parents and grandmother in the
Smith home. Grandmother Smith had her own bedroom and
worked the night shift as an aide at a nursing home. She slept
while the four older children were in school and her son and
daughter-in-law were at work. However, her sleep was little more
than cat naps on some days because she had to take care of four-
year-old Freddie. He usually watched television all morning but
soon wearied from that and resorted to waking his grandmother
for her to take him outside to play. (He was not allowed to go
outside by himself.) Usually Grandmother Smith wearily got up
and took him outside. Getting up meant that she was not usually
able to get back to sleep because the other children were home
from school at three and it was impossible to sleep when five chil-
dren and their friends were running in and out of the house. Al-
though Grandmother Smith was near seventy, she was still very
strong and able to make it sometimes on five hours of sleep. All

of the kids favored her over their parents because she wasn't strict. She kept cookies and candy in her room and often intervened when their parents were about to discipline them. She usually had her way around the home because her son and daughter-in-law rarely stopped her from interfering with their regulations regarding the children. Whenever young Freddie was about to be spanked by his parents, he ran to Grandmother Smith, who immediately petted him and told her daughter-in-law (who did most of the disciplining) that Freddie was too young to be spanked because he didn't always know right from wrong.

All grandparents are not as permissive as Grandmother Smith. Some are more strict than the parents. Also, some parents feel that the grandparents' ideas about child rearing are somewhat old-fashioned and should not always be adhered to. However, usually this intergenerational conflict is not as strong as it is in the middle class, where parents seem to want to assume far more responsibility for the emotional development of their children. In the low-income Black community a stronger amount of respect is given to the knowledge and experience of the elderly. Very few parents were willing to dismiss their advice as simply being old-fashioned.

The development of the peer society continues from around three years old throughout preadolescence. The process is intensified as the child becomes older because of his increased contact with other children. The peer group seems to serve a somewhat different and broader function with these children than with their middle-class counterparts. There is more unsupervised contact with peers and peers also provide some of the non-tangible resources that parents are usually expected to provide. At a very early age many children begin to rely on their peers for company, emotional support, advice, comfort and a variety of other services that parents ideally are expected to offer. In the absence of parents, and in many situations where parents are present but so overburdened with other important matters and do not have the necessary time to

give the child, the peer becomes the person to whom the child turns. If an older person is around he is sought out, but many older people have the same concerns and problems his parents have and therefore cannot provide the necessary services. In the most extreme cases, young children rarely communicate with their parents about anything. Five-year-old Ellen Baker is such an example.

Ellen is one of seven children. Her father is no longer in the home and the family income is received from the welfare allotments. Ellen's first year in school (kindergarten) proved to be a valuable experience because she was able to develop meaningful friendships with three little girls her age. Ellen's mother has two children younger than she and must also take care of her four older ones. Although none of the children receive any more attention than Ellen (except perhaps for the baby, two-year-old Buzzy), she is an extremely sensitive child and would, in an ideal situation, depend very heavily upon her parents for guidance. Her four older siblings are also young, the oldest being twelve, and therefore are really unable to relate to her in the manner in which she needs. Her teacher is very nice but largely unavailable. Ellen only spends half a day with the teacher. So she has turned to her three girl friends and looks to them for constant support and approval. Although Mrs. Baker is aware of this, she is unable to do anything about it because there are six other children to care for. Ellen wants to become a nurse but already she wonders whether or not she can. She told me one day, "I want to be a nurse, but that costs money. Can you be a nurse without money?" Ellen's peers had already told her that it costs money and she wanted reassurance from me that it didn't.

Although Ellen is probably an exceptional child, she still represents, in many ways, the typical Black child who ponders these questions with peers because parents are not always able to be available to deal with them.

As the child grows older peers increasingly serve the same function, only the questions they ponder with each other change in terms of their content. The peer group

can best be understood as a type of solidarity unit. It is the primary group in which the young girl can share her joys, fears, surprises and disappointments. It is her peers who can always be counted on to understand what it is that she is concerned with. Therefore, the peer group can be viewed for the preadolescent girl as having many integrative functions that help her to survive and understand life from day to day. It is in this context that the process of redefinition of one's roles and the discovery of the many exciting facets of one's young life take place.

Although there is much similarity between a preadolescent girl growing up in the Black community and one growing up in suburbia, because of the impact of the larger society, there are as demonstrated distinct differences between the way the child perceives the world in these two environments. All parents in American society attempt to control the lives of their children as much as possible. Unlike children in many other parts of the world, the American child is expected to be provided a "childhood" and kept from the exposure that is granted adults. This strong protectiveness shapes the child's perspective of his world. He basically views his immediate world as a friendly and protective one, or with suspicion and hostility, or a combination of both. For the Black child, whose parents are unable to provide the constant "surveillance" that is expected by the larger society, the world takes on a strong form of realism. So much of one's survival depends, to some extent, on how independent he can be and how much he can fend for himself when necessary. Children in the community are taught to be strong and not to allow others to take them for granted. Inherent in this attitude, although a very necessary one, is the assumption that if one allows his guards to fall too often, he can be taken advantage of. Suspicion and distrust frequently emanate from such a fear. This is not always the case, however, for many young children accept life in a more realistic manner but nevertheless are not particularly suspicious of every stranger who approaches them.

There is ample reason for even more hostility and suspi-

cion of the unknown to abound than is present. If one considers the fact that children at ages four and five and older are expected to assume sometimes a major responsibility for their own care, such as finding food when there is none in the home, caring for younger siblings, doing major household chores, etc., it is startling that so little of the child's world is perceived as a hostile entity.

The negative experiences which Blacks in this kind of environment have encountered with society have fostered and perpetuated within them suspicion and hostility. This reaction to those individuals who reside outside their environment is often generalized and takes the form of prejudice and stereotyping. Thus, a sentiment which is conveyed is that all Caucasians are not to be trusted, for they are only capable of treating Blacks in an inhuman manner. As a result of such attitudes, self-defense mechanisms are deeply ingrained in children at very early ages. These young children are taught early in the home that they must learn to protect themselves against other children on the playground. For example, a mother can be observed berating her eight-year-old daughter for not "fighting back" on the playground. For them, the only reality which they know is that which they experience.

This is the area in which parents of these children, although often considered children themselves by racist whites, are able to attempt to reconcile the two worlds the child must learn to live in. Children are not only taught to be defensive but also to be positive and hopeful for bright futures. It is to the credit of these parents that they are able to make some projections that their children's lives will be better than theirs were. Thus, the child does not always exercise a "reflexive" defensive response to his encounters, but deals with them in a non-defensive manner. It is perhaps the hope that these parents hold in the future that allows the child to take a dual approach to his existence: (1) understand his role in the society as a *Black* person; and (2) be able to function in the dominant society.

# 3

## Racial Oppression and the Black Girl

"What does it mean to be a poor Black girl in the United States?" is the question I attempted to get all of these youngsters to speak to. Most scholars hold that the development of a positive self-concept is necessary for the child's adequate functioning in the society.[1] Popular studies have consistently maintained that the formation of the self in the Black child presents a major problem because of the great influence of oppression. The Black "self-hatred" or negative self-image thesis has become so popularized and highly accepted that it is very rarely challenged. Clark and Clark have written numerous articles based on their research with Black children. It was upon the basis of Kenneth Clark's studies and expertise on the effects of prejudice upon the personality development of the child that the 1954 Brown *vs.* Topeka Board of Education U. S. Supreme Court decision outlawing school segregation was handed down. Clark and others maintain that the Black child's identity is damaged so severely in the very early

[1] Mead contends that the individual must internalize the values of the society before he can relate in a meaningful way to others around him. See George Herbert Mead, *On Social Psychology*, Anselm Strauss (ed.) Chicago, University of Chicago Press, 1964; and "The Genesis of the Self and Social Control," in *The Philosophy of the Present*, Arthur E. Murphy (ed.), Chicago, Open Court, 1932, pp. 176–95.

years of his life that he often experiences a total rejection of self and embraces white role models.[2]

Kardiner and Ovesey, writing in *The Mark of Oppression* in 1951, viewed serious personality disorders arising out of a lack of self-esteem in Black people.

. . . his [the Negro's] self-esteem suffers . . . because he is constantly receiving an unpleasant image of himself from the behavior of others toward him. This is the subjective impact of social discrimination, and it sounds as though its effects ought to be localized and limited in influence. This is not the case. It seems to be an ever present and unrelieved irritant.[3]

Other psychologists and psychoanalysts have followed positions similar to Kardiner and Ovesey's.[4] For example, Pettigrew states the following:

Being a Negro in America is less of a racial identity than a necessity to adopt a subordinate social role. The effects of playing the "Negro" role are profound and lasting. Evaluating himself by the way others react to him, the Negro may grow into the servile role;

[2] Mary Ellen Goodman, *Race Awareness in Young Children*, New York, Collier Books, 1964, revised edition; Kenneth B. Clark, *Prejudice and Your Child*, Boston, Beacon Press, 1963, enlarged edition; Kenneth B. Clark and Mamie P. Clark, "Emotional Factors in Racial Identification and Preference in Negro Children," *Journal of Negro Education*, 1950, Vol. 19, pp. 341–50.

[3] Abram Kardiner and Lionel Ovesey, *The Mark of Oppression: Explorations in the Personality of the American Negro*, New York, Norton, 1951, pp. 302–3.

[4] Two of the most highly acclaimed works on the Black personality *The Mark of Oppression*, published in 1951, and *Black Rage*, which appeared in 1968, but which followed the same intellectual tradition as the previous study, both have serious methodological flaws. Each book, for example, is based on clinical data taken from patients whom these psychiatrists were treating in therapy. Therefore, it would be highly questionable as to whether broad generalizations could be made about *the* Black personality from small samples of individuals who were under the treatment of psychiatrists.

in time, the person and the role become indistinguishable. The personality consequences of this situation can be devastating—confusion of self-identity, lowered self-esteem, perception of the world as a hostile place, and serious sex-role conflicts.[5]

In describing the alleged psychopathology of Black people, Pettigrew takes the position that this behavior is an adaptive response to oppression. The effects of the *caste* system upon the personality formation of Blacks have been dealt with by a number of scholars.[6] Some of these studies are not limited to simple explanations of low self-esteem resulting from the *caste-class* pressures, but also view the alleged malformations of the Black personality as *deviations* of the white middle-class norm. For example, Arnold Rose presents such a view:

The instability of the Negro family, the inadequacy of educational facilities for Negroes, the emotionalism in the Negro church, the insufficiency and unwholesomeness of Negro recreational activity, the excess of Negro sociable organizations, the narrowness of interest of the average Negro, the provincialism of his political thinking, the high Negro crime rate, the cultivation of the arts to the neglect of other fields, superstition, personality difficulties, and other characteristic traits are mainly forms of social ill-health, which, for the most part, are created by caste pressure.[7]

Not only does Rose's position reflect the white middle-class norm as a standard for evaluation, but it is also *racist* in character. Unfortunately, it is the conclusions of studies such as the above which encourage the perpetuation of stereotypes and institutional subordination.

[5] Thomas Pettigrew, *A Profile of the Negro American*, New Jersey, D. Van Nostrand Co., Inc., 1964, p. 25.
[6] John Dollard, *Caste and Class in a Southern Town*, New York, Doubleday Anchor Books, 1957; Allison Davis and John Dollard, *Children of Bondage*, New York, Harper & Row, 1940; Arnold Rose, *The Negro American*, New York, Harper & Row, 1964; and others.
[7] *The Negro American*, p. 294.

The problem of "self-hatred" has also been dealt with by Black psychiatrists. Grier and Cobbs follow the basic argument proposed by white writers.[8] Frantz Fanon deals with the warped psyches of Blacks who encounter the "superior" dominant culture, whether it be Algeria (where he lived) or the United States. Although Fanon recognized the inherent psychological problems Blacks would encounter as members of the oppressed class, he was able to transcend the psychopathological approach to focus on the psychic dilemmas encountered by Blacks who are caught between the influences of the dominant "superior" white culture and that cultural experience in which they have been socialized.[9]

It is inescapable for Blacks who are born into a society that makes such a strong distinction between *white* and *Black* (and even between light and dark skin shades within the race) to grow up without, at some point, entertaining feelings of inferiority because they are not members of the majority, privileged group which has attached a high premium to white skin. To some extent, all Blacks must have made the comparisons between the inferior, subjected status they occupy in the society, which are based primarily on color, and the positive value and privileges that are automatically attached to being *white*. Even the most emotionally stable person has experienced the humiliation and feelings of degradation that have their origin in systematic *racial* oppression. Every Black person can probably recall the time when he first became painfully aware of the lifelong restrictions that would be placed on him because of his color. I can vividly recall, at a very early age, when I cried in sorrow and anguish because I could not attend the newly built brick school for white children, but had to go to the dilapidated frame structure for Black children. Nothing my mother said in the way of explanation

[8] William Grier and Price Cobbs, *Black Rage*, New York, Basic Books, 1968.

[9] Frantz Fanon, *Black Skins, White Masks*, New York, Grove Press, 1963.

could erase my sorrow and bitterness. This was the first lesson of *racial* oppression I experienced, and for which I am still bitter.

Many Blacks must have experienced feelings of inadequacy because they could not measure up to the standards set by whites and developed warped psyches and "self-hatred." It would seem only natural that this process would have been set in motion, especially in view of the fact that the larger society has historically *programmed* its indoctrination of Blacks' alleged inferiority in *every* institution—socially, culturally, politically, economically and religiously.

While it cannot be denied that the system of oppression has taken a heavy toll on the psychological and physical development of the Black child and adult, it can be questioned, however, as to whether or not the impact has been as severe as some scholars maintain. The level of psychological impairment that has been projected in the literature is rarely approximated in real life. There appears to be a negative correlation between these findings about Black identity and the *actual* existence of the problem. One of the rebuttals to the "self-hatred" thesis is advanced in the writings of Robert Coles, child psychiatrist, who conducted research on the effects of school desegregation on Black youth. Coles maintains that the involvement of Black children in social change enhances the development of a more stable, well-integrated personality. He writes:

Still, no matter how hard the lives of these demonstrators, many of them were young by any standard to be initiating such responsible, nonviolent protests, to be leaders in social change. Moreover, they were acting in a region that considers them not merely children but (as Negroes) the children of children. They have persisted in social action despite retaliatory arrests, brutalities and jailings, and *without discernible psychiatric harm or collapse.* Modern psychiatry must certainly ask why children subjected to such strains survive so handily; and modern psychiatry has no precedent for children directly involving themselves in an attempt

to change the social and political structure of the adult. (Emphasis added)[10]

Coles's analysis is one which challenges the stereotypes and recognizes the emotional stability and strength within many Black children who very engagingly fight oppression —and to a great extent exercise control over the course their destinies will take.

The ability to be resourceful in fighting oppression, as are the Black youths Coles describes, is perhaps one of the keys to the development of a positive self-image because the child understands his vital role in shaping his life. Another crucial factor is that many of the symbols of what is *positive* and *negative* have been redefined so that Blackness is no longer a symbol for evil, dirty, fear, inferiority and the many other highly negative connotations the term has historically held. Black psychiatrist Alvin Poussaint notes that the negative self-image of Blacks can be strengthened through the development of Black consciousness programs. He writes:

Since the Negro's self-concept problems cannot be solved through token integration, it is important that black men turn to the development of their own communities as an alternative and supplementary approach for building the Afro-American's self-image and esteem. Unfortunately, the white man cannot give Negroes "black consciousness," Negro Americans must give it to each other. This means that black people must undo the centuries of brain-washing by the white man, and substitute in its stead a positive self-image and positive concepts of oneself—and that self happens to be the black, dispossessed, disenchanted, and particularly poverty-stricken Negro.[11]

[10] *Children of Crisis*, p. 319.
[11] Alvin Poussaint, "The Negro American: His Self-Image and Integration," in *The Black Power Revolt*, Floyd Barbour (ed.), Boston, Porter Sargent Publishers, 1968, p. 101.

The current Black consciousness movement and the call for self-reliance are deliberate attempts to overcome the psychic problems which have affected many Blacks.

The most important aspect of the new thrust is that it has provided Blacks with the power to redefine their identities. With the emergence of a new set of standards, they must no longer experience humiliation because they do not meet the white standards. Thus, the new thrust is the most emotionally healthy *adaptive* and *creative* response to solving the "self-hatred" problem.

It is interesting to note that psychiatrists and psychologists who are bent on discovering the "psychopathologies" of Blacks do not address the problems of negative identity and self-esteem among whites. Studies have shown that whites suffer some of the same identity crises. For example, Gaughman and Dahlstrom conducted a study with Black and white junior high students in a rural southern town and noted the following:

The Negro children in our sample . . . much more frequently reported themselves as being popular with their peers than the white children did. Also, there was a tendency for more Negro than white children to say that they were *very* satisfied being the kind of person they were. In addition, significantly more Negro than white children described their home life as being happier than that of the average child. Clearly, if the self-concepts of these Negro children have been unduly damaged, this fact is not reflected in their interview statements about themselves, nor in the educational and vocational aspirations which they report for themselves (and which they seem optimistic about realizing).[12]

Other studies have made similar conclusions.[13] Some of these studies show that measures of self-esteem among

[12] Earl E. Gaughman and W. Grant Dahlstrom, *Negro and White Children*, New York, Academic Press, 1968, p. 462.
[13] James S. Coleman et al., *Equality of Educational Opportunity*, Washington, U. S. Government Printing Office, 1966; also note Morris Rosenberg, *Society and the Adolescent Self-Image*,

Blacks are higher than those of whites, when comparative
studies are made. There is sufficient evidence to show that
the "alienated" middle-class white youth today are ex-
periencing most profound identity crises, as evidenced by
the "tuning out" and involvement in the hippie culture.
Feelings of self-hatred are manifest in their rejection of the
total value system in which they have been socialized. The
self-rejection they are undergoing is certainly one of the
most overlooked (perhaps consciously so) areas by psychia-
trists and psychologists who seek to discover and analyze
psychopathology. Perhaps it is more difficult to analyze
negative self-image among middle-class white youth be-
cause the problem comes too close to one's own identity
(or "too close to home").

All of the foregoing discussion on Black identity has
been applied on a more specific level to Black women.
Grier and Cobbs view the Black woman's identity in very
negative terms. They say:

While under other circumstances a golden future might be imag-
ined for her, at the very beginning of her life she is comforted
and commiserated with and urged to overcome her handicaps—
the handicap of being born black.[14]

They proceed to elaborate on all of the stereotypes about
Black women, while simultaneously accepting them.

Born thus, depreciated by her own kind, judged grotesque by her
society, and valued only as a sexually convenient animal, the black
girl has the disheartening prospect of a life in which the cards
are stacked against her and the achievement of a healthy, matured
womanhood seems a very long shot indeed. The miracle is that, in
spite of such odds, the exceptional love of parents and the ex-

---

Princeton, New Jersey, Princeton University Press, 1965; and
John D. McCarthy and William L. Yancey, "Uncle Tom and Mr.
Charlie: A Review of the Negro American's Self-Esteem," Nash-
ville, Vanderbilt University, 1970.
    [14] *Black Rage*, p. 41.

ceptional strength of many girls produce so many healthy, capable black women.[15]

Implicit in their position is the assumption that a Black woman has no standards of her own and experiences self-rejection when she finds herself unable to do more than "ape" the standards of white society. It is also clear that they hold an almost condescending attitude toward her and feel that she can only overcome her "handicaps" with "exceptional strength and love." Their conclusions represent an analysis of a small number of patients whom they were treating in therapy. Therefore, it is impossible to accept this thesis as a valid one for the entirety of Black Americans.

Other Black writers are speaking more positively to the woman's dilemma and are asserting, contrary to Grier and Cobbs, that the standards by which Black women judge themselves must be developed internally. Poussaint writes that:

The "femininity" of black women cannot be understood within the framework of the dominant white oppressive society. The entire question of feminine and masculine "personality traits" and "roles" has to be examined from a cross-cultural viewpoint. . . . we should also explore how our African heritage has influenced these patterns! . . . Afro-American women . . . must continue to seek their unique identity as *black women!*[16]

Writing on the importance of a newly discovered "self," Jean Smith articulates the processes of psychological development she experienced as a *Black female* in moving from a northern integrated setting to the very different life she lived after joining the southern civil rights movement.

[15] Pp. 41–42.
[16] Alvin F. Poussaint, "The Special Position of the Black Woman," *Essence Magazine*, April 1970.

Sometimes I am nostalgic for the days when you knew me.
Sometimes I miss the clarity of those days, the assurance that
what I was doing was right because it was helping to make a bet-
ter country and, in turn, a better world. The black self that I am
now has a difficult time, having to start all over again and dis-
cover the best ways to work in this new, black world. And yet,
after a searching and painful evaluation of the last years' experi-
ences, it is the only self that I can honestly allow.[17]

The strong sense of power over one's identity formation,
and the ability positively to shape it, is an outstanding
theme in this young Black woman's work. The powerful
processes of development she helped to create for her own
life are representative of the new trend among young
Black people.

When I went out to conduct this study, I was expecting
to find two basic types of responses to my queries about
racial identification and the effects of oppression. To some
extent, I had anticipated that their responses to being
poor Black girls would typify some of the stereotypes about
the feelings of inadequacy, worthlessness and self-dispar-
agement. I also felt that others would have been influenced
by the Black consciousness movement and would articulate
"Black pride" sentiments. Still others would, I expected,
be proud Black youngsters without having come under
the influence of Black pride slogans and ideology. Many
of these young ladies possessed an abundance of human
resourcefulness and hope for improving their life chances.
And the hatred, if present at all, was directed toward those
individuals and institutions which inflict pain upon them,
instead of being directed inward. Of course, there is al-
ways the possibility that much of what was expressed in
positive terms about one's identity by a few of them was a
"reaction formation" and that consciously they liked them-
selves but unconsciously they did experience self-rejection.

---

[17] Jean Smith, "I Learned to Feel Black," in *The Black Power
Revolt*, Floyd Barbour (ed.), Boston, Porter Sargent Press, 1968,
p. 218.

For the purpose of this analysis I defined oppression as a strong recognition of or succumbing to or giving in to the pressures of their environment. When one attempts to understand the basic quality of their lives and those factors which would allow them to "make it," or to become another of the millions of faceless members of the oppressed minority, it becomes important that one look beyond what are considered traditional resources for achieving success. These girls do not have money, adequate housing, quality educational facilities, and they do not come from small families. Moreover, they come from families who have been denied these material resources for generations. It is here that the social analyst must turn to the inner resources and ego strength for an explanation of how they can function and go on to excel in spite of the odds which are set against them at birth. Thus, an important factor in this analysis is the extent to which they perceived themselves as individuals who could deal with their problems with their own resourcefulness or whether they turned to the external world—whether they relied upon someone from the outside world to aid them in fighting their battles with the world. Of course, the other alternative is some form of escape, whether it is manifested in the use of drugs or alcohol or in any other manner that would emotionally remove them from the problematic situations. These girls have adopted what is probably the same quality of fortitude and resoluteness that enabled their parents, grandparents and other forebears to adapt to and overcome the obstacles which beset them. Thus, I will demonstrate that what one finds in most of them is a quiet, forthright determination to remove those obstacles from their paths and to continue to draw on their seeming abundance of human resourcefulness. This will be the conceptual framework from which their identification as Black girls will be analyzed.

A fairly common assumption of psychologists and psychiatrists is that Black women develop a negative self-image because of their Black skin tone, kinky hair, broad

features, etc. (For a full discussion of their involvement in making themselves physically attractive, see the section on "Femininity" in Chapter Four.) These "liabilities" cause them to feel inferior and express a desire to be white. Thus, one of my concerns was to find out to what extent they wished to be white or felt psychologically crippled because they were Black. I asked all of them what did it mean to be a poor Black girl. Some of the typical responses follow:

A thirteen-year-old said:

I'm proud of being a Negro. I mean it's not bad to be a Negro and that's why I am proud. A lot of people ask me, "Don't you wish you were white? . . ." I say no. I ask them what's wrong with being a Negro. They say they don't know but they still want to know if I want to be a white person. . . . Some white people ask me that sometimes.

A fifteen-year-old stated:

I feel that I'm just as good as the next person. I feel that a white person or someone of any other race, if they're as good as I am, well I feel that I'm even better. . . . I don't think there should be any setback just because I'm a Negro.

A sixteen-year-old:

I feel good as a Negro. I think that we have special rights as everyone else because you know Thomas Jefferson said every man was created equal and I think that just being a Negro doesn't mean we can't have the finer things of life just as the white person does.

An eighteen-year-old stated:

I feel very proud of it [being Negro]. Nothing can be done about it so I have to feel proud about it myself. . . . I wouldn't change it if I could.

A fourteen-year-old:

I'm glad that I'm a Negro. . . . Well, some white people dislike Negroes and some Negroes dislike white people. But to me it doesn't make any difference. Some white people are poorer than Negroes.

A fifteen-year-old was very specific about her position:

I'm very fond of being a Negro because Negroes have much talent. . . . I was kind of glad to see that we have one Negro in the White House working and they can sing and dance, and do things just as well as white people can. I don't mind being poor . . . because I'm getting along and it doesn't matter to me. . . . I think my friends feel the same because I never hear any of them say anything like "I wish I was white." . . . To me a Negro knows how to have fun.

The most politically articulate girl, a seventeen-year-old, said:

I see myself as being *not* an "Uncle Tom." . . . [That means to] believe in the white people. Believe that Negroes can't live without them; and, too, believe that I love the white people when they do not love nor like the Negro race. . . . We are not Negroes. We are "so-called" Negroes. That's the name they gave us. Our original name is Black. . . . If you look it up in the dictionary they say the people originally came from Africa and they are the so-called American Negroes. . . .

I asked her why she felt that Blacks had allowed themselves to be called Negroes without protesting. Her reply was:

Some of them try to be white. Some of them make themselves up like white people. They just don't know that the Black race is trying to get more and more like the white race *but the white race is trying to get more and more like the Black race.*

A fifteen-year-old was also very articulate on the subject:

I've always been proud of being Black because I think it is a superior color. I never thought of being . . . well, you know, white is pure and black is dirty. I've always thought of being Black as a way, a will. If you see someone Black it's not a dirty thing . . . Black stands out against any color.

I asked her if she could describe how things had gotten better for Blacks in recent years. She said:

Well, we are changing. We are seeing that there is a way. We are beginning to shape up. If you put anything in a cage where it can't go out and can't see anything on the outside, it is always going to think that this is the right way and that there is no other way but this one. But if you can see out of this cage and you see that this bird is flying not only from this end to the other but up and down, the other bird will go up and down and all around. We see now that we can go to college and other places to improve ourselves and we will. Somebody that wants to be somebody will try every inch to make it.

Being Black had many consequences, even though one could still be proud. Two girls spoke to this. First, a fifteen-year-old:

I'd rather be a Negro than be a white person . . . because they say that the "nigger" does more [bad] things than the white people do. Like when you walk in the store, they look at the "nigger" first while the white people are stealing. I went downtown one day with my brother and my sister. . . . The white people were just putting blouses and dresses and stuff in their pockets, while they [salespeople] were watching us.

Finally, an eighteen-year-old talked about her difficulties on being Black and poor:

I consider it hard for me to . . . be a Negro . . . financially and the fact that I have to live here in the city being poor. And again

it doesn't bother me too much because there are so many that are in this condition that it seldom crosses my mind. . . . There are a lot of things that rich people have that I don't have . . . and things that I need. Maybe someone in the family will get sick and a rich person can go right ahead and have it taken care of whereas poor people have to wait and wait and wait and sometimes it is too late.

Clearly these girls' statements speak for themselves. There is a wide range of views on what it means to be *poor* and *Black* in the city today. A very small number of girls did not speak favorably to being Black, but none wished to be white. The overwhelming majority of them seemed proud of their race, and accepted it as a factor of life which, although problematic at times, was still real and did not need to be changed. Thus, there was no evidence of low self-esteem and severely damaged psyches among these young ladies. They did not seem to experience feelings of inadequacy, lack of popularity, etc. because of their racial status. As a whole, they were widely accepted by their peers, boyfriends and other reference groups. In other areas of their lives they saw themselves as desirable love objects, mothers, job holders, valued friends and individuals with much resourcefulness. There was not a single girl who expressed disdain for her physical features or skin color. In other words, *none desired to be white*. Perhaps they felt *Black and proud* long before the slogan came into being.

When I asked these young ladies to speak to the problem of being Black in American society, most did not speak directly to the volatile issues that are now being raised by young Black people in every community throughout the country. Although the civil rights movement once concentrated in the South moved north, most of them had had very little direct contact with racial demonstrations and other forms of organized protest activity. Much of this can be explained in terms of the geographical and political climate of the city in which they lived. As a conservative Midwestern city, St. Louis has never been known

for its "liberal" atmosphere which would encourage a pre-
ponderance of Black radical groups and activity. Another
equally important factor, however, was that there is a
very large segment of the Black urban population who
rarely, and sometimes never, come into direct contact with
those activities which are designed to transform the society
which oppresses them. Therefore, it is not surprising that
these girls did not speak that often to the issues of Black
consciousness, Black nationalism and Black revolution.

This does not imply that they were unaware of what the
effects of being Black in American society meant. They
were strongly aware! It is only that their awareness was
manifested in a different form.

In a variety of ways, all of these youngsters were clear
about what the negative consequences of being Black *and*
poor meant. The best description of this realization and
the preparation for its consequences came from a fifteen-
year-old girl, Ruth, whose parents had migrated to the
North from Mississippi before she was born. At the time
of the study, both of her parents were unemployed and
close to retirement age. In a conversation with Ruth, I
asked her what it meant to be a poor Black.

My family is actually real poor. No one in my family has a job
and I intend to go through school and help my mother and fa-
ther after I get out because I know I will be unable to go to col-
lege. . . . After I finish high school, I will get a job and *support*
my mother and father. . . . We really do have a hard time. Our
parents don't have jobs. . . . There are some that do have jobs,
and others who just finished high school and can't get the actual
good jobs they really deserve. . . . I hope things change because
the Negroes really do need jobs. I used to think school was square.
I used to didn't do my work. I thought it was nothing to it. Then
I sat down and watched my mother and father, and how hard it
was for them. My mother didn't go to school and my father
didn't either. My real father doesn't know how to read. . . .
When I just looked at my mother and my stepfather it made me
feel kind of ashamed of myself because I felt that I was the only

one left to go to school and make something of myself. Negroes just need help. If girls and boys would just finish high school I think we would be able to make it and there would be some changes in the near future.

Implicit in the minds of all these girls is an acceptance of sharing the twin burden of being Black and poor. Few of them spoke directly to racism, and only did so when asked a pointed question. However, all of their feelings about poverty alluded to it as one of the manifestations of being Black. Somehow there was a strong sentiment that things would not be so bad if they were not Black. This was especially evident when they spoke of racial discrimination that involved them and poor white girls when both were applying for employment. Several girls had observed white girls get the jobs that they too had applied for, only to be told that no positions were available.

Ruth's thirteen-year-old niece, Hazel, spoke to the same condition when I asked her to make three wishes for those things she desired most out of life.

First, I would wish for a new home, mostly for my grandmother and grandfather, but also for my mother too. [She lives with her grandparents.] Because they are getting older and maybe I would wish for a couple of maids, doctors and nurses in case they get sick and someplace to take care of us in [rest home] when we get old.

. . . Second, I wish that I can go all the way through school and maybe to college and come out making a nice life so I could support myself. . . . I would like to be a nurse or maybe a secretary and I would like for my life to turn out happy.

There is no difference between these two girls' conceptions of their present status and the routes they feel they must take to enhance their life chances. Education was viewed by the majority of the girls as the most viable way to improve their lives. Within all of them was the desire to emulate their teachers, nurses, secretaries and other

professional people with whom they had had contact. Miriam, an eighteen-year-old, who lived with various relatives, including an aunt, her grandfather and her mother, and sometimes with friends, expressed a desire to elevate her status above what she described as "tough, bad and dirty" Negroes. She was the only girl in the study who expressed disdain for other Black people. Maybe she was also the most honest person I interviewed because others may have shared her feeling without expressing it. She said:

I would like to be better off than I am now because I want to hurry up and get my education so I can be on my own. I don't like to depend on people to take care of me. . . . My grandfather takes care of me now because my mother gets a welfare check for my younger sister but not for me. I'm not on welfare. My grandfather gives me money and he used to buy my clothes when he was staying here. But now that he has moved back home [to the country] he sends me money every now and then. That's why I want a job, so I can buy my own things and don't have to depend on anyone.

Although Miriam was prone to express dislike for Black people and to blame their condition on their "laziness" she also understood that three generations of abject poverty which her family had experienced in the city did result from race as much as class factors. The strong attitude she held about the hard life and the difficulty involved in succeeding is reflected in the seriousness she took toward her schoolwork. She only rarely missed school because she saw education as the means to her goal—to overcome the impoverished environment in which she had always lived. On at least two occasions she spoke of her own difficulty in finding summer employment with the full knowledge that white girls her age found it less difficult to do the same.

Another measure of racial identification was expressed in the way the girls described their environment. It was

very common for them to perceive their environs as a downtrodden, dilapidated, faceless community. Nevertheless, it was not always viewed in completely negative terms because the community did provide a certain amount of security, various forms of entertainment and, above all else, was home. Edith, an eighteen-year-old, described her neighborhood in response to my query:

I would say that I live in one of the slum areas of St. Louis. . . . There is nothing to do around here. I like to write poetry because . . . there is nothing else to do around here. People around here think you are "jive" [square] if you tell them you like to write poetry.

For Miriam, the description was even more precise:

If I could change my neighborhood I would get me a bomb and blow up the liquor store on the corner, because there are too many wine heads there. Then I would fix up the houses. I would tear them down and build them over completely because some of them aren't any good. But I would fix up those that are pretty good.

Anna, a very intelligent eighth grader, who became pregnant a year after the study was completed, expressed her feelings this way:

If I could change my neighborhood I would tear every house down. . . . I wish we would move. . . . I would have a two-story house and then a one-story house throughout the neighborhood. There would be a drugstore at one corner and a grocery store at the other. . . . At the other end of the street, I would have an apartment house of five stories with about four rooms.

Melba, an eighteen-year-old high school dropout, made the following observations:

If I could change my neighborhood I would make some of the people move out or try to straighten themselves out. The ones

that are loud and the others that stay up all night with a lot of
noise disturbing people are the ones I am talking about. . . . As
far as the houses are concerned I would just try to make it look
a little better for the people who come through the neighborhood
so that it would look like a nice neighborhood.

This strong concern with improving the physical and hu-
man quality of their environs symbolizes their stark reali-
zation of poverty produced by oppression. None of the
girls visualized their neighborhood as the desirable place
where they would like to continue to live unless they could
change it. To all of them, it represented the worst of the
human condition. A few girls refused to allow their more
economically stable friends to visit them in their homes
because they were ashamed to do so.

Josetta, a seventeen-year-old girl who described herself
as having "strong perseverance," indicated that:

I know girls at school who have their own telephones in their
bedrooms. I like to go to school to watch the fashions. Some of
the girls wear real fine clothes. . . . I don't like for them to come
home with me because I don't want them to see how we live
. . . poor and all.

She continued:

I work for the Neighborhood Youth Corps in the dietetic depart-
ment. I work four hours on Saturdays and Sundays and I make
ten dollars a week. I use the money to keep my clothes clean or
buy a new pair of shoes if I need them. Sometimes my brother
needs some money and I loan it to him but he pays it back. . . .
If only I could get away from around here, which I am in about
a year from now. This neighborhood brings you down. That is
what brings you down. People down here are always making a
scene. If someone from out west were to come down here and
look at our streets, I would be ashamed. ["Out west" is a better
section of the Black community in St. Louis.]

Josetta represents a prototype in this community. Her mother and father were separated several years ago and she and her sisters and brothers live in a three-generation household with their mother and grandmother. An older sister is a narcotics addict and served time in prison on drug charges. In spite of this, Josetta spent much time studying and frequently talked about the strong perseverance that would enable her eventually to work her way through Howard University. Instead of succumbing to the pressures of the environment, she seemed to have developed a stronger will to survive and triumph over it. Josetta, Anna and Miriam are perhaps exceptions to many of the other girls, but not exceptionally different.

There was also present among some of the girls the early formation of an awareness and open expression of disliking whites for the roles they played in the maintenance of the oppressive system. One of the girls had come under the influence of the Black Muslims through a sister and brother-in-law who were then members of the Nation of Islam. Janice, at age seventeen, held open contempt for whites and angrily described them as "blue-eyed devils" whom she held responsible for the poverty and discrimination which afflicted all the Black people she knew. Her anger and dislike was so intense that she alluded to "secret" plots that she knew of that were to be carried out by her Black male friends against white people who came into her neighborhood. The following is an excerpt from one of my conversations with Janice.

Before the Civil Rights Bill was passed you didn't see Black men or Black women with white men and women. After the bill was passed you saw more Black men in their convertible cars with their cigar or cigarette hanging in their mouth with a white woman sitting so close to them that you just thought it was just him in the car. But the only difference is that you know it is a white woman because he is so dark or brown, and the white next to him stood out. I dislike it. . . . It looks like if a Black man is going to get him a white woman, he should get one that has

character, decency, and one that looks like something and has a job. But most Black men have these women that look like they have been doing a little of everything. They've been prostituting. . . . They've been in every little hole in the city of St. Louis. . . . And when they do something bad white people look upon them as Negro. They don't count them as white. The Negroes are with tramp women.

Janice also described how the behavior between Black men and white women had, she felt, been curtailed in her neighborhood.

In the housing project now, none of this goes on because . . . just about everyone feels they don't like white poople. I had a boyfriend once. He was definitely Black but he was very light-complexioned. He looked like he was white but if you would keep looking at him, you would know that he was Negro. When he first came down here and started dating me, they thought he was white and these boys in my building were going to jump on him because they thought he was white. We had an argument one night. This was before they found out he was Black. They were going to jump on him that night. They said, "If that white so-and-so ever hits you, we'll kill him." Well, after I got them together that he was Black, everything was okay.

Janice's friends shared her feelings toward whites and this probably accounts for her belief that "in the housing project . . . just about everyone feels they don't like white people."

To be sure, she and her primarily male friends were in the vanguard in terms of verbalizing their feelings, for there were no others who alluded to secret plots to kill whites, although a small number of girls did talk about knowing of planned robberies and physical attacks against white bill collectors and salesmen. However, none of these assaults appeared to have taken a purely racial character because of the robbery element involved. It would seem reasonable to assume that race, as well as robbery, could

act as sufficient motive when one considers the fact that the people in this community are among the most oppressed class in the nation, economically, politically and socially. Sometimes robbery was probably the only motive and race played no role whatsoever, because Blacks were also occasionally robbed.

Racial identification and its implications for their lives can be measured by the kind of understanding they have about the various forces which operate in their environment to perpetuate the exploitative conditions. Their dislikes are for the bill collectors, exploitative merchants, abusive police and others whose economic and political interests are located in the community in which the girls live. Thus, there is some justification, they feel, for the retaliation against these forces. It was very common to hear young boys boast about eluding the police, throwing bottles and other objects out of the windows at whites in the neighborhood and stealing food from the local grocer. Certain types of manipulative strategies are used against the "exploiters" to obtain certain resources. Stealing is one form of behavior that is fairly common. Although most of the girls expressed an almost reflexive response as being opposed to stealing, on the other hand they were able to rationalize why one steals. A typical reaction to stealing came from sixteen-year-old Scarlet:

Interviewer: How much do you consider yourself to be like the kids in your neighborhood?

Scarlet: I'm not really like them but I think that some of the things they do are really all right. I wouldn't sit around and talk about them stealing. . . . It's all right and I wouldn't mind my boyfriend stealing. . . . I would be scared he might get caught and put in jail, but stealing is just a way of getting some money.

Interviewer: Do you think it's necessary for some people to steal? And, if so, under what conditions?

Scarlet: I think it is all right to steal when they can't get a job
   and don't want to join the Army and get sent to Vietnam
   or something like that. They steal to get some money.

Interviewer: Have you ever gotten any clothes or other things that
   were stolen?

Scarlet: Yes. I buy them all the time.

Interviewer: Does your mother care if you buy them?

Scarlet: She'll buy them.

Scarlet's justification of stealing can be considered a
form of defiance to what she probably feels is an illegiti-
mate system. Her reference to unemployment and op-
position to serving in the Vietnam War relates directly to
her feeling that things would be better if these problems
did not exist.

The general attitude toward stealing among some of
these girls is one in which they feel some type of "right"
to do so. It is not perceived strictly in terms of "stealing"
but rather of "taking." She feels entitled to "take" that
object which she wants. This sentiment seems to have its
formation in early childhood and is generated throughout
adolescence. Thus, the five-year-old girl will take a candy
bar from a store because she feels she has some right to
have it, although she does not have the necessary resources
with which to purchase it. These girls are forced to deal
with the fact that others possess and enjoy objects which
seldom filter down to their world. While others have access
to such, they probably never will. It is difficult, if not im-
possible, to explain to a five-year-old the ethics involved in
"taking" things when he is constantly deprived of them,
sees no possibility of being able to acquire them in the
near future, but is yet forced to know that they exist and
that they have meaning for the lives of other people.
Therefore, when I asked eight-year-old Sharon and Connie

as to why they stole "goodies" from a small candy store, the only reply was:

Connie: Because I wanted it. I don't have any money so I just took it.

Interviewer: Did you think it was wrong?

Sharon: I don't know, maybe, I don't know. I just wanted it but I couldn't buy it.

These patterns are carried out by some children through the formative stages of adolescence. Connie, a twelve-year-old, told me:

I stole the baby clothes from the rummage sale for Alice's baby [Alice is her sixteen-year-old sister]. They were pretty little clothes. I wish you could have seen them but Mama made me take them back. . . . I got in the shop through the broken window.

As some of these girls grew older (those who stole), there was a gradual change in the type of things stolen and their relative worth. There is a graduation from stealing a candy bar, to stealing from the rummage sale shop, to stealing from downtown department stores, to stealing, signing and cashing welfare checks.

There were two peer groups involving about fifteen girls who often stole their clothing. One fifteen-year-old who stole a great portion of her wardrobe discussed her activities with me:

Well, I need clothes and things like that that my mama can't buy me. I remember when I first started stealing, the children at school and around the project had things that were much better than mine. I didn't have any shoes or any kind of good clothes and I started hearing children talking about stealing so I said, "Now I care about what they say about me when I start doing this but how do I know they haven't stolen what they have on? They might have stolen their clothes too." So I started stealing then.

Thus she is able to rationalize her activities on the basis of sheer need, and because she has been socialized into this activity by others in her environment, thus becoming "just like everyone else."

Sixteen-year-old Frances gave the following description of her design for stealing:

Interviewer: How would you set up a scheme where you could do this [referring to stealing a welfare check] and not get caught?

Frances: I sit up and plan things like this. . . . I take days and nights like that, I really do.

Interviewer: How would you set up a perfect scheme to steal something and not get caught?

Frances: It would probably take me nights to do it, you know, because I have to draw little symbols and everything on a piece of paper . . . and draw hallways and stuff like that.

Frances was a most unusual person and the only such atypical girl I met in this regard. The point I am trying to make is that stealing items and pawning them have a high functional value for these girls because of their poverty circumstances. They are able to rationalize their activities because they serve a highly utilitarian purpose. A girl will have money to buy food; will have adequate clothes to wear; will be able to share some of life's necessities which would otherwise be unavailable to her. Again, the risk of getting caught often does not run nearly as high as the valued object itself; the valued object is worth the risk involved in getting caught; and when one is caught the consequences are somehow manageable.

The concern with providing the essentials for oneself by whatever available means are forthright expressions of their feelings. It is important to understand that they are operating within two value contexts—one which condones stealing because it is functional and another which condemns it for ethical reasons. The moralistic attitude that

is traditionally taken toward stealing does not apply within this context because it is dysfunctional. This is perhaps one of the most blatant symbols in their minds of the inequities of the society. For when one is forced to steal food and clothing because they are unavailable otherwise, this offers the necessary proof that the social system can and should be violated. It is in this sense that their awareness of racial subjugation can be observed most clearly. The indirect and/or subtle manifestations of the violation of the oppressive system shows clearly that they hold antagonism toward it because it produces the *poverty* they must endure or devise coping strategies to deal with.

Another theme that relates to their conceptions of the oppression is the attitude they hold toward the police. The police are perceived, most often, as antagonistic forces whose duties are to punish rather than to protect the community. Children learn to fear and avoid the police at very early ages. They also learn to conceptualize what the community's response to the police is. The internalization of this fear occurs so early because they observe the various confrontations and conflicts that take place between the police and their relatives, friends and other people in their community whom they know. They have seen the beatings, jailings, shootings and almost any other type of violence that is carried out by the police. Thus, the stereotyped image of the policeman as the protector who guides young children and old ladies across the street is alien to their concept of his functions. Rather, he is the person they try to evade when necessary, or call to aid them in the settling of disputes, etc. Although they may occasionally seek his aid, he is viewed as being among the hostile forces because of his granted official *right* to use force and violence against them. Too often they have seen him use repressive actions against people whom they know, but are usually unable to strike back.

The theme of violence and its consequences was an ever present symbol in the lives of these girls. Since violence is such a frequent occurrence in their community, it was

often discussed. Therefore, the police, who are usually called on to deal with this violence, must necessarily be a preoccupation. A fourteen-year-old said:

The cops come down in our neighborhood and beat people up if they want to. You don't have to be doing anything for them to do it. I have seen them beating boys over the head with their clubs when they were just standing around in a group talking.

For another girl, (sixteen years old), the police were necessary although she viewed them in a hostile manner:

This man and his wife were fighting and she called the police and they arrested him. The man was beating her so they should have taken him away, but they didn't have to beat him up.

Thus, the policeman is viewed negatively because he has the power to incarcerate, punish and therefore oppress them. Yet, he was, on occasion, vital for his ability to aid them in the time of trouble. It is this ambivalent attitude that many of the girls were groping with.

It is probably this confusion and highly troubled environment that encourage them to desire a more orderly and less troubled world. It is very important that they have not succumbed to the pressures of their day-to-day lives and given up all hope for a better world. While there were a few girls who expressed little hope for a better life in the future, the overwhelming majority felt there was a considerable amount of hope for them. Indeed, some were able to extend their hopes beyond clearing up the chaos and problematic situation of their immediate environments to hope for a "better world" in the universal sense. They see their world as one that involves a conflict between the rich and the poor. And they envision the day when this conflict will be resolved. A fifteen-year-old girl spoke about the inequities that were involved in her projections for her own life.

Interviewer: When you grow up what kind of life would you like to live?

Respondent: I wouldn't want to be rich at all. I don't think it's fair for anyone to be rich and not help people because if they think back they will realize that deep down inside they could have been the people that they now see walking the streets looking like tramps. I just want to be the average person like I am now, have a good job to support my mother and father or my own family.

A "better world" also involves a desire for peace; a world that is free from the strife of war. Conflict on the international scale was perceived by some as a greater problem than strife within their immediate environment. They spoke of the problem that the Vietnam War presented. Fifteen-year-old Karen tells it as she sees it:

If I could wish for anything in the world, I'd like for there not to be so much war. . . . I wish the war in Vietnam would stop because what they are fighting for doesn't seem right. Most people—like relatives—they go over there and get shot and it causes a whole lot of crying. There shouldn't be a war over something that doesn't hardly make sense. It could be solved if they actually wanted to solve it. . . . Most of the people I know who went to war live down here in the housing project. . . . If the President had a little get-together and actually talked about things, then there wouldn't be too much fighting. Actually, everyone should be satisfied with what they've got. . . . Maybe the land is not big enough for food for the people the Vietnamese government has or something like that. People always want more than they have when they are greedy.

Melanie, a fifteen-year-old, also spoke out against the war.

As long as they are sending men to fight in Vietnam, we won't have any peace here. If I could wish for something, I would want peace for everybody. I am tired of all the confusion that is going

on. . . . People need to get together and talk about how they are going to stop killing each other.

The concern with justice, elimination of war, oppression, etc. speaks to the various manifestations of what it means to be Black in the community today. Their statements show in a variety of ways how they perceive their environment, and how strongly they feel that changes must be forthcoming to eliminate the problems to which they address themselves.

These young women talked about themselves as Black people in a very positive manner, but yet in a manner which strongly reflected the fact that was most important in their lives. Too much of the literature on identity has dealt with Black people as impotent, weak individuals who lack the power to shape their lives. These conceptualizations negate the fact that they are *creators* who act, instead of only being acted upon. Their environment is not so overwhelming that they have relinquished all control over it.

When one views closely the responses the girls gave on the effects of unemployment, the role of the police, their rationalizations for stealing, etc., it is apparent that they have a clear understanding of what the sources of oppression are. They do not turn their disparagement inward because they have been cut off from the dominant society's resources, but rather, they usually place the burden of blame upon the root causes. Their stark understanding of the "whys" and "hows" of their conditions is phenomenal. Thus, their ability to cope with them and to try to find some means of eradicating these conditions is a decided advantage they have over white middle-class kids whose adaptability to poverty and racism would be more difficult to manage were they suddenly confronted with it. In this context, self-hatred becomes meaningless and invalid because it does not apply. In this regard, one must note that the suicide rate among Blacks, particularly women, is considerably lower than the rate for whites. Neither do Black

women experience the same degree of psychological depression as white women.

The question should be raised as to why the "self-hatred" thesis has been consistently advanced when there has been little empirical evidence to validate the thesis. Without a definitive analysis of the psychological condition of the masses of Black people, it would seem unwise for proponents of this thesis to continue to advance it. Two of the noted works on the subject, *The Mark of Oppression* and *Black Rage*, were based upon clinical studies of a small number of psychiatric patients, many of whom revealed strong neurotic tendencies. Yet these analyses have not only been accepted, but taken as important and unheralded successes on the Black psyche. An important flaw in each of these analyses is that they deal with the pathological character of Black people as a point of departure and not with assessing the burden of such conditions on the society. It is impossible to investigate the so-called self-hatred without an investigation of the institutional character of racism which produces these manifestations. Thus, one must understand the role the policeman plays, for example, in order to understand why he is disliked and considered an oppressive force. One must understand why education is viewed as the source of salvation to these girls in order to comprehend the essence of their disdain for a system which refuses to grant adequate employment to their fathers and mothers. Finally, one must understand the dynamics of severe physical and psychological deprivation in order to realize the necessity of five- and six-year-olds stealing food and clothing.

The "self-hatred" thesis can be categorized with the many other myths that are propagated about Black people. It falls within the realm of institutional subjugation that is designed to perpetuate an oppressive class. For, so long as the Black community is perceived as being composed of "matriarchates," "self-haters," "criminals," "deserters," "oversexed individuals" and the like, then the

perceived "institutionalized" pathological character is more than adequate justification for its subordination.

One must ask the question, why do social and behavioral scientists have a psychopathological approach to the study of Blacks. The type of research that is conducted may, itself, victimize Blacks and contribute to promoting negative self-images. If, when one reads studies about himself and most of the analyses are laden with concepts such as "illegitimacy," "cultural deprivation," "matriarchal society," "deviant," "pathological" and the like, it is bound to have some effect upon him, if it only makes him spend a small amount of time pondering the reasons why. Though he may never accept their definition of him, he is forced to attempt to comprehend why they choose to view him as socially *inferior* instead of *normal* or *superior;* culturally *disadvantaged* instead of *advantaged.*

It is only when the analysis of the oppressive forces which produce various forms of antisocial behavior has been conducted that we can reverse the conceptualization of pathology. *The society, instead of its members, becomes pathological.*

# 4

## The Definition of Womanhood

The identity an individual assumes is crucial to an understanding of her behavior. Human behavior can best be understood by probing into the set of individual characteristics that define her ideology, sentiments, beliefs, life-style and so forth. However, an individual's identity is in large part a product of her experiences in the society in which she has been socialized. The person she is, the way she comes to feel and respond to events in her environment are highly conditioned by the cultural milieu. Thus, coming into womanhood in the Black community means that the environment largely shapes what kind of form and content her identity assumes.

Black lower-class adolescent girls in the urban centers assume sexual identities that play important roles in determining the types of women they eventually become. The sexual identity of these girls in this study refers to the self-conceptions they held toward approaching womanhood. Specifically, I am referring to the attitudes, feelings and beliefs they had and expressed about themselves as they related to being young women who were approaching maturity or becoming "grown." The corporate set of ideas they held about their relationship to the area of sexuality —both philosophical and existential—constituted a major portion of their sexual identity. While it is not an easy task to determine the distinguishing characteristics that comprise the corporate identity of any group of individ-

uals, one can attempt to understand elemental factor
such as patterns of belief, ideas, sentiments and behavio
that are held by a high proportion of the group members
Rarely does an entire group of individuals hold precisel
the same ideas to the same degree. Nevertheless, ther
are enough basic similarities among group members t
describe the sameness that exists.

In every racial, ethnic, social class and religious grou
in American society, a standard norm prevails: Member
of each sex are strongly encouraged and expected to adop
specific traits and patterns of behavior that are character
istic of their particular sex. Failure to comply with thes
norms at the appropriate age frequently causes the indi
viduals to be classified as marginal, homosexual or mal
adjusted, and can be the source of much discontent and
embarrassment. Garfinkel writes the following on the nor
mative regulations of sex status:

Every society exerts close controls over the transfers of person
from one status to another. Where transfers of sexual statuse
are concerned, these controls are particularly restrictive and
rigorously enforced. Only upon highly ceremonialized occasion
are changes permitted and then such transfers are characteristically
regarded as "temporary" and "playful" variations on what the
person "after all" and "really" is. Thereby societies exercise close
controls over the ways in which the sex composition of their own
populations are constituted and changed.[1]

The anticipatory socialization of young girls into the vari-
ous facets of the womanly role is one indication of the
high prevalence of this norm. Girls are bought dolls, play
make-up, toy washing machines, baby carriages, high-
heeled shoes and stockings for these anticipatory socializa-
tion roles. As they grow older, they are encouraged to be-
come more womanly, adopting the appropriate make-up,

[1] Harold Garfinkel, *Studies in Ethnomethodology*, New Jersey,
Prentice-Hall, 1967, p. 116.

fashions, etiquette and other styles that reflect this on-going process. This continued process involves the female adopting specified behaviors at certain appropriate age periods and practicing them as an integral part of her entire repertoire of behaviors.

In every sense, becoming a woman is measured by the degree to which they are able to adopt or possess the distinguishing characteristics that their community has defined as necessary for gaining the status of womanhood. There is a more or less continuous process during adolescence of assuming, utilizing and maintaining these necessary credentials. What does "becoming a woman" mean symbolically to the adolescent girl? What are the credentials that she must possess if this process is to be accomplished? Is there any single factor that culminates this process—a final *rite de passage*?

## PEER GROUP ACTIVITY

Peer group activity was briefly discussed in Chapter Two as it relates to the young girl moving away from the influences of the immediate family to those of the peer age group. Its influences can be observed more pervasively with teen-agers than among the younger girls. It is within the peer group that girls come to define and delineate certain areas of womanhood. The adolescent peer group can be viewed as a solidifying agent: one which welds them together to combat the many problems, fears, despairs, etc. which confront them in day-to-day situations. It is also a source of many of the positive things that happen to them as they grow up. The peer group has many integrative functions, ranging from showing slight approval, to being the most pervasive influence acting to shape the girls' life in almost every important area. The Black lower-class adolescent girl is confronted with many conflicts, important decisions and choices. Her decisions in many of these important areas can have lifelong consequences if she is not careful to make the correct one. For example, the de-

cision to drop out of school and work for better clothin
and other necessities might mean that she makes the d
cidedly wrong choice and will be forced to live the rest
her life in abject poverty. It is often the peer group th;
causes the girl to make her decision. The Black girl is a
fected, in many ways, by the period of adolescence whic
American society prescribes. Although she reaches h
womanly status earlier than her white middle-class counte
part, she is still in the precarious state of self-definitio
that defines the period of adolescence.

To understand the adolescent Black girl in the ghett
properly, one must first explore the general life situatio
with the so-called "average" adolescent girl. I am referrin
to the adolescent who is high-lighted in some of the li
erature which presently exists.[2] The adolescent has bee
described as:

. . . a child who has left the safe harbor of childhood but ha
not yet reached the shores of maturity. In short, he is at se.
He has the hope and promise of reaching a land of opportuni■
so long as he does not fall prey to the doubts and temptatior
of his travel companions, his peers.[3]

The adolescent can further be described as an individua
who is in a constant state of change: His life is dominate
by one crisis after another, many of which affect his even
tual outcome in later adulthood.

In American society, the adolescent to whom I am re
ferring has come to take a high priority in terms of he

[2] Refer to David Gottlieb and Charles Ramsey, *The America*
*Adolescent*, Illinois, The Dorsey Press, Inc., 1964; David Gottlie
and John Reeves, *Behavior in Urban Areas: A Bibliographic Re*
*view and Discussion of the Literature*, New York, Free Press
1963; F. Musgrove, *Youth and the Social Order*, Bloomington
Indiana University Press, 1964; Ernest A. Smith, *American Yout*
*Culture: Group Life in Teenage Societies*, New York, Free Press
1962.

[3] Maier, "Adolescenthood," *Social Casework*, Vol. 46, Januar
1965.

popularity and great efforts are extended to attempt to understand her. The "confusion" of the sixties which brought on student rebellion manifested in various forms attests to this point. She is the subject of much interest to social scientists, counselors, psychologists and psychiatrists, journalists and parents. In other words, she has made the great majority of Americans aware of her dissent: Some have sought to articulate it through literature, music, dress and a complete life-style, as expressed by the hippies. The group I am referring to indeed comprises a large segment of the population, but not its entirety. In sum, they by and large represent the economically advantaged instead of the poor.

The poor Black girl does not find herself among the white majority group described above. This pre-occupation with "confusion," "rebellion" and the generation gap is not characteristic of Black girls because it, as noted in Chapter Two, is a luxury which most Black parents find themselves unable to allow their children. Therefore, instead of a preoccupation with the precarious existence of being a teen-ager in the middle-class sense, the preoccupation is related to more vital issues of survival. (It will be demonstrated in a later chapter that although they do indeed have problems they consider peculiar to their age period, they are vitally different in content and implication.) It is within this context that peer group activity takes place, and consequently, for many of the decisions that are influenced by peers, the outcomes might have more long-range and serious effects. Indeed, peers serve the very instrumental functions in this group that are vital to one's welfare. One's peers may, on occasion, be the most important and dependable persons in a girl's life.

The peer group is the earliest source of feminine identification. Many of these girls first discuss menstruation, sexual intercourse, boyfriends, kissing, etc. with their girl friends before these topics are discussed with their mothers or other adult females. Often, they are never discussed with adults. Almost every facet of a girl's sexual ideas is

verbally tested with her peers. They share information and advice on the onset of menstruation, the first sex encounter, pregnancy, abortion and contraception. Moreover, the discussion of ideas generates the appropriate and acceptable norms governing these areas of behavior. There was much disagreement within the peer group over what the regulative norms should be. That is, rarely did the girls arrive at a set of beliefs and attitudes that formed their sexual identity without first engaging in intensive discussion with peers about the relevant facts and issues. They also gave much self-appraisal to the same. Examples of this process of arriving at a set of regulative norms as they were generated through peer discussions were found among the several taped discussion groups I had with the participants in this study. I often asked them to discuss such topics as dating, boyfriends, being in love, contraception and so forth. One such discussion group with eighteen-year-old Edith and fifteen-year-old Scarlet and three of their peers pointed up the important role of discussion as a means of generation of the regulative norms for the individual and the group, as well as some of the disagreement and indecisiveness that is never resolved. In discussing contraceptives, four of the five girls felt sure they would use them when they got married. A fifth maintained throughout that it was wrong to use them. The other girls made strong gestures of disapproval as she talked and often challenged her position. She finally altered her position to considering the possibility of using rhythm and Emko foam but was unalterably opposed to the pill and other forms of contraception.

It is in the peer group that the definition of womanhood becomes extremely important. What one's peers regard as appropriate behavior is usually taken very seriously —that is, such conceptions are rarely dismissed. On the other hand, one could say that the interaction among peer group members is one of such meaningful interchange that they have an impact upon each other. The girl is drawn into a particular group because of her similarities

with the others, but once she becomes a part of the group, she acts to influence and shape it. Thus, she both derives her identity from her peers and she helps to shape theirs.

It is typical in peer groups for girls to experiment with such valued items in their identity kits as lipstick, hosiery, tight sweaters and hair styles. Experimentation involving non-material things (such as ideas) was carried out in a similar manner. Perhaps the most vital function of the peer group in this regard was its role as a clearinghouse for ideas and as a judge or evaluator for sifting various ideas as to the best or most appropriate form of behavior in specified situations. Girls relied heavily upon their peers for counsel and advice, and they also reciprocated with the same. A strong value was placed on having sincere friends who could be depended on to share secrets, offer sound advice and offer companionship when needed. Close friends were expected to fulfill the above obligations constantly and failure to do so aroused feelings of distrust, sorrow and a strong tendency to categorize the insincere friend with other individuals whom the girl had, for whatever reason, come to regard as unconcerned with her welfare. Friendships lasted for varying periods of time. Most girls appeared to maintain relations with their "closest" friends over many years. A great number had kept close from preadolescence to the present. However, they often severed ties for short periods of time (up to a few months) with friends whenever they felt that circumstances dictated doing so. The expected obligations were these: Peers depended heavily upon each other for things both material (borrowing clothes, shoes, money) and non-material (friendship, trust, companionship). Sometimes one got the impression that friends were expected to fulfill obligations beyond the average expectations of individuals outside one's immediate family. Despite the ambivalence that was present over whether or not to trust friends and what obligations friends should keep, there was still a strong tendency to depend on opinions and approval from their reference relationships. So, regardless of the pressures and conflicts that arose in peer rela-

tions over boyfriends, alleged "lies" told by peers, jealous
and petty fights, there was still a considerable amount o
influence over conceptions of womanhood emanating from
the peer group.

Friendship within peer groups does not always have
stable and harmonious quality. There is often tensio
about friends, how one gets along with and is accepte
or rejected by friends. There is also frequently conflic
within peer groups over such issues as leadership, pett
jealousy, boys, etc. A good example is that of sixteen-yea
old Elizabeth and thirteen-year-old Kathy, who had grow
up together in the housing project and lived across the hal
from each other. The two girls, despite the differences i
age, were very close friends and were constantly in eacl
other's presence. On the other hand, one could always ex
pect that they would engage in bitter competition ove
boys, over who could outdress whom and other issues
These would always cause them to stop associating witl
each other for a few days or several months, as was onc
the case. Each accused the other of causing the rift in th
friendship. In *Tally's Corner*, Liebow states that Blac
street-corner men's peer or pseudo-kinship relationships ar
very close but brittle, and therefore often prone to dissolu
tion when subjected to great amounts of stress. He state
that:

The recognition that, at bottom, friendship is not a bigger tha
life relationship is sometimes expressed as a repudiation of al
would-be friends . . . or as a cynical denial that friendship as a
system of mutual aid and support exists at all.[4]

These girls' relationships suffered from some of the same
tensions but overall were much more stable and durable
Although there were often high expectations of friends
there was still a starkly realistic acceptance of the limita
tions of one's friend's resources.

[4] Elliot Liebow, *Tally's Corner*, Boston, Little Brown, 1967
p. 180.

Other examples of the influence of peers, as well as the perpetual conflicts within the peer group, can be given.

Fifteen-year-old Scarlet describes one such friendship and her attitudes toward one of her closer friends:

I don't know why I like Rose. She is just like one of the family since she moved into the projects. Sometimes she's all right but most of the time she gets on my nerves. She is immature. [She is] with me and my sister most of the time.

Another fifteen-year-old describes another rift:

I have one close friend and about nine other good friends. They are good friends to me but not as good as Caroline is. They consider themselves best friends but sometimes the things they do make you not want to call them your friend. . . . One of them tried to start trouble with someone at school and got everyone blamed for it since we all run around together.

In response to my query about why she selected two girls to be her closest friends, Ruby stated:

Once I had a fight with one of them but that didn't break the friendship between us.

Edith, an eighteen-year-old, talks about why she parted friendship with a girl with whom she had grown up.

Emma and I grew up together. We lived on Tenth Street and then we moved in the project together. She lives in the same building I live in. We went to school together. She used to be with me and Donna a lot but I think she grew up faster than us or something, I don't spend time with her any more. She runs around with a faster crowd. . . . They go around drinking and stuff like that.

These are some of the typical responses that the girls gave to queries about their peers. These girls choose friends

according to their friends' abilities to aid them in the proc
ess of clarifying for them—behaviorally and conceptually—
what womanhood means and what routes should be unde
taken to accomplish this goal. Most of the girls rathe
adamantly stated that their peers rarely influenced impo
tant decisions they had to make. They were unable t
articulate the more subtle day-to-day encounters that ar
also part of the decision-making process.

There are several specific manifestations of achieving th
womanly status. The first of these to be defined is th
adolescent girl's involvement with that conspicuous preoc
cupation of women the world over—femininity.

## FEMININITY

One of the salient characteristics they possessed was thei
high degree of femininity. Feminine identification is ex
pressed in a variety of ways. One of the manifestations o
expressions of femininity is that of their interest in th
various methods of making oneself more beautiful. From
the preadolescent to the eighteen-year-old, there was a
preoccupation with making oneself physically attractive
which included wearing fashionable clothes, jewelry, make
up and hair styles. While all of them accepted and prac
ticed this norm, some were more fashion-conscious tha
others. They were also the ones who perceived their fem
ininity as being directed toward the particular goal of be
coming adult women. It was probably these girls who had
defined most clearly the routes they must take to accom
plish their goal.

Their financial security was a major determinant in thei
ability to purchase fashionable wearing apparel and to en
hance their femininity in other materialistic ways. This i
not to suggest that inadequate financial resources created a
major obstacle for attaining womanhood, but rather tha
alternative strategies had to be adopted. The girls who
came from the more financially secure homes were enabled
to secure the proper clothes and shoes and to go to thei

hair stylist without much strain. Others were often forced to borrow pretty clothes or purchase stolen goods at reduced rates. Without these alternatives they were forced to go without the much desired material objects. The financial instability and inadequacy of their families did not permit the kind of indulgence for which they hoped. An example of a girl's desire to adopt the feminine qualities and to own the necessary fashions is illustrated in the comments made by seventeen-year-old Josetta:

Interviewer: Tell me what it is that you like about going to school.

Josetta: I like going to school because . . . you see all different fashions of clothes because some girls wear some real nice clothes. . . .

Interviewer: Do you like clothes?

Josetta: Yeah, *clothes* and *cars*.

Interviewer: Do you buy many fashionable clothes?

Josetta: No, because I don't have the money.

Interviewer: Do you look forward to the day when you can buy them?

Josetta: Yes. If I work this summer, all I'm going to do is buy clothes for school next year and pay for my senior activities.

Interviewer: Where do these girls who wear very sharp clothes get them?

Josetta: I think their parents buy them and they have jobs after school or on the weekends.

Two further cases in point can illustrate the discussion above. The first is that of seventeen-year-old Eileen, who was an only child. She and her mother lived in a small apartment in the housing project and were supported by the income from her late father's pension. Her mother, who was in her late thirties, was enrolled in a skilled train-

ing program and received additional financial support from her boyfriend. Eileen wore all of the latest fashions, although her clothes were inexpensive, and made a weekly trip downtown to purchase clothing. One of the items she valued in her wardrobe was a wig for which her mother paid one hundred dollars. In contradistinction is fourteen-year-old Benita, who, although an only child, was supported entirely by her foster mother's meager physical disability income. Benita was abandoned by her mother as an infant and reported that her now alcoholic mother who lived with the family had never contributed to her support. She had not seen her father for several years although he resided in the same city. Benita dressed very shabbily in old clothes. She had strong desires to own fashionable shoes and clothes and sometimes borrowed nicer clothes from her girl friends. Although she was unable to afford the life-style she preferred, a cheap tube of lipstick and a compact of powder which she used continuously was her compensation for her inferior economic status. For both girls, the value of making oneself physically and sexually attractive through outward appearance was important, but because of the situational factors involved different adaptations were made.

One of the strongest ways in which the preoccupation with femininity was expressed was their involvement with charm and beauty culture. Several of the girls were members of charm classes in their schools. Charm clubs were taught by teachers who were interested in promoting good grooming habits, but they also served as service clubs that help the elderly and as extracurricular groups that enriched the girls' educational experiences. Lisa, a thirteen-year-old, described it thus:

One of the reasons I like school is because we have a charm club. We stay after school from three-fifteen to four-thirty. It is kind of like school but we do a lot of things we wouldn't do in the classroom. Like for instance, we're going to Chicago in May. The "charm method" will teach us how to travel alone by ourselves. Some of us already know but others don't know about going to

big places, etc. We do a lot of things like take trips and save money, and learn how to work and everything in the class. . . . Just about the average girl participates. . . . There are about forty or fifty girls in the class. . . . They don't teach us how to wear make-up yet [she is only thirteen and in junior high] but our teachers teach us how to dress and how to use the proper language in meeting people.

Carol, seventeen and expecting her first child, stated:

When I was going to grade school, we dined out and went to the fashion show at the City Auditorium. These were some of the best things that ever happened to me.

In an informal discussion with five girls, two of whom I knew over a period of years, I asked them:

Interviewer: What do you think is missing from your life or what is it that you would like very much to have?

Respondent 1: Money for me.

Respondent 2: I don't have enough clothes.

Respondent 3: Money and clothes.

Fifteen-year-old Anna describes her past involvement in a charm club:

We used to have a charm class. We named it the Debutantes. We had lots of fun. We went on camping trips and to shows and skating. We had barbecues and we even had a car wash. We went visiting old folks' homes and we bought gifts for them, and birthday presents for ourselves. . . . We learned to use make-up and wear our clothes properly.

Anna also had a long-range interest in this aspect of femininity:

There are two things I want to be—a fashion designer and if I can't be that I want to be a secretary. I made two dresses in home

economics. I made an Empire dress and a lounging shift. . . .
If there is any way possible I want to be a fashion designer
because I like colors and clothes. . . . I remember once I made a
dress with a scarf that was yellow and orange. The next week I
saw a lady wearing one just like it. I was surprised and I said,
"Well, at least that's a start." . . . If I can't go to college and
study design, I will be a secretary.

Melba, an eighteen-year-old, talked about how she planned
on getting the nice clothes she wanted:

[When I dropped out of school] I was planning on having my
own apartment, maybe two or three rooms, and buying
clothes. . . . Maybe a three-room apartment that's furnished off
nice and neat in appearance. Nice clothes to wear and maybe
some money in my pocket every now and then. . . . But since I
stopped school I didn't get a job.

Melba sought a job through practically every possible
source, including the Neighborhood Youth Corps and the
YWCA. None of these possibilities proved fruitful, so she
was without a job when I interviewed her. Other girls had
a preoccupation with buying pretty clothes, but perhaps
as much out of need as for the aesthetic fulfillment. It has
long been a source of bewilderment to the American mid-
dle class as to how and why impoverished Black people can
garner the necessary resources to purchase the most fash-
ionable and expensive clothing when their other needs
seem to go unattended. It is commonplace to observe this
behavior at almost any time among many of the younger
people. This is often the source of a number of attacks by
social workers, government officials and others (including
the Black middle class) who adhere to the position that
these individuals could vastly improve their lives if they
calculated where their resources should be placed and if
they rearranged their priorities. Such a position reflects
the "Protestant ethic" attitude of striving and self-denial
where, ideally, one's life is well organized and projections
are made into the distant future. In recent years this con-

cept has come to be called "deferred gratification." Since this is a middle-class norm, it has been the middle class who have stigmatized poor Blacks for being "hedonistic" and "pleasure seekers" because of their inability to adhere to the norm.

However, when one examines the conspicuous consumption patterns, for example, of people who by middle-class standards cannot afford such luxuries, this behavior must be examined symbolically. What is the significance of beautiful clothes to these teen-agers? Why do they make sacrifices in other more traditionally important areas to satisfy their desires for wearing apparel?

Beautiful clothes can be viewed as a way of affirming one's belief in his own self-worth and dignity. Often in the absence of a balanced share of life's necessities, clothes act as a medium through which one can declare to his peers that he is "somebody." It is a way, for these girls, of telling those individuals (adolescents in particular) who either have escaped the poverty-stricken environment or were fortunate enough to have never been a part of it, that she is their equal. When I asked sixteen-year-old Vera, the oldest of five children, why she spent so much time concentrating on how she was going to buy or borrow clothing, she stated:

When I get clean [i.e., fashionably dressed] I can tell those uppity girls that go to the Do-Drop-In Dance Hall that I am as good as they are. I might live in the housing project but they sure can't outdress me even though they might live out in the West End in a nice house.

In this context, dressing is an outlet. In a minor way it might be viewed as a compensation for all those things which she cannot obtain within the present state of her existence. It can be recognized as a positive approach to fantasy because it provides her with the strength in an important area to proclaim her worth and perhaps, too, raises her level of self-esteem.

There is also a more basic level on which these behaviors can be analyzed. It is perhaps a part of the Black cultural tradition to "look clean" and to "style." There is nothing abnormal about one being desirous of high-fashion clothing. Is it not just as normal for these girls to express their femininity in this way as it is for their counterparts in other racial and social class groups? Perhaps it is through this expression that we can perceive the high degree of femininity that they possess—femininity which *they* consider important.

We should also note that their preoccupation with materialistic goods is only a reflection of the strong influence the dominant society has had upon them. America is a materialistic society that often values tangible goods over human life. (The best example of this is the disproportionate amount of resources that is expended on the war on poverty and the war in Southeast Asia.) The materialistic drive that is found in these young ladies is partly attributed to the fact that there are areas of overlap between the dominant culture and the Black culture. Although the Black culture is distinct in its life-styles, a number of the decadent dominant cultural values exist in the psyches of Black people. Thus, the preoccupation with grooming (make-up, clothes, hair styles, etc.) and other chemical beauty elements only represents one of the areas of overlap between the dominant culture and the Black culture. As a broader extension of this anti-humanitarian symbolic representation, one could view this behavior as one of the weaknesses of Black culture. The strong impact which the larger society has had upon the Black community has certainly produced some pathology within it. The "beauty trip" is only one such representation.

Black culture is dynamic, and can be perceived as involving constant *struggle* to combat the detrimental influences and to establish the necessary priorities that we should seek to accomplish in the future.

*Images of Black Womanhood*

There was much concern as to what kind of woman one should become, and this subject is addressed when girls are still preadolescents. There were a number of role models in their immediate environment who were used as sources of identification. In a few cases girls chose not to be like any of these models but to be either like someone beyond their environs (such as an actress or singer) or like no one they knew. Therefore, images of what kind of woman one should be took a variety of forms. Conceptions of emerging womanhood are transmitted from generation to generation. Although there were a variety of role models for these girls to choose from, they were still restricted, more or less, to emulating and following certain patterns of their mothers and other women in their immediate environment. Thus, there were often pervasive influences which they experienced within the home and community, even if they did aspire to move higher in the social class hierarchy. Becoming a nurse or teacher did not necessarily alter the fundamental conceptions of what it would mean to become a woman in Black America.

In the home and elsewhere she begins her long preparation for this role. Her conceptions of what kind of woman she is eventually to become are molded through her associations with older sisters, mother, grandmothers, aunts and a variety of other role models. Moreover, the responsibilities she has to assume are often those carried out, in

other social classes, by adult females. Such duties as caring for siblings, doing housework, interacting with adults on an equal basis and attempting to imitate many adult behaviors contribute substantially to the learning process.

There were several typical models to which they aspired. A common model was their mother, a favorite teacher, an aunt or a neighbor. The choice of a model frequently centered around one who had been successful. Thus, Lois' homeroom teacher was a model because she had demonstrated success by having gone to college.

I want to be like Mrs. Jones, my teacher. She is nice. She went to college. . . . I want to go to college like she did.

For Carolyn, an eight-year-old, the ideal success model is her older sister:

My twenty-one-year-old sister is in the WACs. I want to be like her when I grow up because she travels a lot and makes money . . . she sends money to my mama.

Again, success is measured by the extent to which one can not only care for himself, but help others in the family. There is a strong sentiment developed in young children that they must provide assistance to other family members when it is needed. One must stick to one's own and never turn her back on them.

Preparations for future responsibilities as a woman also involve learning how to relate to members of the opposite sex. Early in the lives of many young girls, a distinction is learned as to how one should relate to a boy. Boys become *sexual* persons at an early age. The asexual character which is often described to exist between middle-class preadolescent boys and girls disappears more rapidly here than in other groups.[1] The strong sexual awareness the

[1] For further discussion, see Carlfred Broderick, "Social Heterosexual Development Among Urban Negroes and Whites," *Journal of Marriage and the Family*, May 1965, pp. 200–3; and Boone

girls and boys experience causes them to relate to each other in a manner that is highly influenced by their knowledge of the roles men and women play with each other. In anticipation of these future roles, the pace is set early for this interaction eventually to take place. The following is a description of this type of anticipatory socialization.

A group of eight or nine girls in the housing project (ages six through twelve) were sitting huddled around a tape recorder answering questions for me. They were talking about a wide range of their day-to-day activities when a knock came at the door. I went to answer it and there were several preadolescent boys (all friends and boyfriends of the girls) who wanted to come in and talk over the recorder. I told them we were busy and to come back later but they insisted on staying. During this interaction, the girls tightened up (although they had been very much alive before the boys arrived) and began to act like "little ladies" in the presence of the boys. They were very coy and related to the boys as though all of them were eighteen-year-olds. They were less playful, several went into the bathroom to tidy their appearances and all became so engrossed with the presence of "men" in the apartment that we were never able to get back to the tape recorder.

The above illustration reflects the intensity of the anticipation of approaching womanhood for very young females. The deep realization of sexuality—of being a sexual person—does not negate the general preadolescent boy-girl rivalry that is experienced by children in other groups. That is also found here but perhaps to a slightly lesser degree.

The anticipation of womanhood is symbolized by certain types of acquired characteristics that are felt to render independence. One of these independent characteristics is

Hammond and Joyce A. Ladner, "Socialization into Sexual Behavior," *The Individual Society and Sex: Background Readings for Sex Educators*, Carlfred Broderick and Jesse Bernard, eds., Baltimore, Johns Hopkins University Press, 1969.

the belief by some of these preadolescents that having a baby will achieve a certain kind of responsibility for the girl, and consequent womanhood, that she could not otherwise enjoy. The acceptance of having a baby as a symbol of womanhood was expressed by girls of all ages, as will be demonstrated in Chapter Six. Twelve-year-old Terri told me that she wanted to give birth to a child when she reached sixteen or seventeen because she felt that it would give her some "responsibility." When I inquired as to what kind of "responsibility," and why was it felt necessary, the reply was that her older sister had had a child at sixteen, and she was now a "responsible" adult. The twelve-year-old felt that this was the way to achieve the same status her sister had achieved.

Interviewer: Do you want to have a child when you get older?

Terri: Yes. I want to be sixteen when I do. . . .

Interviewer: Do you want to be married?

Terri: I don't know.

Interviewer: Why do you want a baby?

Terri: So it can give me some responsibility of my own. My sixteen-year-old sister just had a baby and she is grown because she has some responsibility.

Lois, a ten-year-old, also wanted to have a child but she was more certain than Terri about marriage.

Interviewer: Do you want to have a child when you get older?

Lois: Yes. I want to be seventeen.

Interviewer: Do you want to be married or not married?

Lois: I want to be married because if I am not married everyone will probably be telling me to let somebody adopt my baby because I won't be able to take care of it without a husband.

Although legal adoption is very rare in the community, a modified form of it occurs when children are "given" to

their grandparents, other relatives and neighbors who are felt to be more capable of providing for the child than the mother. This is, no doubt, what Lois was referring to.

Other girls did not want to have children. For the majority of these, having children meant trouble because men could not always be counted on to support them. Rachel, at six years old, had probably been sufficiently exposed to the attitudes of her teen-age sisters and mother about the negative qualities of some men. Her parents were separated and she and her five sisters and brothers lived with their mother in the housing project. They enjoyed a pleasant relationship with their father and often expressed preference for him over their mother because of her drinking habits. Whenever their mother was away (sometimes for weekends), their grandmother came over and assumed responsibility for their care.

Interviewer: Rachel, do you want to have a baby when you grow up?

Rachel: No, because boys are no good. When the baby comes, they go with another girl.

They have accepted and believed in the same symbols and criteria for achieving womanhood as their older sisters, aunts, mothers and grandmothers. Change in this inter-generational context could take place very slowly. For other girls, there is a realization that to have a child could bring on responsibilities that will make life more complex. The possibility that one might have to rear a child without assistance from the father is probably not worth the "maturity" that is said to come from being a mother.

Although Lois and Terri represent the knowledgeable preadolescents, there are others who, at the same ages, have not yet been sufficiently exposed to be as opinionated as these girls. Gail and Carrie are two such girls. Gail lives in the housing project with her parents and attends a Catholic grade school nearby. As a fifth grader, she is preoccupied with her teachers, her schoolwork and her family. She is eleven years old, and the third oldest of four chil-

dren. Her mother is a housewife and her father works as an employment specialist in a community agency. She attends mass each day before school and on Sundays with her parents. Her parents are not strict with her but she chooses to spend a considerable amount of time in their presence. She occasionally brings her friends to her home and likewise visits them. Most of her friends live in the same building as hers. Some are Catholic and some are not. She goes out to movies, riding, dinner and picnics with her family. When asked about her ideas on having children, getting married, etc., she could only say "I don't know," in such a manner that one felt she was not relating to the question in any direct way. Her ideas on these topics had not yet been formed.

Carrie, also an eleven-year-old fifth grader, is the third of four children. She lives in the housing project with both parents (thirty-three and thirty-four years old). Her mother works infrequently (about once a week) as a caterer's helper, and her father works at a box factory. All of the family are very devout members of the Christian (Colored) Methodist Episcopal Church. Carrie's mother sings in the church choir and she and her older sister and brother are ushers. Carrie is a bright and sensitive child. She makes good grades in school and she adores her teachers. Her parents are considered reasonable but strict. All of the children must be in by dusk, especially on the weekends, because (according to her mother) "things happen to kids around here." Each summer she goes down South on vacation with her family for a week. This period is looked forward to with much anticipation because she likes to travel. Carrie is a sheltered child to some extent, and she is unable to say very much about what she foresees for herself in terms of serious courtship, eventual marriage and children. She talked about boys in what she and her thirteen-year-old sister considered the "proper" and "respectable" manner. For them having a boyfriend meant that one must be fifteen years old because that was the rule

their father had applied. Her thirteen-year-old sister expressed their father's sentiment.

He said he'd like for me to start receiving company and have a boyfriend when I'm fifteen, and when I get about sixteen I can go out on dates. He kind of watches over me since I'm the oldest girl and entering the teens rapidly.

They did not consider it proper to say that one had a boyfriend until he could come to visit them in their home. They did feel, however, that there were boys they liked and could talk to over the phone or in the presence of adults. Approaching womanhood meant for them a time when they must prepare themselves in the proper etiquette, poise and refinement. They were very concerned with their personal appearance, manners (especially in the presence of adults) and schoolwork. The latter emphasis, they maintained, would help them in the preparation for future careers as teachers.

The transition between preadolescence and adolescent status is not a sharp one because of the strong interchange of communication between younger and older girls and the general closeness of all females within the extended family. The strongest conception of womanhood that exists among all preadult females is that of how the woman has to take a strong role in the family. This fundamental principle or value is imparted by mothers to daughters, and by *women* to *girls* in a variety of ways.

All of these girls had been exposed to women who played central roles in their households. Almost half of them were growing up in homes headed by females. This is not to suggest that they approved or disapproved the woman being the central figure; they accepted the situation as a part of life and tradition in the Black community. Perhaps all of them were aware that there was a 50-50 chance that they, too, would eventually have to play this role in the future. It is against this backdrop that the

symbol of the *resourceful* woman becomes an influential model in their lives.

In the course of this investigation, I often talked with the parents of these girls. Most often it was the mother with whom I communicated because of her availability etc. There were occasions, however, when I was able to talk to their fathers (those in the home) about their conceptions of child rearing and the kinds of lives they desired for their daughters.

The task of conscious preparation for womanhood is described by Mrs. Lester, the mother of sixteen-year-old Margaret, who is in her mid-fifties. Mrs. Lester heads her household and is the strictest parent I met during the entire course of this study. Mrs. Lester's daughter, Margaret, was one of the girls with whom I became most acquainted during the course of this investigation, and I still maintain contact with her.

In describing how she perceived her role as a parent in rearing Margaret and her son Tommy, Mrs. Lester made the following comments:

Some parents don't mind the kids knowing things. Some don't try to hide anything from their children. I started talking to Margaret [about womanhood] when she was about ten years old. I told her about her period. I don't know why I thought she would start her period about the same time I did, because I was ten years old when I did. . . . I told her about boys . . . and to keep her dress down. Tommy [her fifteen-year-old son] was listening so I said, "The same goes for you. Keep away from girls because every time a girl says it is yours it doesn't have to be yours."

Again, Mrs. Lester talks about how she manages to keep her daughter in line with her conception of what the proper course toward womanhood should be.

Interviewer: Do you think there are many problems around your neighborhood that your children could get involved in if you were not so strict?

Mrs. Lester: Yes. Some of the problems are with boys, especially for Margaret. . . . I wouldn't say I worry about her because I keep her too close so I can see what she is doing. The only time she is a long ways out of my sight is from here over to her high school. . . . I don't let her boyfriend take her anyplace except for a walk on Sunday afternoons. He comes here to see her.

On the question of her daughter getting married in the future, she said:

I would really like for Margaret to finish high school, get herself a job and work and take care of herself for a while. . . . I'd like for her to wait until she is around twenty or twenty-one before she gets married. I definitely do hope she doesn't make a mistake [get pregnant]. . . . I think she would be better off staying here with me when she gets out of high school. . . . I don't want her to go steady because she might marry before she should.

In Mrs. Lester we observe a woman projecting the model of the economically independent woman onto her daughter's life. She often talked about the poverty she experienced as a child and young adult, and felt that her design for child rearing was calculated to rectify the errors that she had made. In her own life, she exemplified the hardworking, strong woman. Although she was in constant touch with the fathers of her two children, she rarely relied upon them to help her in their disciplining. Both fathers provided adequate financial support on a weekly basis. There is a strong possibility that Mrs. Lester's strictness was having a negative impact. Margaret and her brother Tommy occasionally told their mother lies about their whereabouts and Mrs. Lester acknowledged that she was beginning to have "trouble" with them. (In 1969 Margaret secretly married the boyfriend to whom Mrs. Lester refers, and said that she did so in part to get away from her mother's strict regulations.) Although Margaret is a fairly timid and reticent girl, she will probably develop into a strong woman because she is, in many ways, emulat-

ing her mother. She admits that she admires her mother's strength and ability to rear her family without a husband.

Another mother, whose fourteen-year-old daughter Ellen was involved in this study, talked about the perceived problems of rearing her daughter.

It is hard nowadays to raise a child. I think I'm doing a good job but sometimes I really wonder if I am. I sit back when I see my kids wanting to do things other children are doing and I just don't know how successful I am being with raising them. All I can say is that they haven't gotten into any trouble but my daughter here just turned fourteen today and I pray that she will be able to graduate from grade school next year and then from high school and maybe go to college. But it is so hard raising children.

Mrs. Jones was addressing herself to the fact that fourteen-year-old Ellen was approaching womanhood and there would probably be more problems and concerns to which she, as a parent, must begin to deal with as her daughter grew older. Mrs. Jones considered her role as the transmitter of certain models and cultural traditions to her daughter a very serious one. This was manifested in the various aspects of extracurricular activities that she was responsible for getting Ellen involved in. She tried to teach her the importance of church, of valuing the close relationships among her extended kin and the efforts made to continue these relationships, including the annual trip down to Mississippi to visit her grandparents and other relatives. Ellen's father also played an important role as the strong male figure who took a great interest in the psychosocial development of his daughter. It was he who determined how old she should be when she started dating, etc.

The models of appropriate womanhood were arrived at after oftentimes careful evaluations of the obligations, duties, responsibilities and privileges that were involved.

Most of the girls viewed the duties of the woman as those associated with keeping the home intact. This included caring for the children, cleaning house and, if necessary, providing for the financial support of the family. They frequently described these *strong* roles as ones which they were preparing themselves for when they became adults. They expressed strong admiration for their mothers and other women they knew who had to accept these heavy responsibilities, but in a non-romantic way because to them it was a way of life. Whenever they talked about their future lives as *married* women, they consciously spoke of their potential abilities to support themselves and their families if the marriage was not successful or if there was a dissolution of the family for other reasons. In sum, women were expected to be *strong* and parents socialized their daughters with this intention because they never knew what the odds were for them having to utilize this resourcefulness in later life.

Yet they sometimes expressed an ambivalence about the role of the hard-working woman because some felt that there are more desirable forms of activity in which to engage oneself.

The problems that the hard-working woman encounters were expressed in a variety of ways. The difficulty of having to struggle for life's bare necessities and still never achieve a secure life is a factor which girls perceive as a part of life—a part of life which is not considered to be good, but nevertheless, a reality which cannot be easily escaped.

These girls were drawing on centuries of traditions in attempting to conceptualize and emulate the hard-working woman, because this is probably, more than any other, the strongest image of the Black woman that exists. This image has persisted through the centuries because conditions are fundamentally unchanged. The same factors which produce Black male unemployment and subordination continue to cause the Black female to assume the responsibility

for her family which this society has relegated to men in other social classes.

Another image of what kind of woman one should become has to do precisely with the ambivalence that they have about the role of the hard-working woman. There was some concern among a number of the girls with fighting/opposing this role. Somehow, women were expected to be able to exercise some of the same rights and privileges that men had. This was manifest in their feelings that women, indeed, could have freedom of movement, freedom from certain responsibilities and should not be expected, in some cases, to be completely "faithful" to their boyfriends and/or spouses. There was a strong feeling that women were very often the objects of ill-treatment by "unfaithful" men. There was a general rebellion against playing this role because it was assumed that such a role was unfair for women to play when men were allowed complete freedom to do as they pleased. The stable and hard-working woman model is not always rewarding. Frequently this type of woman has been abandoned by her husband, and has sometimes had a series of unfortunate relationships with men. Sometimes making the strong commitment to the role of the "proper" woman ended in disillusionment and despair—disillusionment because things did not turn out as they were expected to, and despair because the end product of one's hard work to fulfill this role was met with unfortunate circumstances that were difficult to overcome.

It is in this context that some of them talked (in the interviews and discussion groups) about certain ideas they held and behaviors they practiced regarding their relationships with males. There is nothing especially glamorous about being the hard-working woman, even though this model is widely accepted because it has, historically, been necessary to fulfill. Some of the girls had consciously begun to view themselves as carefree. When I asked Judith, a fifteen-year-old who had been reared by her grandparents (she is one of fourteen children and her mother has all

of the other children), how she thought her siblings would describe her, she said:

Judith: They would probably say that I am too fast. My two brothers would say that I mess around with too many boys and I am going to get hurt. I mess around with a lot of boys because if I am going with one and quit him, I'll have another spare on hand. . . . I trip [cheat] on my boyfriend and almost got caught about two weeks ago. These two boys were arguing and fighting over which one was my boyfriend.

Interviewer: How did that make you feel?

Judith: It kind of makes me think they like me a lot because if a boy didn't like you he would say, "That's all right man, you can have her. I didn't want her anyway."

Part of Judith's explanation of her role as a somewhat flirtatious girl seems heavily dependent upon the personal gratification which she derives from it.

Other girls talked about "tripping" as a part of the normative process of dealing with boys. Cheating on one's boyfriend did not necessarily assume a negative overtone. Rather, it was just another one of the models of a certain kind of woman. Many girls were experiencing this as one of several phases which they will undergo in their continuous process of development. A lot of them could describe the physical conflicts unfaithful women had become involved in as a result of their activities. Benita, fourteen years old, stated:

I knew this woman who had a mean husband so she got herself a boyfriend. Her husband caught them together and beat her and threatened to kill her boyfriend.

Other girls talked about adultery as the cause for divorce. Fifteen-year-old Scarlet seemed to have accepted the model of the carefree woman as a fact of life.

When men don't act right women should be able to play around. Sometimes if you see someone else that you want then you should just go ahead and be with them. You don't always have to let these things break up your home but if two people want each other, the best thing for them to do is to get a divorce and get married.

Benita and Scarlet understand that there are certain kinds of repercussions for the unfaithful and carefree woman, even though it is a model that frees the female from the sometimes burdening obligations with which she must contend. Here the desire to enjoy life, and to get what it is felt life owes them, is a frequent theme. The image of the fun-loving and somewhat carefree woman probably represents the desire to be released from the constraints and pressures of the oftentimes cumbersome task of fending for oneself and one's family. The tragedy is that this society forces the Black woman to pay such a heavy penalty for breaking out of the prison which not only confines her, but forces her to be the *man* of her household.

Benita and Scarlet's attitudes symbolize the deep problems Black females find in the unfaithful and selfish model of womanhood. Even though there is often an attraction to it, they nevertheless have problems justifying it as a legitimate role. I feel that part of the reason for this ambivalence is because of certain moral feelings they hold about it. There was always present a strong sense of fair play. Many girls frequently referred to the teachings of Christianity as a proper set of ethics to follow. One got the feeling that, although they could rationalize tripping or cheating on their boyfriends, and possibly in the future with their husbands, they still felt it was wrong. The preoccupation that some of them held about getting caught while engaged in such activities is verification of their feelings that this was the wrong thing to do. Perhaps this can also be explained in terms of a certain kind of humanism they felt about engaging in any kind of illicit and/or immoral activity. The fact that they always pointed to the

dangers involved is one such indication, as well as their concern that there is something basically wrong with cheating—wrong for the individual to do and certainly a dishonest deed to do *to* someone.

The model of the hard-working woman is somewhat traditional and is perhaps more representative of their parents' generation than of their own. The fact that some of them feel so strongly about their desires to be autonomous is also a symbol of the gradually changing perception of the Black woman's role. Basically, the data could suggest that the carefree, laissez-faire, egalitarian model of womanhood is slowly gaining ascendancy among these adolescents. Still, however, the dominant model appears to be that of the traditional Black woman. Both models have always been present in the Black community. Each also indicates a sense of independence, strength and self-reliance. Autonomy is equally present in the *old* and the *new*.

Although the hard-working woman is viewed as a good model, she has certain features that prevented the girls from viewing her in an entirely positive manner. Under close examination, one finds that they had desires for the emotional and economic security that a stable marriage could provide as well as a concern that their lives not become drab and unexciting. They wanted to continue to enjoy themselves in parties, dances and other peer group settings without having to worry about the responsibilities of wife and mother. There was a strong feeling among them that one should not have to surrender her freedom completely.

There is still another prominent model of womanhood that was a recurring theme projected by the girls and their parents. This was the model of the educated and upwardly mobile middle-class woman. There is no contradiction between being an independent, hard-working woman and being prepared for a middle-class life. However, the emphasis is upon the girl's desire to remove herself from the low-income area and the many preparations she and

her parents are engaged in in order to accomplish this goal. Only a small minority of the girls in this study would fit the "Black bourgeoisie" typology which E. Franklin Frazier defines.[2] I only encountered two or three girls who were involved in the worlds of "make-believe" and "fantasy" which Frazier felt characterized a large segment of the Black middle class. However, a fairly large number of them were aspirants to the middle-class life in conceptions and behavior. It should be pointed out that *none* of the girls were satisfied with their present socioeconomic statuses. All of them had a desire to achieve the conveniences that are offered by a middle-class life-style. However, the difference that is crucial is whether or not the actual *behavior* of the girl is geared toward accomplishing this goal. Thus, in my attempt to describe the model of the educated and projected middle-class woman, the chief consideration upon which such a model will be based is the behavior I observed and learned about in other ways that was geared toward the realization of such aims.

The role of education has already been dealt with briefly in the chapter on "Racial Oppression." It was these girls' and their parents' perceptions of the value of education that formed the basis of the model of the middle-class woman. More than any other single index, education was regarded as the key to upward mobility. Although some girls talked about "finding the wealthy man" who could provide them with the middle-class life, the majority, however, felt that they must prepare themselves for this lifestyle because that was the only reassurance they had that they could indeed achieve it. The desire for education and the desire for a middle-class life-style also projects the woman as strong, independent and self-reliant because she expresses the *determination* to accomplish these.

Becoming middle class meant a variety of things. It meant that one's perspective on life was colored by a

2 See E. Franklin Frazier, *Black Bourgeoisie*, New York, Free Press, 1957.

conformist attitude—comformist primarily to what the larger societal expectations are. It meant that one was involved in the anticipatory socialization process and was indeed making attempts, wherever possible, to emulate the life-styles and accept the attitudes, values, etc. of other middle-class people. It meant that there was a strong desire to leave their community, to (in a small number of cases) forget that one was ever a part of the low-income Black community.

The origin of their aspirations to become middle class came from a variety of sources. The home was the most frequent source because parents simply desired a better life for their children than they had experienced. In some cases, it was the girls themselves who made the attempts to elevate their statuses, with or without the aid of parents and other family members. In these situations it was frequently the impact that other role models outside the home had made, such as teachers, favorite "successful" aunts and other women who were decisive in shaping the girl's image of what she wanted her future life to become. Sometimes these images were generated within the peer group almost independent of these outside sources. These external influences were often responsible for the carefree, egalitarian-type model also.

One of the distinguishing factors related to whether or not girls could identify with the upwardly mobile model of womanhood was the extent to which the family had the adequate material resources to provide their daughters with. Smaller families were always more capable of providing girls with the added incentives that encouraged them to remain in school, to look up to middle-class role models, and to aspire to achieve even more material resources than their parents had been able to achieve.

One of the obvious ways for girls to be assured that they will achieve their goal is to avoid serious involvement with boys. This means that, although they might have steady boyfriends, there is an understanding that the relationship will not involve sexual activity that might cause pregnancy.

The greatest deterrent to achieving one's goal is pregnancy. (This will be taken up more thoroughly in Chapter Six.)

The most upwardly mobile family I knew was that of fifteen-year-old Melanie, whose father worked for a community action program. Melanie and her younger sister and brothers were enrolled in Catholic school. Although the family lived in the housing project, they seemed to have had the feeling that they were "different" from their neighbors. However, when I asked them why they remained in the project, their response was that they stayed on in an effort to help stabilize the very transient population. Her father said that too many of the "good" families like his own picked up and moved out as soon as they could afford to do so, and that was the major reason the housing project carried such a negative reputation.

Some of the interview notes on my initial visit to the Knight household will be helpful to the reader in getting a clear picture of this family.

I went to the Knight apartment and knocked on the door. A child's voice said, "Come in." I went inside and I found that the kitchen, living room, dining room area (these rooms were combined) were filled with very good furniture, which was new or very well kept. The walls were painted a bright color and beautiful draperies were hanging at the windows. There were two small boys (one about two or three and the other about eight or nine) and a girl whom I later learned was ten but looked thirteen in the living room. . . . I asked the ten-year-old girl if I could see Melanie Knight and she informed me that Melanie was not home. I asked, "Is either your mother or father home?" She said, "Daddy's in the back." . . . She came back and said, "He'll be out in a minute." About five minutes later a man who looked to be about twenty-eight came to the living room and sat down. He said, "How are you?" I said, "Fine, thank you. My name is Joyce Ladner and I'm from Washington University. Last summer one of our researchers interviewed you and your wife about living conditions in the housing project." He said, "Yes, I remember that. Do you work for Dr. ———?" I said, "Yes, I'm on his staff."

He said, "I work for a community agency and we get all of the papers and reports he puts out." I asked, "What do you think about the work we're doing?" He looked at me for a moment and said, "Well, it's all right I guess. I don't have anything against it." We then got into a conversation about the merits and validity of the research. The general conclusion was that it was all right to do research but the money could be spent doing something else. . . . I then told him that I would like to set up an appointment with his daughter because I was concentrating on the life situation of teen-age girls in the housing project. . . . He said, "She is not here and you will have to come back when she is here . . . so she can decide if she wants to be interviewed."

One of the reasons it is necessary to include this transcription is because Mr. Knight was an exceptional parent with regard to his interest in and knowledge of the research and his concern that his daughter must make the decision as to whether or not she was to participate. Most parents did not express this type of concern. Many of them made the decisions for their daughters and even encouraged them to participate. It is also important that Melanie was perhaps the most difficult of all the girls to collect the data from. When I returned to the apartment (after calling her and arranging the appointment) I learned that her father had taken her out to dinner to celebrate her fifteenth birthday. On another follow-up occasion, there was some other problem. In each of these visits I attempted to communicate with her mother about notions of child rearing but was unable to establish a friendly line of conversation. I did learn that the family considered itself middle class and that they were preparing their children for college by providing them with a private school education (Catholic school). Mrs. Knight was suspicious of being "researched" and was not hesitant in communicating that fact to me. Her primary consideration was that she did not want to be classified with the other low-income people in the housing project, with whom she did not seemingly identify. Thus, much of the informa-

tion I have about the effects of this middle-class child-
rearing pattern came from her daughter Melanie, who
wants to become a teacher.

Interviewer: How do you describe your parents?

Melanie: They understand me. . . . When I ask them something
they explain it to me. . . . They explain my schoolwork to me
and try to make me understand it. They talk to all of us [her
sister and brothers] about a lot of things. . . . My father took
me to dinner on my fifteenth birthday.

When I questioned Melanie about her relationships
with boys, she expressed a most unusual sentiment—in-
deed the only such sentiment among the entire group of
girls.

Interviewer: Did you look forward to becoming fifteen since your
parents said boys could come to your house now?

Melanie: No. . . . I don't like boys. . . .

Interviewer: Why don't you like boys?

Melanie: I don't know. . . . When I was thirteen I had a boy-
friend but then I didn't know any better. . . . A lot of girls
start dating too early. . . . Some of them come up with
babies. . . . This is bad, because some of them don't know
what they are doing. . . .

Interviewer: How do you feel about marriage in the future?

Melanie: I don't know but I don't want to get married. . . .
I might change my mind. . . .

Interviewer: . . . Are you afraid of boys? Do you dislike boys?

Melanie: I'm not afraid of them but I dislike some of them. . . .
I like those boys who respect a girl. A boy who treats a girl
like she is a lady and not like she is just a tramp. . . . Most
of these boys are the ones who get a girl pregnant. . . . [If I
have to give girls advice about boys] I'd tell them to leave boys
alone until they get about seventeen or eighteen. . . . If I ever

decide to get married it will be to a man who has gone to college and has a good job. And have two children to grow up and be ladylike and nice.

It was difficult to get Melanie to respond to many of my questions because of her reticence. But it was clear that she held negative views toward boys because she felt they were prone to involve a girl in trouble. She also had a strong feeling about what "respect" and being "ladylike" meant. Although she is somewhat confused about what role relationships she will have with men in the future, it is understood that if she does marry, she wants a well-educated man with a good job. It is difficult to determine the source of Melanie's feelings about boys since both her parents discussed the possibility of boys visiting her since she has turned fifteen. However, many of her other feelings about being "ladylike" are the teachings of her father and mother, who imparted these values to her through conversation and by example.

Becoming middle class meant that one had to be willing to make certain sacrifices. This involved taking on after-school jobs, being conscientious students and internalizing middle-class values. It also meant that one took on a role model who could be emulated for the sake of being a constant reminder that a successful career awaited them if they continued to strive toward that goal.

Education was viewed as the means to an end—to a successful career.

Irma, an eighteen-year-old girl, was about to graduate from high school when I met her. She was going to enter a local junior college in the fall. Although she had grown up in the housing project, she had experienced a middle-class life-style. She had been provided with the adequate material resources for this to be accomplished. It seems that much of the influence toward this orientation emanated from her widowed mother, who, although not very strict, still enforced certain moral codes and images of respectability, especially as related to boys. Irma was

eighteen, but considered marriage to be in her distant
future because of the career objective she intended to
fulfill. When I asked her to describe her older sisters and
brothers and their socioeconomic statuses, it was quite
apparent that she was following a middle-class tradition
that had been established by her older siblings. She said:

My oldest sister is forty-two, lives in Chicago, is married and has
two kids. She is a beautician and owns three houses and two
beauty parlors. The next sister is married and lives in New York.
She owns a beauty shop there too. My next oldest sister is married
and has one child. She attended college and works at [an aircraft
factory]. My thirty-three-year-old brother lives in Michigan, is
married and has one child. My next sister is taking up a business
trade.

In response to my query about why she stayed in school:

If you want a good job you have to have some sort of education.
I want a good job and I want an education. . . . All of my sisters
and brothers graduated from school so I just wanted to stay in
school and make the record right.

Irma wanted to become a secretary or clerical worker
and intended to work "for a number of years and then
get married." She took a very casual attitude toward boys,
preferring not to take them seriously.

Interviewer: Do you ever think about getting married?

Irma: Yes, I think about it. I can marry right now but I'm not
ready for it. . . . I'm too young. There's too much ahead of
me in life. . . . If I get married I will have to settle down and
I'm not ready to settle down.

Irma's middle-class family orientation was reflected in
the annual family "reunions" that were held each Septem-
ber when all of her siblings came from out of town. It

was also evident by the close relationship she had with her older sisters, to whom she confided her "personal" problems. Most important, it was reflected in the expectations she had toward the kind of man she eventually hoped to marry.

I want the kind of husband where I wouldn't have to work, just stay home and be a housewife. . . . I want him to be a lawyer or detective. . . .

Irma aspired to become middle class through preparing herself in a chosen profession, and later, by marrying a professional man who could provide her with the comforts of the middle-class life-style. Her middle-class aspirations were more evident in the admiration of the accomplishment of her siblings than in the actual life-style by which she and her mother lived. Their apartment was filled with old furniture and they probably lived, for the most part, on her mother's pension and money contributed by her sisters and brothers. Yet all of her associates were from upwardly mobile families and she had defined her personal "style" with males in such a manner as to avoid the possible "trouble" which could emerge from overinvolvement. But again, there are other girls who can be classified in the same category as Irma, the only differences being minor situational factors.

Because of the sparse resources of the majority of their families,[3] almost any girl with great ambition was forced to formulate her own coping strategies by making day-to-day adaptations, as well as devising certain schemes for fulfilling long-range goals. The survival techniques they employed were varied, but are easily recognized in their particular "styles."

There are several variations of the type of girl who

[3] The median family income for the girls in the housing project was $2400 for female-headed households and $3350 for those with male heads; in the community outside the project the female-headed households received $2200, the male-headed $4200.

strives to become a "respectable" and upwardly mobile
woman. Sometimes the odds that militate against this
goal of upward mobility exist within the family proper.
It is probably this kind of girl, who even has to over-
come severe obstacles within the home, whose chances for
upward mobility are strongest, because of her strong inner
resourcefulness and determination. At this point, the
material resources that can enhance one's ability to go
through college, etc. are sometimes not as effective as the
forthright determination and fortitude that provides the
strong motivation and drive toward success.

Harriett Wells, a sixteen-year-old high school junior, is
the prototype of this "model" of womanhood—one who is
determined to succeed in spite of all odds. She is the
oldest of seven children. Her mother and father are sepa-
rated because her "father got tired of fighting other men
about my mother." She considered her father a morally
upright man and strongly identified with him, even though
he no longer lived with the family. Mrs. Wells was in
her mid-thirties and did not seem interested in accepting
the responsibility for the care of her children. She re-
ceived support money from her former husband for the
children but did not spend much time with them. The
burden of responsibility for their care was placed with
her two older daughters, Harriett and Josie. When Mrs.
Wells was away for extended periods (weekends), her
mother came over and stayed with the children until she
returned.

When I first met Harriett she appeared to be a friendly
but reticent girl who wanted to make a positive impression
on me. She talked about herself, her goals in life (to
become a teacher), but in a somewhat subdued manner.
I learned early from her that she had been raped by an
adult male when she was twelve years old. She was playing
in the housing project building in which she lived and
was pulled away from her friends by a stranger who took
her into one of the secluded areas of the building and
raped her. It is unclear as to whether or not his identity

was known and subsequent prosecution occurred, but she thought that a man had been arrested for the crime. I was never able to learn much about the details of the rape, nor the devastating effects it had upon Harriett's life from Harriett. I could only surmise as much because she found it extremely difficult to discuss and became very emotional when I mentioned it. I therefore did not feel it within my rights as a researcher to penetrate into this area of her life.

It was probably for the same reason that much of my information about Harriett came from my observations of her and from her younger sister Josie (fifteen years old), with whom I became very familiar, and Josie and Harriett's peers. Harriett was viewed by Josie as a "goody-goody" who pretended to be more "moral" and was considered very self-righteous. An excerpt from a conversation I had with Josie about Harriett gives some indication of the differences that existed between them as they grew up. Josie recalls:

Josie: . . . I remember when we moved out of the housing project [for a few years before moving back] my sister, Harriett, cried all night long because she wanted to go back and live in the project because all of her friends were down here.

Interviewer: As you and Harriett grew up together did you think there was any great difference in the way you felt and acted about things? Were you any different from Harriett?

Josie: Ooh, yes. She tried to be good, you know. She tries to tell you to do right and all that old stuff but yet and still she doesn't do right herself. But she tries to tell me to do right.

Interviewer: She doesn't do right herself?

Josie: Well, most of the things she does are right but . . . I know she is having relations with her boyfriend but she won't tell me or discuss it with me. If I am around to listen, I'll hear about it but she won't just come on out and tell me things.

Interviewer: Why do you think she tries to be good?

Josie: I don't know. She just sits around and she just has to go
to school and that stuff. . . . She goes to school nearly every
day. . . . She plays hooky sometimes with her friends.

Although Josie felt that Harriett was having premarital sex
and playing hooky from school, there was no evidence
that her accusations were correct. It appeared that Josie,
who was pregnant and unmarried when this interview was
conducted, was offering rationalizations that had to do
with her own behavior. This is evident in an interview
I conducted with Josie less than two weeks later. Harriett
had borrowed five dollars from Josie and had not come
home to pay her before leaving for work. Josie was angry
and accused Harriett of being dishonest:

Josie: Harriett makes me sick. She always does things like that.
. . . She's still trying to be goody and all that.

Interviewer: Is she still going with the same boy?

Josie: Yes, she is still going with him and she goes out with him
[on dates] and all, but she doesn't want anyone to know that
she is not a real good girl like she pretends. *She is still good
and all but I just believe she is doing some of the same things
we* [her peer group] *are doing.* (Emphasis added)

This is a clear indication that Josie would like to believe
that Harriett is no different from her. It is expressed in
her ambivalence about what her sister is doing in fact, as
opposed to what she would like to *believe* her activities
consist of.

Josie's peers viewed Harriett as "good" and did not allude
to the same kinds of reservations about her character as she
did. They were quick to defend and sometimes "revere"
Harriett as one who was worthy of praise. Although she
was very different from them because of her strong deter-
mination to go through school and her independence (she
held a part-time job after school and on weekends about

which she was very diligent), they still admired her because she, ideally, represented someone they were perhaps unable to become—unable because some of them did not have the inner resourcefulness that was required, and others found the role she was committed to playing unrewarding in their day-to-day situations.

When I asked Frances, a sixteen-year-old mother who had returned to school and who was described by some of her peers as "dangerous" because of her quick temper and deceptive character, to tell me of her impression and/or evaluation of Harriett she could only praise her:

Interviewer: What about Harriett? How do you view her in terms of your peer group? [Although Harriett was not a part of the group, she was always on its fringes because of Josie's deep involvement in the group.]

Frances: Harriett is not around too very much but when she is around, she is a very nice person.

Interviewer: Is she just like the rest of you or is she different?

Frances: She is different. She is very different. All Harriett thinks about is education, education, education and her job, her job, her job. That is all she ever thinks about.

Interviewer: Do you respect her for this or not?

Frances: Yes, I respect Harriett for being this way.

Interviewer: Is she the kind or person you'd like to be or are you satisfied with being the way you are?

Frances: I am satisfied with being the way I am.

Interviewer: Then how is it that you can have respect for someone like Harriett?

Frances: Because she has respect for me. She is a good girl. A *good one*.

Interviewer: Are there some things that the rest of you and your friends would do that she wouldn't?

Frances: Yes. I don't remember her stealing things. And she says

she hasn't ever had sexual relations. But I have never known her to steal anything from anyone. . . .

Interviewer: Do you know why it is that two girls like Josie and Harriett could grow up in the same family together and one turns out to be like Harriett and the other like Josie? What are some of the influences that you feel caused Harriett to be the way that she is?

Frances: I guess it is the people that Harriett went to school with, I guess. And then again, it might not be. It's just the way her mind runs. And Josie, it's the people she runs around with. . . . I don't think either one is easily influenced but if it is either, it would be Josie.

The other girls in the peer group dealt with the question of Harriett in the same manner. It is difficult to determine what causes a "Harriett" and a "Josie" to emerge from the same family. Harriett was strongly influenced by her father, whom she described as a "good" man, highly moralistic and a stable figure within the family during his tenure there. She felt closer to him than most of the other children, although she and her mother got along well together. Perhaps the more important question to be raised is, "What is it that allows for the existence of the many Harrietts within the low-income Black community—girls who have no one within the home to encourage them, and scant, if any, material resources with which to accomplish their goals?" Harriett was almost self-sufficient because she received no money from her parents for clothes and other necessities. Of course, the rent and food were paid for by her parents. On occasion, however, she had to take her money to buy food for the family—when her mother disappeared for several days and they were trying to get in touch with their father and/or grandmother. She played the role of mother to her six younger siblings in the absence of her mother and did it well. One would think that the "burdens" and responsibilities this young girl carried from time to time would have caused her to

succumb to the pressures. They did not. In fact, she handled these routines as though they were normal activities for a girl her age. There is something peculiar about the psyche of a girl like Harriett because she represents all that is contrary to popular thinking about the endurance capacity of people—especially young, inexperienced people. In all probability, Harriett was determined to get an education and move up into the middle class because she was totally dissatisfied with living the kind of life she was forced to live. It is possible that she was also reacting to her environment and was determined to remove herself from it as soon as possible. But still, such explanations are insufficient because they have little to do with Harriett the person. It is probably the combination of her special insight into what she could get out of life if she worked hard and *alone* (because no one else could be counted on to help her) and her individual personality that accounted for her being the way she was.

In a slightly different way, sixteen-year-old Gwen had to devise certain strategies for coping with the present and projecting into the future. Although her father had deserted his wife and six children (Gwen was the oldest), her mother was able to provide adequate supervision over them. The family was supported by an inadequate ADC welfare allowance and by the small amount of money her fifteen-year-old brother made (on a part-time basis) at a grocery store. Gwen said that the family breakup, caused by her father's drinking problem, was such a heavy blow to her and her younger sisters and brothers that their schoolwork was affected. She was retained for a year because she no longer found school interesting. (She was about nine years old at the time.) However, as time passed, she adjusted to the breakup, and is no longer bothered by it, except to recognize from time to time that she and her siblings could have adequate shoes and clothing if her father was still providing for them. The burden of responsibility for child rearing had fallen upon Mrs. Martin, a strong woman in her mid-thirties, who

was barely surviving on the ADC allowance. She had a very bitter relationship with her former husband (from whom she was not divorced) and expected nothing from him. Perhaps the dynamics of Gwen's parents' relationship is responsible for the way she has come to perceive and respond to her environment and for the strategies she has adopted to guarantee her upward mobility in the future.

Gwen explained her career objectives:

Gwen: I plan to finish high school and after then I don't plan to go to college cause we don't have the money. . . . When I get out of school I plan to find a job as a registered nurse. . . .

I told her: But you must go to nursing school in order to become a registered nurse.

Gwen: Yes, I know that. Maybe I can get the money to go.

As a ninth grader, most of Gwen's grades were above average but she participated in no extracurricular activities—probably because her mother did not allow her to spend the free time away from home.

Gwen's views about boys were very puritanical. At age sixteen, she did not yet consider herself to have a boyfriend even though a seventeen-year-old "nice" young man frequently called her on the phone. In reflecting on this, she said:

[When I was fourteen] I wanted to have boyfriends because I was big for my age and you know the boys thought I was older than I was. But I see now that I think it was best that my mother wanted me to wait until I got sixteen because I think I'd be in trouble with boys and have a baby now. . . . I think she did best to make me wait.

It was unusual for me to discover a girl who was in such agreement with her parent(s) about this area of her life.

Many of them felt that parents were often unfair and without understanding of their interest in boys. For example, Gwen did not go anyplace without her thirteen-year-old brother accompanying her, including the times when she had to come to my office for the interviews. (Her brother was left in another room of the office to ensure privacy for the interviews.) Although she sometimes found her mother's strictness a little overbearing and expressed a desire to go to "record hops" and other teen-age activities with her friends, she never rebelled against these parental dictates. A characteristic she shared with some of the other upwardly mobile types is that of not identifying with her neighbors. She carried herself in a serene but yet somewhat haughty manner. Realizing the economic limitations that were placed on her life by her family situation, one got the impression that she was making tremendous adjustments to them. The fact that she showed few signs of disagreement with the way her mother conceptualized the "problems" involved in rearing a teen-age daughter and bringing her into womanhood without the problem of premarital pregnancy, etc. which many of her peers have to deal with is an indication of her own acceptance and adjustment to this model of womanhood. Her mother is quite ably transmitting certain values about womanhood—about the respectable and decent, upwardly mobile woman—that Gwen is readily accepting.

One observes this even more clearly when we think of the many problems Gwen and her mother have to deal with and the obstacles they have overcome as a result of the father/husband's absence from the home. Gwen recalled the "happy" days in her life, when, as a young girl, her father adequately provided for them and she had a close relationship with him. However, after the separation, she was forced to make the necessary, but extensive, adjustments. In spite of the inadequate resources, the unhappiness she felt, and the fact that her mother became what all of her peers considered overbearing with her

strict regulations, she was still able to garner the strength
and determination to believe in herself and her ability
to become "somebody" someday. In all probability, Gwen
will achieve her goal.

There were other girls whose lives almost paralleled
Gwen's.

I can immediately think of Josetta, a very resourceful
girl, who was the third oldest of six children. Josetta's
parents were separated and her oldest sister (age twenty-
five) was a drug addict. I was never able to understand
why her parents separated. She related that her mother
was difficult to get along with but she was very close to
her father. He visited them weekly on payday and she
spent every Sunday with him and her paternal grand-
mother (her maternal grandmother lived with them). A
twenty-two-year-old brother was not drafted into the Army
because her mother pleaded a "hardship" case, i.e., he
was the oldest son, and the provider for the family.

Josetta, unlike some of the other girls, had several boy-
friends, but the relationship she had with them was some-
what on the level of what would be expected between
two ten-year-olds. At one point during the time I knew
her, she had about five boyfriends, each of whom was very
handsome, which seems to have been one of the major
reasons for such a selection. She also selected them on the
basis of what she called their "strength" or masculinity.
Many of the boys she knew were from upwardly mobile
families; all of them were from "respectable" families.
Yet she did not define her relationship with them as
anything more than a casual acquaintanceship. She pre-
ferred being with her girl friends on weekends to going
out with one of her several boyfriends.

Her ideas about education were very firm. She intended
to spend the first two years at a local junior college and
then transfer to Howard University, where she hoped to
study dietetics. In high school, she was enrolled in all the
courses that would give her the adequate background for

a career in the food sciences, such as commercial cooking, etc. Moreover, she was working as a dietician's helper's assistant on a part-time basis at a VA hospital year round. Her father had promised to borrow the money for her to go to senior college; she also planned to save money for the same purpose. Her image of future womanhood reflected her strong belief that she would accomplish her educational goal. It was equally expressed in the kinds of projections she made about the kind of man she intended to marry (an engineer or high-level construction worker); she felt that her chances for marrying such a man would be "a hundred to one." Such a man, according to Josetta, must have "a nice personality, ingenuity, must want the things I want . . . we should be madly in love with each other." She went on, "I don't want a coward for a husband. He must be masculine." It was very easy for her to project even into the lives of her children, yet unborn.

I probably want my sons to become doctors or lawyers, to have substantial occupations that regardless of whether you are sick or at work you still make money. . . . I think I want them to be like me—to have a lot of ingenuity and perseverance.

Womanhood to Josetta meant strength, becoming middle class by getting an education, as well as marrying the right kind of man. Her role models were two favorite teachers, her father and, to some extent, her mother and grandmother, although they did not get along very well because she and her mother were "too much alike." Her mother and father instilled the value of education within her and seemed to have turned to her to "make something out of her" after failing to do so with their twenty-five-year-old daughter. I talked to Josetta about the effects her sister's addiction had on her family:

Interviewer: Are you fairly close to your sister? Do you visit each other and do you talk over the phone?

Josetta: No. We might talk to each other once on the telephone about every two or three months but otherwise we don't run into each other.

Interviewer: Is she close to anyone in your family?

Josetta: No.

Interviewer: Is this the same sister you told me about whom you call a kleptomaniac? I didn't know whether or not you were kidding.

Josetta: She is though.

Interviewer: Is she also an addict?

Josetta: Yes.

Interviewer: What kind of drug is she addicted to?

Josetta: I don't know. She takes it in a needle in her arm.

Interviewer: Has she ever gotten into trouble because of this?

Josetta: Yes. My mother tried to get her in this hospital in —— ——. But she had got in some trouble and they sent her to prison.

Interviewer: Do you know how it affects her physically?

Josetta: I think my sister is sick. She really is sick but she doesn't try to do anything for herself.

Interviewer: Do you know how she got hooked on drugs?

Josetta: I guess it was this crowd she was running around with. They were bad.

Interviewer: Does your father talk to her?

Josetta: No. He doesn't ever want to see her again.

Interviewer: Do you think that if you talked to her it would help?

Josetta: No. Because she has her own mind and she knows what she wants to do I guess.

Interviewer: Does her husband also use drugs?

Josetta: I really don't know.

Josetta's parents had attempted to rescue their daughter by trying to get her admitted to a narcotics addiction hospital but she had to serve a sentence in jail instead. When her parents were unable to save her from this severe problem, they seemed to have turned to Josetta as their success model. Josetta was determined not to let them down not only because of their belief in her but also because *she* believed in herself. She had an intense motivation to succeed, probably with or without their help. Two favorite words in her vocabulary, especially when describing herself, were "ingenuity" and "perseverance." In a taped discussion group with some of her friends, I asked them the following question:

What are some of the ways a girl can make her life better and live a wholesome life even though she lives in a low-income community?

Josetta's response was: They should have an ambition; then they should have perseverance and have the ingenuity to do what they want to do.

I then asked her: Suppose a girl has all of these things but she sees that in her family, there is little hope that she will ever be able to pull herself out of the environment?

Josetta: She can pull out! *She can make her own self have a better life, even if she has to leave her surroundings.* I think that is what she is going to have to do anyway, leave the surroundings she lives in, go to a better neighborhood. . . . If I were her, I would continue going to school. I would join some kind of club like the Job Corps or something. There they train you and pay a little, plus they have a little home for you to stay in and then you could go to night school or day school. . . .

Few girls of any racial and class group could speak with such determination and lively resourcefulness. Such an attitude was reinforced by the frequent admonitions of her parents and grandmothers, who encouraged her to continue to forge ahead and make a better life for herself.

And Josetta was just a rare-breed person. Josetta will triumph!

I have dealt with several conceptions of womanhood and the paths different girls were taking and the resources they were utilizing to prepare themselves to approximate these models. It has already been stated that the ideal for all of the girls I came to know was to "be somebody" and to enjoy all of the material possessions a middle-class life could afford. At the same time, it is true that many of them could only verbalize such an ideal and had long since stopped trying to live the kinds of lives that were necessary to accomplish the "good life." Unfortunately, I came to know a fairly large number of girls who had, before reaching adulthood, already given up. Although this group constituted a minority and cannot accurately be considered a "model" of womanhood to which certain girls aspired, it becomes one of the typologies of womanhood as a consequence of many other failings—as a consequence of one's not being able to overcome the insurmountable odds and obstacles. It is the point when the individual finds herself powerless to become anything else but a failure. One cannot state conclusively why some girls overcome the obstacles and others don't. There are a variety of factors involved, both on the structural and individual levels. And it is only in this context that I can describe and analyze case studies of those girls, some at fourteen, who represent the stereotype in much of the literature that is written on the lives of this group of Black people. Even in the many stereotyped portrayals of this aspect of Black womanhood, many of the *essential* intricate elements involved in the actual processes that lead a girl to this low ebb are not presented. It is these processes that we must attempt to understand.

There are many factors which cause a girl to give up and to possess low motivation. Also, some girls are not lacking in motivation so much as having been socialized in a family tradition that is not geared toward upward

mobility. I will illustrate that there are many Black girls who are coming into their womanhood who do not presently have and have never had the adequate role models to emulate. These girls also suffer the most severe economic difficulties. There are probably hundreds of thousands of Black people who have, in the seventies still not dared dream of becoming upwardly mobile. The perpetual cycle of abject poverty has not been affected in such families' history over several generations. Then there is another model of womanhood that must be recognized that is not a distinct typology as such, but a slight variation of the kind of girl we are presently describing. That is the girl who starts out with adequate motivation but eventually gives up. She eventually finds herself succumbing to all of the pressures and weaknesses that are produced by poverty and racism. Thus, she develops certain attitudes and assumes certain characteristics *after* her initial acceptance of the role of the future "matriarchate." (This is best demonstrated with adult women who are household heads. A case study will be presented below.)

One of the girls who fit the model of the person who has already lost hope for the "good life"—except to verbalize it, infrequently, in nothing more than a perfunctory manner—was sixteen-year-old Elizabeth. She had two children (one three years old and the other a few months) and had taken a job as a maid in a hospital. Elizabeth's life was atypical when compared to most of the girls I came to know because she represented one of the most precocious types I met during the entire investigation. She was the oldest of four children (thirteen- and ten-year-old girls and a three-year-old brother). Her thirty-three-year-old mother headed the household and had been separated from her husband for a number of years. I first met Liz and her family in 1965, and during the several years I knew them, her father was never present, and rarely mentioned in the home. When I first met her, she was thirteen and her daughter, Lena, was less than a year old. The family was supported entirely by ADC wel-

fare and Liz and her two sisters were in school. Mrs. Marshall (Liz's mother) kept her grandchild, Lena, and Charles, Mrs. Marshall's son, during the school day. Charles and Lena had been born during the same week.

Liz could be described as an attractive girl, whose appearance was always well-kept. Her clothes were very nice (frequently expensive) and she took pride in wearing them well. She was one of the best-dressed girls I met during the several years I was conducting the study. (The source of these clothes will be discussed below.)

In recollecting some of my first impressions of Liz and her family, I made the following observations:

The living room had been rearranged and was disorderly. Large scraps of paper, articles of clothing and shoes were lying on the floor. Apparently someone had started painting the apartment since I was last there because half of the wall was newly painted. . . . There were two bedrooms in the apartment. The one on the left was Mrs. Marshall's and her one-year-old son's. A lot of clothes were strewn on the floor and I didn't notice any curtains at the window. The bedroom to the right is that of the four girls in the family—Liz, Sue, Kim and Lena, Liz's baby. There were two beds in this room. One was a double bed and the other was a single. This room was more disarrayed than Mrs. Marshall's bedroom. . . . Mrs. Marshall got up from watching a "soap opera" on television and started cleaning house. Once she finished sweeping she put the trash in a box that she got out of the kitchen. After she started mopping the floor she began fussing at Sue. She told her that she, Kim and Liz would have to clean up the two bedrooms and the kitchen. She said, "I give you all money every weekend. I'm going to get something back for it. You all don't do a thing around this house. While you're at school every day I keep these children, I cook and clean house and you all don't do a thing but stay outside and play and go anywhere you want to. But I'm not going to keep on doing all this work. You're going to have to start helping me." (Liz and Sue had stayed home from school while, according to Mrs. Marshall, "pretending" to have sore throats.) It appears that Mrs.

Marshall is very lenient with the kids because several times during the evening they would simply tell her that they were not going to do a certain thing that she had asked them to do and she would only say, "Girl, you'd better go on in there and do it." No attempt was ever made to force the children to do what she had asked of them.

I was later to learn that Mrs. Marshall had long since "given up" with doing little more than mildly scolding the children for not complying with her dictates. Mrs. Marshall had simply grown tired. Upon learning that I was a native Mississippian, she explained:

I'm from down there too. I come from a place called Sunflower, Mississippi, but I've been here since I was fourteen. I've been doing this kind of work for all my life and there was only one in my mama's family. I was an only child but even after I got grown I had to continue to do it because these lazy children of mine don't do a thing. I have to do all the work. I'm tired of it.

Mrs. Marshall told me that she had once been highly motivated to see that her children did well in school and kept a closer check over their activities, but after her husband left, she found it increasingly difficult to manage the family in these areas, as well as be responsible for providing them with the essentials of food, clothing and shelter. It is against this backdrop that I was able to understand why and how Liz had given birth to a child at thirteen and another a few days after she turned sixteen. As Liz's mother found it too great a task to manage all of these areas of family life adequately, the children were able to come and go as they pleased, and this was one of the major reasons for Liz drifting in the direction in which she was headed when she had her first child, and into the permanent drift toward which she is now directed.

Liz explained to me that she became pregnant by a young man in his late teens, whom she started dating at

age twelve. Her mother often left her alone with him while
they baby-sat with her younger sisters.

After Lena was born, Liz returned to school and con-
tinued to spend a considerable amount of time with her
peer group outside the home. Her school attendance was
sporadic and she found school dull and uninteresting. On
one of my many visits to her home, I had the following
conversation with her about school:

I asked her if she had gone to school today and she said yes. I
then asked her if she had taken final exams (it was near the end
of the semester) and she said, "I don't know. We've had a lot
of tests but somebody said we're supposed to have the end-of-
semester tests in two weeks but they gave us a lot of them last
week. I guess those were the ones we were supposed to have. I
don't know. . . ."

I then inquired about how she was doing in school, how she
liked it and so forth. She said, "It's all right but I don't care that
much for it." I asked, "What don't you like about school?" She
said, "I just hate to get ready to go. That's too early to get up
in the morning."

Liz was an integral part of her peer group, which con-
sisted of thirteen-year-old Kathy, fifteen-year-old Josie and
sixteen-year-old Frances. Most of her time was spent with
them at dances, parties, shopping and visiting them in
their homes. (All of the girls lived in the same building in
the housing project, and had grown up together.) One of
the activities which occupied a considerable amount of the
peer group's time was that of stealing clothing and other
items (those which were easily disposed of) in the large
department stores downtown and in suburban shopping
centers. I have already mentioned that Liz had a large
wardrobe that included many expensive articles of cloth-
ing. All of the girls in her peer group seemed preoccupied
with fashionable clothes and constantly sought ways and
means to obtain them. However, Liz stole in greater quan-
tity and higher quality than the other girls, and had

"taken" her entire wardrobe from two of the largest downtown department stores. (Infrequently she went to a few other stores.) In discussing these activities, she told me:

Well, I need clothes and things like that that my mama can't buy me. I remember when I first started stealing, the children at school and around the project had things that were much better than mine. I didn't have any shoes or any kind of good clothes and I started hearing children talking about stealing so I said, "Now I care about what they say about me when I start doing this but how do I know they haven't stolen what they have on? They might have stolen their clothes too." So I started stealing then.

She was able to rationalize stealing on the basis of sheer need and because she felt others might be doing the same thing. To Liz, this was not stealing so much as it was "taking" what she needed and could not otherwise afford. On one occasion she and one of her girl friends were caught and arrested. Their mothers had to get them out of jail and she recalled that she "tearfully" promised her mother that she would not steal again. After a few weeks, however, the activity was resumed. Mrs. Marshall probably got tired of asking Liz to account for all of the stolen items and started ignoring them. Most frequently Liz told her mother that the clothes were borrowed.

Liz continued to drift more heavily into these activities with her peers and to spend considerable time with boyfriends. School became less and less important and she soon found herself pregnant again. The second pregnancy was a jolt for Mrs. Marshall and Liz. Mrs. Marshall was not at all prepared for the arrival of a second grandchild born out of wedlock.

I asked her on the eve of the arrival of the birth what she thought about the new baby coming:

Mrs. Marshall: I don't know . . . I just don't know. I know the baby has been gotten and it should be born. I wouldn't let my

child do anything not to have the baby since she's gotten it, but all of us are concerned. I've got enough on my hands here as it is.

Interviewer: What do you want it to be, a girl or a boy?

Mrs. Marshall: I don't care what it is.

Interviewer: I probably wouldn't mind having a little baby.

Mrs. Marshall: Oh no you don't! No you don't! No you don't! No you don't! All children are a lot of trouble. It's almost impossible to take care of yourself, not to think of having to take care of little babies, because you have to feed them, you have to clothe them; if they get sick, you have to take them to the doctor, to the clinic or the hospital and it's just too much trouble. Maybe if you have a good husband who works and provides for you and your family, then, it might be all right. But as long as you have to go it by yourself—and you would be better off by yourself—without even having a husband, because even if you are married and you've got a husband who is a good provider, you don't need that many children; two or three would be fine; that's enough because you don't ever know what might happen. A man might walk off and leave you and the children after he's been good to you for many years or something might happen to him and you have to get out and take care of them yourself. And then too, you get tied down if you've got a lot of children. You can't go anywhere and you get old before your time. [Although Mrs. Marshall was thirty-three, she looked ten years older.]

Interviewer: Do you think this is what has happened to you?

Mrs. Marshall: Why sure I do. I know it happened to me because I had a fairly good husband; he would take care of us all, but he got tired and left and now I'm getting aid [welfare] for the children. I can't get a job because I have to stay here and take care of them. But when Liz has the baby I think I'll probably go back to work, because Liz will stay here and take care of them.

Interviewer: Does Liz plan to go back to school after the baby comes?

Mrs. Marshall: She says she does; she says she wants to go to school, she wants a job; I don't know what all she wants to

do, but I expect that I'm going to get a job and she's going to stay here and take care of the children.

Normally Mrs. Marshall was a pleasant person but this interview reflected a great amount of despair because it came on the wake of another crucial period in her life. She seemed to have felt that the birth of another grandchild was plunging her family deeper into the "troubles" they were experiencing. Her problems were endless.

Liz was undergoing similar despair. I talked to her on the same day the above interview was conducted with Mrs. Marshall and elicited the following response to my queries about the new baby:

Interviewer: Liz, what do you want, a boy or girl?
Liz: I don't want nothing. . . . I don't want no more babies; I don't care what it is; it can be anything it wants to be; I don't want it.
Interviewer:  Well, what do you plan to do with the child?
Liz: I guess Mama will put it on aid. . . . I want to go back to school. I also want to get a job working and get me some nice clothes. . . . I just don't know what I want to do yet.

There is basically no difference between the attitudes expressed by mother and child about the forthcoming baby and the additional burdens it symbolized. I have presented the detailed data on Mrs. Marshall and Liz (although the image of womanhood I am dealing with specifically is that which is portrayed by the daughter) because in both of them we can observe the impact that Mrs. Marshall's life has had upon her daughter—the intergenerational influences and the intricate interplay they pose in such a situation/family as this one. One cannot, therefore, describe Liz and the trend she is following at sixteen unless the continuous cycle that is passed on from generation to generation is also dealt with. Needless to say, Liz did not return to school and she took a job while her mother stayed home and cared for the three young children.[4]

[4] In 1970 Liz had given birth to her third child and was working as a maid in a hospital.

Liz did not become this way because her mother did not care, but rather because Mrs. Marshall was powerless and could not do better. There seems to be a perpetual cycle in this family, because I began to observe the formation of the same kinds of attitudes toward school, boys, peers, etc. in twelve-year-old Sue, the next oldest child. With the absence of viable role models, economic resources and internal discipline, Sue will probably end up like Liz. Unfortunately, Mrs. Marshall's family became disintegrated when her husband left, and she was unable to pick up the pieces by herself. This model of womanhood that Liz depicted represents many low-income Black women, but it is one which all of them have eventually come to represent almost by accident. It is impossible to say why some women succumb to these pressures and others are able to withstand them, except to say that some are stronger—physically and psychically—than others. The tragedy is that once the girls reach the level that Liz reached, and that her mother reached before her, there is almost no point of return. The cycle is rarely reversed. Only profound structural changes will eliminate the conditions which produce a Marshall family.

The last model of womanhood which will be described is a variation of that which is represented by Liz Marshall in that this girl has never experienced anything but stark, unremitting poverty and has *never* had any hope for anything that reaches beyond this kind of existence. This girl usually comes from a large family which has never had any of its members graduate from high school, has always lived below the median family income level of $3000 and suffers from the most harsh living conditions that result from poverty and discrimination. The cycle of poverty in these families has never been interrupted over all of their generations. The kind of hope that was present in the early stages of Liz's life, particularly as expressed by her mother, is never present in this latter group, and they represent the lowest rung of the socioeconomic ladder in the Black community.

It is difficult to make such fine distinctions among various models of womanhood, especially when they involve the single category of the woman who has none of the typical middle-class aspirations. For the almost single factor that distinguishes her from the girl who once tried but gave up is that she just never had any reason to try. I feel that there are many girls whose lives have not been sufficiently affected by social change in the Black community who represent this type. What one observes among this group of young women has its counterpart among the girls growing up on the plantation in the rural South. In a sense, they represent the transplanted "plantation" girl in terms of economic, social and political oppression. The effects of migration are quite apparent in such families because very little progress has been made by them to elevate their socioeconomic statuses and life-styles beyond those which they experienced in the rural South. Several decades ago E. Franklin Frazier described the effects migration would have upon Black families who are most representative of the girl who has never expressed aspirations for the "good life."

As long as the bankrupt system of southern agriculture exists, Negro families will continue to seek a living in the towns and cities. . . . They will crowd the slum areas of southern cities where their families will become disrupted and their poverty will force them to depend upon charity.[5]

During the course of this research, I met several girls who came from families that were chronically debilitated by the effects of racism. Although the debilitating effects had prevented them from expressing any desire for upward mobility, they had still made fairly successful adaptations to these forced circumstances on the most elementary level. (I only met one woman from 1964–68—about thirty-three years old—who was so overcome by these crip-

[5] E. Franklin Frazier, *The Negro Family in the United States*, Chicago, 1939, p. 487.

pling factors that she developed neuroses and was barely able to function.)

Mary Jane Johnson was an eighteen-year-old mother of two—two-year-old Phyllis, and Ray, who was a few months old. Mary Jane is the oldest of seven children. Her mother, Grace, heads her household and supports the family on $202 per month, which she receives from welfare. Mrs. Johnson's family has been on welfare for nineteen years. Mary Jane's two children and her sister's child are also supported in large part by ADC, although this income is supplemented by money they received from their fathers.

Mrs. Johnson came to St. Louis from Mississippi in 1935 and has not been back, although she vividly recalls her life there and reminisces about it.

I haven't been back there since 1935 but I have cousins and friends who go there and they tell me, "Grace, you wouldn't know that place now."

In referring to a nightclub in East St. Louis, she said:

The Top-Hat Club reminds me of [the clubs] down home in Mississippi. You can really have fun over there.

Another time she suggested that I spend July Fourth with her family because "Child, if you're down here with us, you'll have a good time *just like you do down home.*"

I recall my first impressions of the Johnson home, taken from my field notes.

The living room and kitchen were combined. Regular kitchen furniture including stove, refrigerator, sink and a kitchen table were situated in this area. In the living room a couch was situated beside the wall. The arms of the couch were made of some type of makeshift plywood or board. The couch was covered with a very used bedspread. I noticed about three or four chairs; one was cushioned and the others were padded. A dresser was also in the living room. About three different types of curtains were hanging at the windows of the living room-kitchen area.

I noticed a large dishpan of corn bread mixture sitting on the table. Also some silver cans whose tops had been removed were on the table. It looked as though these cans were used for drinking glasses.

Mrs. Johnson usually fed her family corn bread and dried beans or greens practically every day. Her small income was used to pay the rent, buy food and cover whatever other expenses she incurred. The family was on the perpetual brink of financial disaster.

Mary Jane appeared to be very timid, dull and totally without motivation. She had gone to a technical (trade) school, and indicated that she had graduated. (This was open to question because she did not appear to have much formal education.) She had her first child when she was seventeen and it was fathered by a forty-four-year-old married man. Mary Jane reported that after having an argument with her mother one day, she was walking down the street when she met this man.

I was coming down the street and he said, "Hey, girl." You know how these boys meet you on the street. I said, "What do you want?" and he said, "Come here, I have something to tell you." . . . He bought me an ice cream cone . . . and he went home with me. Then we started going together.

Mary Jane did not know at the time that he was married, and only learned so after the birth of her child. She said he agreed to buy the clothes for the baby when he learned she was pregnant, and now gives the baby $10 per week, half of which is given to her mother for food and rent.

Her second child was born less than two years later. Again, her acquaintance with her son's father took the same form as the meeting with the man described above.

One Saturday I was going up to the grocery store and he was coming across the street and you know men meddle. He said, "Hey, lady, don't I know you from somewhere?" So I didn't know. He asked me where was I going. I told him I was going to

the store. He said, "Are you going to get a whole lot of groceries?" and I told him yes. So he asked me what did I drink and I told him beer. He went and bought me eight cans of beer. We went on to the grocery store and met my mother and I told her me and this guy had met. So he asked her could he carry the food home and she said yeah. Then he started coming to see me every day.

Mary Jane started dating this twenty-seven-year-old man, who she later learned was also married. She became pregnant soon after she started dating him and acknowledged that she wanted to marry him but he didn't have his divorce yet. She seemed to have been waiting for the divorce because she expected him to marry her and provide her and her children with a home once he got the divorce.

As I became more familiar with Mary Jane, she seemed to have been searching for someone to relate to, and became very close to anyone who paid some attention to her. I think part of this can be explained because of her problem of being overweight and fairly unattractive. The problem also resulted from her mother having made it clear that her seventeen-year-old daughter was her decided "favorite child" who received all the favors, which included baby-sitting, allowing her boyfriend to live with the family whenever he wanted to, etc. Mary Jane had a very difficult time in the home and turned to other people for emotional and physical security when she could not find it within her family.

She also represents a pattern that has been set in her family. Her mother has received welfare for nineteen of her thirty years in the north. (Mrs. Johnson is no more than fifty.) Most of her children have spent the greater portion of their lives in the housing project, and all of their lives have been spent in substandard housing in low-income neighborhoods. Mrs. Johnson had all of her seven children by two husbands, one legal and one common-law. Both her oldest daughters had already given birth to children without being married (one at sixteen and one at seventeen). Some of the cycle that is involved in this family's

northern poverty-ridden experience, especially as it relates to that which the mother has undergone, can be observed in an analysis of a field report by Lee Rainwater in an article entitled "The Crucible of Identity: The Negro Lower-class Family."

When the argument started Bob and Esther were alone in the apartment with Mary Jane's baby. Esther took exception to Bob's playing with the baby because she had been left in charge; the argument quickly progressed to a fight in which Bob cuffed Esther around, and she tried to cut him with a knife. The police were called and subdued Bob with their nightsticks. At this point, the rest of the family and the field worker arrived. As the argument continued, these themes relevant to the analysis appeared:

1. The sisters said that Bob was not their brother (he is a half brother to Esther, and Mary Jane's full brother). Indeed, they said their mother "didn't have no husband. These kids don't even know who their daddies are." The mother defended herself by saying that she had one legal husband and one common-law husband, no more.

2. The sisters said that their fathers had never done anything for them, nor had their mother. She retorted that she had raised them "to the age of womanhood" and now would care for their babies.

3. Esther continued to threaten to cut Bob if she got a chance (a month later they fought again, and she did cut Bob, who required twenty-one stitches).

4. The sisters accused their mother of favoring their lazy brothers and asked her to put them out of the house. She retorted that the girls were as lazy, that they made no contribution to maintaining the household, could not get their boyfriends to support them by taking them to court, and Esther threatened to cut her boyfriend's throat if he did not co-operate.

5. Mrs. Johnson said the girls could leave if they wished but that she would keep their babies; "I'll not have it, not knowing who's taking care of them."

6. When her thirteen-year-old sister laughed at all of this Esther told her not to laugh because she, too, would be pregnant within a year.

7. When Bob laughed, Esther attacked him and his brother by saying that both were not man enough to make babies, as she and her sister had been able to do.

8. As the field worker left, Mrs. Johnson sought his sympathy. "You see, Joe, how hard it is for me to bring up a family. . . . They sit around and talk to me like I'm some kind of dog and not their mother."[6]

This incident occurred during the presence of another field worker who had close, sustained contact with the same family over a long period of time. It symbolizes the multiple problems that underscore their day-to-day existence. The problems of identity, womanhood, economics, violence, etc. are themes which were constantly raised. These were problematic to Mrs. Johnson, and would certainly be viewed in the same context by her children as they became more mature and approached womanhood and manhood.

Mary Jane's life as an eighteen-year-old mother of two must be placed within the context of this family structure. The most dismal glimpse of her future would tell us that the perpetual cycle of poverty which her mother experienced as a child growing up in rural Mississippi, and which she was undergoing as a mother of seven children in the urban North, would be experienced by her oldest daughter. Mrs. Johnson had never hoped for education, money and the "good life" because she was never exposed to it; she never had adequate motivation, role models, economic resources and the like. Unfortunately, she is unable to provide these for her children.

Thus, coming into womanhood for Mary Jane means the same as it meant for her mother several decades ago. The scant resources have not improved to the extent that Mrs. Johnson can teach her children to aspire to finish high school, or for that matter, even to go to school. Education

[6] See Lee Rainwater, "The Crucible of Identity: The Negro Lower-class Family," in *The Negro American*, Talcott Parsons and Kenneth Clark (eds.), Boston, Houghton Mifflin Co., 1965, pp. 201–2.

was denied her and even though she knows its value, it is no more than an abstraction for her. Perhaps she cannot teach what she has not experienced even on the vicarious level.

It has been demonstrated in this chapter that there is no single route to becoming a woman. The different resources that are required, including role models, economic stability, family and community traditions, inner resourcefulness, i.e., values, determination, motivation and a variety of other mechanisms and factors determine the way in which a girl conceptualizes womanhood and the way she will be able to achieve it *behaviorally*. The mutliplicity of factors involved in these different images of womanhood should enable us to destroy our "monolithic" concept of Black womanhood.

Although there is a diversity of conceptualizations of what kind of woman one should become and the accompanying behavior that enables one to become that kind of woman, there are, however, a set of commonalities that aid in molding each girl into what can be referred to as "Black womanhood." These girls are influenced by a set of traditions, a common value system and a set of beliefs that, although varying from group to group, are still shared to some extent by all of them. Their aspirations for being the hard-working backbone of the family, for children, for an education and for a kind of spiritual quality of empathy —the ability to understand and develop the necessary resources to fight oppression and make healthy adaptations to what are sometimes overwhelming circumstances—are common features. It is only in the "downtrodden," hopeless cases that we can barely recognize these strengths to exist.

Even in the latter cases, there is much reason to hope that their lives will change. For them to continue to *live* and fight for survival on the most minimal level is a quality which should be admired. One must note that for them to continue to live and not attempt to cut off that process through suicide—for suicide to them is the ultimate

weakness—indicates the presence of some strength, some resiliency in the face of overwhelming obstacles. To give even lip service to the ideals of the "good life," however defined, and to attempt to attain these ideals even in the most minimal way in the face of the *odds* described, indicates the existence of some determination, some inner strength, some ray of hope, even though appearing small —and above all, some will to survive.

Therefore, it could be that if some means of achieving a *breakthrough* against those seemingly insurmountable odds were to occur, some motivation and new hope would appear, especially among the young. This would be true for women if they could find the *right* man, and vice versa for men under similar conditions.

As a Black person committed to social change, I refuse to surrender the last glimmer of hope for the hundreds of thousands of Black men, women and children who appear to have lost incentive to continue to strike out against oppression. Many seem to be finding that sorely needed *motivation* and *hope* within various organizations which are designed to encourage political expression and also enhance one's individual feeling of power over his destiny. The National Welfare Rights Organizations and scores of other grass-roots nationalist organizations have begun to serve as the vehicle through which the assumption of power over one's destiny takes place. This trend was started on a broad scale in the 1960s with the advent of the civil rights movement and the war against poverty, and will continue, on greater scale, in the decade of the seventies.

Unless Black men and women are able to create within themselves and for each other the *hope* from despair, the neo-colonialist forces will continue to destroy those who do not have the overwhelming resourcefulness to survive the systematic lethal attacks. Even Mary Jane Johnson and Elizabeth Marshall can realize the "good life," providing all the resources of the Black community and others are united to ensure their survival.

*Becoming a Woman: Part I*

Becoming a woman means many things to many people including the time when one gets married, becomes self-supporting either while remaining in one's parents' home or by leaving home, being liberated from parental controls without the security of being economically independent, the onset of menstruation, having premarital sexual relations and having a child. In some tribal societies, a girl experiences formal puberty initiation rites at the onset of menstruation and makes the sharp move in status from that of *childhood* to *womanhood*. No carefree period of adolescence is experienced.

When one talks about becoming a woman in the Black community it must be considered in the context of how and whether or not one actually achieves the goal. Here is where we become interested in the difference between opinion and practice. While these girls are affected and influenced by the legal prescriptions of the larger society (becoming grown at eighteen or twenty-one), they have also absorbed the community's prescriptions as well. In a sense, they are caught between two worlds—the Black community and the larger society. I will demonstrate how they mediate diverse sets of definitions and the processes they undergo in deciding which course they should take in their own lives.

ONSET OF MENSTRUATION

The first symbol of womanhood comes at the time when
girls experience menstruation. The onset of the menses
is defined technically as the period when the girl is able
to conceive—to bring forth life. The attitudes that mothers
hold toward their daughters at this time are very similar
to those held by African parents whose daughters experi-
ence puberty rites. For a great many mothers, the onset
of the menses is the *rite de passage* from childhood to
womanhood. For others, it is the first stage of the long
process that has its culmination several years later. For all
parents, however, this is an important period and the at-
titudes they hold toward their daughters change, as will be
illustrated below. Even though there is a recognition in
the change of status, many mothers find themselves unable
to discuss this topic freely and often fail to provide the
necessary information about the meaning of menstruation
until the girl asks for it. The imparting of this informa-
tion frequently came from the females within the
family including the mother, grandmother, sisters and
aunts. At other times, however, female peers were called
on to explain these physiological processes, and were able
to do so with far more ease than mothers, but with less
credence, however. The sensitivity of the topic, as it relates
to the way the discussion of sex is held in abeyance in this
society, is the reason many mothers found it difficult to
engage in frank discussions about it. Miriam, a seventeen-
year-old, describes the "folklorish" manner in which this
process was defined by her mother and grandmother.

Mother told me that the monkey was going to "split his tongue"
one of these days and he was going to bleed. That is how she
used to explain it to us [her sister included], so I started looking
for my monkey. . . . I was about fifteen. At first I was kind of
scared because I thought she was talking about a real monkey
that had cut his tongue out. I didn't really know what she was

talking about at first. . . . That is the way old people explain it. My grandmother told me the same thing when I was fourteen.

Undoubtedly this is deeply rooted in the folklore of the Black communities in which Miriam's grandmother and mother grew up. Carol, a seventeen-year-old, recounts her experiences:

I was down South with my sister. She told me what it was when it started but my mother told me about it before then. I was about eleven years old. My sister told me it would come every month and be careful and don't do certain things . . . don't play around with boys.

The theme of "keep your distance from boys" was expressed by a number of girls. Cynthia, a sixteen-year-old, stated:

My mother told me that if I ever did anything with a boy after I started, my menstruation cycle would stop for nine months. . . . Girls should talk to their mothers about these things because they have gone through these stages. Friends don't know enough about life to tell you what to do and what not to do.

Janice, a seventeen-year-old married girl, encountered a traumatic experience:

My mother told me . . . not to let a boy touch me or I would have a baby. And I always thought if a boy touched my hand I was pregnant. . . . One day a boy bumped against me. I was scared. I went home and laid in bed and I said, "Oh Lord, I'm pregnant."

Many girls considered the onset of menstruation as a traumatic event, where they expressed fright and a general uncomfortable feeling of not knowing precisely what was happening to their bodies. After the effects had passed,

they became more cognizant of the change in status, and begain to redefine their relationship with boys. No longer could they perceive boys in the same manner as they had as preadolescent peers because *boys could now make them pregnant.* They also began to understand that they could enhance this process by the way they related to boys, i.e., they could be the aggressors or co-operate with boys and become pregnant partly by their own attitudes and activities.

This probably symbolizes the first concrete or distinguishing factor in the total process of becoming a woman. As a beginning point in this sometimes long process, it seems to leave an imprint on their minds because of the psychological and physiological changes involved. The physiological changes are clear: One is reminded monthly that, theoretically, she can conceive, that she can bring forth life, and for the overwhelming majority of these girls, having a child means that one has become a woman. The psychological changes are very important because the basic redefinition of her status from that of *childhood* begins to take form. She is on her road to becoming a woman. Indeed, for some parents, she is a woman because, theoretically, she has the same reproductive powers that adult women have.

INTERPERSONAL RELATIONSHIPS

The young woman growing up in the Black community views the world from a feminine perspective after she learns that she should relate to boys on a different level than the way in which girls relate to each other. The quality of her interpersonal relationships begins to assume a feminine form in a number of specific ways, especially as it relates to males. She learns that becoming a woman has a variety of meanings and requirements, among which are certain styles of etiquette that she must adopt. There are certain normative behaviors they must adopt and practice in order to be successful in the womanly role.

They are learned both formally and informally. That is, in a formal sense they are taught specific ways to behave as young women. Mothers regularly tell their daughters that "young women behave in this manner and do not act that way because it is not fitting." An example of this is the following. The mother of Margaret (Mrs. Lester) always carefully observed Margaret's social decorum, grooming habits and so forth. Whenever a visitor (including myself) came to the house, she overtly cautioned Margaret and her younger brother to "act like women and men." Other mothers took an equal amount of interest in their daughters' projecting the proper "ladylike" image. (This was discussed in the section on "Femininity" in Chapter Four.) Informally the process of learning the appropriate behavior for womanhood is primarily one of observing ways in which women behave (role model).

Girls realize early that one of the ways to achieve the status of a woman is to learn the more complex game that is involved in interpersonal male-female relationships. There are appropriate things to say and ways to behave at appropriate times in the interchange of communication and contact. The way one begins to perceive the different kinds of men in one's environment begins to take a sharp and concretized form.

Men play an important and sometimes decisive role in the girl's process of emerging womanhood. A great portion of the interpersonal contact that is important to achieving the womanhood status occurs with men. It is the male who helps a girl affirm her womanhood. Her ability to measure up to the standards that he sets for her is considered a major accomplishment. Prestige is often derived from high evaluations of femininity and womanhood made by men. Men also serve as elements in facilitating the girl's becoming a woman when the evaluation of her status is made by other women (adults, peers, older siblings) and not just in the sense that men do the judging, measuring and evaluating. The way in which a girl is able to interact in her relationships with men, whether

she is innocent, detached or whatever, is an item in other girls' evaluation of her.

One of the key determinants in the quality of interaction between girls and males was their own self-perceptions, based upon what their goals in life were. Men were perceived, in the broadest categories, as *good* or *bad*. One observed, however, a wide variation of the *good* man and the *bad* man. It is the good boy, girls are taught, who can be trusted to be nice, "decent" and protective. The bad boy, on the contrary, frequently poses problems for them because they cannot always be trusted, and their maturity and "worldliness" are sometimes the cause for many hardships which she must endure (frequently pregnancy). Sometimes, however, the more worldly males were sought after by girls who felt that they could handle them and perhaps also felt that they could enhance their feminine status by being able to deal with the mature (and sometimes) manipulative male.

There were basically two types of girls, as these related to perceptions of one's relationship with males. First, there was the childish girl who had a strong quality of immaturity, especially as it related to the unpleasant circumstances which confronted her in her day-to-day existence. She usually approached her relationships with boys in a sincere manner, expecting them to reciprocate in a similar fashion. the second type of girl was more sophisticated in her view of the world and in her relationships with men. Honesty was sometimes practiced and sometimes not. Rather frequently she engaged in manipulative strategies as they became necessary in her interpersonal relationships. Her negative experiences with the mundane end of her immediate environment were accepted as factors that must be reckoned with because of their inherent nature. She had learned the rules of the game and devised her own strategies to cope with what was often a hostile world. For each type of girl there was a different kind of adaptation to the norm of knowing how to interact with members of the opposite sex. The girl who still possessed

the childish quality usually approached her relationships with boys with a quality of innocence and more often engaged in daydreaming about her "romance" than the more mature girl. This daydreaming was very similar to fantasy, for these girls often sought to "beautify" their worlds by creating illusions about their existence.

Because the childish girl was still in the process of becoming a woman and did not consider herself to have learned all the rules of the game, she was often more vulnerable to suffering the pain and trauma that sometimes results from the unfaithfulness of boys. These girls seemed to feel that they were often more faithful to their boyfriends than their boyfriends were faithful to them, but were still less realistic in their relationships than the most mature girls. The immature ones were also those girls who, for a variety of reasons, elected to play an "immature" game, which does not mean that they are necessarily immature. A major factor that determined their behavior with boys was the degree to which they felt committed to achieving a certain model of womanhood. Thus, girls who had decided that they were going to become teachers, nurses, secretaries and the like were prone at least to act as though they were immature, and to adopt an innocent quality about their relationships with males.

Most of the sixteen-, seventeen-, and eighteen-year-olds clearly understood, for example, what risks were involved in engaging in premarital sex and had a sophisticated understanding of boy-girl relationships on this level. But they often flatly refused to discuss sex with boys. Gwen, a sixteen-year-old, told me that, "Mama says, when a boy wants to talk about sex with you, ask him if he is ready to get married."

It is probably this special quality of being able to project an image of innocence (they were indeed innocent girls) and to maintain certain standards with boys that allowed them to continue to strive toward achieving their goals in life.

Nevertheless, there is a difference in the way girls in

the two broad categories interacted with boys, as well as the perceptions they had toward the kind of man with whom they eventually wanted to establish a stable relationship. It is important to understand what their aspirations were, in the context of the way they perceived their present relationships with men. Most often, their present quality and level of interaction was determined by the kinds of goals to which they were aspiring. Thus, girls who had middle-class occupational and marital goals, for example (to become a nurse and to marry a doctor), had learned, by the time they reached their mid-teens, that these goals would be obstructed if they acted too "grown up" with boys. This was by calculation and design more than by accident. As a result, they sought the "good man," who was usually described not only in terms of his middle-class occupation, but in terms of his character. He was one who exemplified the qualities of honesty, strength, endurance, faithfulness, congeniality and hard work.

It was easier to gauge their present perceptions of their relationships with their boyfriends by asking them to address themselves to future roles with men, since I felt that the future projection was a major determinant for present behavior. In other words, they were following a present course of action that would ensure success. When asked, "What kind of man would you like to marry?" some of the typical responses were the following:

An eighteen-year-old said:

I like a nice easygoing young man, have a job, like to go out and have fun, love his children, participate in his children's activities, like his sons—take them swimming, play baseball, talk to their daughter, tell them what's right from wrong, treat your kids equally, love both of them the same, I mean all of them the same, understand your wife, give her respect, if you're going to do anything don't let her know nothing about it, and don't come home and get mad at her just cause somebody in the street made you angry, don't come home and take it out on your family, and the family comes first before anybody else.

A quiet sixteen-year-old said:

[I would like to marry somebody] strong who can do things on his own and have a nice job.

A serious fifteen-year-old:

I wouldn't like for a man to be jealous. I would want a person who likes to have fun. I wouldn't like a person that would drink too much and has a quick temper and don't know how to come home from work and stay out in the streets and everything, one who beats on his wife. I don't like no person like that.

After having given a description of the kind of man she would not want to marry, I asked this girl what kind of a person she desired:

I guess I would like a person who would be a father to his children and not have the mother be the father too. I want someone who would take care of the household bills and wouldn't have to be in debt, a man who has time for his children and not put all the money on drinks and all that stuff. He would know how to bring money home.

A fourteen-year-old who describes herself as "sometimey":

[I would like to marry] a doctor or a teacher. I would mostly want to marry a doctor because if anything happened in the family he could probably help them before you get to the hospital or something like that because it could be an emergency. . . . I just like teachers.

A very amiable sixteen-year-old:

I'd like to marry an ambitious, intelligent, understanding man and not a person that I can tell something and he can talk about it and not just say what do you think. I want me and my husband

to talk about anything and we could do anything and be happy. We would just be so much alike that we could probably even pass for sister and brother. . . . I want a husband that can support me and my children without having us go through a great strain. . . .

Finally, an unassuming fifteen-year-old:

[I want a man who is] tall, handsome, one that I know will work and take care of me, that will not beat on me all the time and that will pay the rent and all that.

These are illustrations of their desire to marry men who fit the model of an ideal mate by any female's standards: protector, supporter and companion. The wish was often to find a doctor, lawyer, teacher, but more often they were willing to settle for a man who might be a non-professional but a good provider, such as a brickmason or carpenter. These conceptions of one's future life weighed heavily upon their images of men as being *good* or *bad*. Boys who were headed toward successful careers and who possessed "character" were not always available, and some girls did not have boyfriends because of this reason. They made deliberate attempts to avoid men who were aggressive, unstable, temperamental, unfaithful, jealous, brutal, lazy and drunkards. Men who followed these patterns were the types that many of the girls had had associations with on the personal and vicarious levels. These associations acted to reinforce their desires to evade such men when looking for potential mates. And for those girls who had found the ideal boyfriend, the relationship proceeded on a level that would virtually ensure her of not having a premarital pregnancy and other major problems that would hinder her from accomplishing her goal.

The mature girl is one who has, for a variety of reasons, chosen to interact with boys in a fashion akin to adulthood. Some of these girls could be considered "fast," precocious, and others are ordinary girls who have learned

how to become women because they were forced to (when they became mothers, etc.). Such a girl often took pride in displaying her ability to deal with the rougher, more discomforting areas of her life. Men frequently posed no special problem to her because she had learned the strategies involved in coping with whatever problems her relationships presented.

Another important dimension to understanding the way she interacts with males has to do with her conception of them. She is perhaps far more realistic about what her chances are for upward mobility—for her own career and for marrying an upwardly mobile man—and has resorted to living on what she feels is within her boundary of realistic expectations. From roughly age sixteen (sometimes fifteen) to eighteen, many of these girls experienced a great degree of disillusionment with life in general. It seems that as they grew older their attitude toward men became more ambivalent. (This was true to a small extent for those girls I have classified as less mature.) Such perceptions obviously determined, to a great extent, the way they interacted with men. Their belief that only a small number of men could be depended on to fulfill their aspirations for a stable marriage and family life came from their vicarious experience with men as abandoning fathers and husbands, runaway brothers-in-law and so on. The idea that men are weak or impulsive was formed very early. In a study with preadolescents in the same community it was found that some young girls had firmly established the idea that men are "no good" by the time they were eight years old. These young girls had observed interpersonal conflicts between adult males and females in their homes and in the families of other relatives and friends, and had based their conclusions on the same.

This attitude can also be analyzed by taking into consideration the fact that these girls have achieved a degree of understanding of what their environment is about—its strengths, weaknesses and limitations—that has allowed them to transcend an acceptance of the stereotypes that

are applied to the low-income Black males. Perhaps it is their understanding of the role the racist society plays in keeping the male in a perpetual state of subordination that causes them not to "dream" and hope for the right kind of boyfriend, who, to them, does not exist. His non-existence is based upon their knowledge that few men around them can transcend the effects of the system and become the ideal models they desire in a companion. Thus, they observe the weaknesses and flaws in the social system that are manifested in the men they know. His weaknesses and impulsive moods do not represent imperfections in him which she holds him responsible for as much as they do the imperfections which have been cast upon him. In this context, one can understand why girls hold ambivalent attitudes toward males. On the one hand, they see them as weaklings who cannot provide adequately for them, and as *bad* influences on them who can get them in trouble. However, they also embrace these same males because of the reasons I have described that are endemic to the social system. On a purely practical level, these are the only men around for them to date.

The quality of interaction with males is based upon what was described above. This necessarily calls for more intense relationships because the boys are usually older (late teens to young adult) and are not geared toward becoming upwardly mobile, although this is not always the case. Their expectations of the girls frequently involve premarital sex, to which some of them submit. Boys are also taken more seriously in a way that the less mature girls do not subscribe to. That is, the obligatory demands that the boy and girl in this type relationship place on each other are fairly serious. This girl is more prone to try to please her boyfriend, sometimes regardless of what his requests and/or demands are. He frequently attempts to do the same for her. In a sense, this type of relationship approximates engagement or marriage in the larger society. I knew some couples who were only courting but their courtships resembled engagement, and in a few in-

stances marriage, because of their deep involvement with each other. Fifteen-year-old Ethel's courtship with her fifteen-year-old boyfriend was one such intense relationship. When I met Ethel she had recently dropped out of the eighth grade because of pregnancy. Her boyfriend of almost a year remained in school after she became pregnant, but worked evenings in a concession stand at a large sports arena. During the summer when school was not in session, he would come to her home in the morning (10 or 11 A.M.) and stay until the late afternoon, when he had to report to work. He often came back to her home after work and stayed until midnight. He gave her part of his earnings at each pay period. Ethel reported that when he was not at her home, they talked over the phone. She frequently visited his home, and both families were looking forward to the birth of the child. However, she did not feel that she was ready to marry because she considered herself "too young." Her fifteen-year-old boyfriend took pride in the fact that he was about to become a father and promised that he would "take the child from her" if she ever left him. In spite of the fact that they were only fifteen, and would be considered children by their own parents, to some extent, they were still fulfilling adult roles. Thus, another step toward achieving womanhood is reflected in the way the adolescent Black girl begins to perceive and respond to males. These perceptions are used as mechanisms for socializing her into womanly roles.

## LIBERATION FROM PARENTAL CONTROLS

For every female in American society beccoming a mature woman means being able to cut oneself off, to varying degrees, from parental controls. Females are declared legally grown when they reach age eighteen. Becoming a grown person is determined not only by age but by other factors such as comparative responsibilities, resources, power in relationships and the like. However, this norm often takes different forms within families, cultures and other groups.

In the low-income Black community, parents are more prone to follow the traditional pattern of declaring the girl grown when she reaches eighteen, except when the circumstances which allow for the official entry into womanhood occur earlier. (The circumstance that most often allows for an entry into womanhood is having a child. For an elaboration refer to "Becoming a Mother" in a later part of this chapter.) For parents in this study becoming eighteen did not automatically mean that daughters were free to act as they wanted. Some eighteen-year olds who lived at home adhered strictly to the rules of parents, while other fourteen-year-olds were permitted to supervise their own lives completely by coming and going when they pleased, selecting their own friends, etc. It does appear, however, that all parents felt that should it become necessary they could exercise the ultimate control over their daughters so long as they remained at home. Usually, when a girl reached eighteen parents came under considerable pressure to relinquish their controls. This occurred more often in those situations where the girl had left school and taken a job or had some other means of support (boyfriend, Aid to Dependent Children).

Although parents usually adhered closely to the legal norm described above, girls unanimously felt that maturity came at eighteen or earlier and that parents who denied them the privileges of grownups were treating them unfairly. For some girls there was no compromising on this point and it was the source of much intergenerational conflict. An illustration of this conflict can be viewed in the case of eighteen-year-old Miriam, who was the oldest of two children. Miriam lived with her mother intermittently, spending some time with friends, an aunt and other relatives. Her mother, a chronic alcoholic, received an A.D.C. welfare allowance and a small but steady amount of money from a long-term boyfriend. Although Miriam acknowledged the sources of income for the family, she maintained that she did not receive any of it. Her grandfather in southeast Missouri, and occasionally her aunt and her boy-

friends contributed to her financial support. Miriam had found it difficult to get along with her mother for several years and the conflict in their relationship had intensified over the past year. When Miriam turned eighteen, she announced to her mother that she was no longer obligated to "mind her" because she was grown. To Miriam this meant coming and going as she pleased or not coming home at all. She had already started on this course of action before reaching the legal age she felt necessary. When her mother protested, she became more defiant by leaving home and staying away for weeks without allowing her mother to know her whereabouts. However, she would stop by her mother's home occasionally to visit her younger sister, but refused to tell where she lived. (She was usually at a girl friend's home.) She finally agreed to return home after her mother took the position that she was indeed "grown" and there was nothing she "could do with her" because she was eighteen. Miriam moved back home and behaved in the manner she desired.

Although Miriam's behavior was somewhat extreme, other girls have exhibited similar behavior by openly and continuously defying parental authority. Frequently the conflict reached the stage where parents either submitted or the child left home. Rarely did the girls completely submit. Sometimes they showed outward signs of submission but used any opportunity they had to carry out their desired activities in secrecy. An example of this behavior is that of seventeen-year-old Janice. She reported that her mother was so strict that she often resorted to falsely accusing her of engaging in premarital sex with boys on her way home from school. Janice said that she eventually tired of these accusations and stopped attempting to defend herself. Instead, she showed stronger outward signs of submission to her mother's biblical teachings but also started having premarital sex with her boyfriend in an effort to get back at her mother. She eventually married him and became pregnant after the marriage occurred. So in a sense the girl usually won the fight even if it meant that she

had to leave home to do so. There were a few exceptions where the girl who reached eighteen continued to follow the dictates of her parents so long as she lived with them. This usually involved the less rebellious-type girl who felt that her parents knew what was best for her. Since only a minority of the girls were eighteen, it was not possible to observe what had happened to them once they became "grown" in their relationships with their parents. Therefore, I resorted to observing trends of sixteen- and seventeen-year-olds, and the attitudes they were forming about becoming grown at the so-called legal age.

The girls who considered themselves more mature and deserving of their freedom often accused their parents of not wanting them to grow up. A conversation with five girls illustrates this sentiment:

Interviewer: What are some of the problems teen-agers have with their parents?

Respondent: Another problem with some of the parents is you can't reason with them. They think you're getting smart if you try to reason something out with them and get an understanding. Like if your mother tells you you can't go out one night and you ask her why, they'll say, "What are you talking about why?" They start getting mad and fussing and everything. *They don't want you to grow up.* I'm eighteen but my mother still treats me like I'm eleven.

Interviewer: Why do you think your parents don't want you to grow up?

Respondent: I guess they feel as though they're losing their family. Like my mother, one day she'll tell me to get out and the next day she'll tell me what I'm going to do around the house and everything so I don't know what's wrong with her. (Emphasis added)

Perhaps the statement above referring to parents feeling that they are losing their family is very important in explaining the attitude they sometimes take about granting

"grown-up" privileges to their daughters who have reached the legal age for maturity. For many mothers, children offer a sense of fulfillment, security and consolation, especially those who are serving as both parents in the absence of a husband. Therefore, such mothers cling to their children because they fear additional losses; they have experienced losing husbands and other significant individuals in their lives; to give up the child before it becomes absolutely necessary might be too great an expectation. This clinging is not only to be viewed in this somewhat "selfish" context, but also in terms of the value children hold in the family. The mother who doesn't want to see her "child" become a "woman" is also oriented in a tradition that holds children at the center of the society and does not want to relinquish the control over the valuable child until she feels that the child is prepared to handle the world she is about to face.[1] Thus, one observes a certain degree of protectiveness in this attitude toward children.

Liberation from parental controls means that the girl is able to do more than come and go as she chooses. It means that she has the freedom to make other important decisions about her life: decisions about whether she should stay in school, take a job, get married, have children, aspire for a successful career, smoke, drink alcoholic beverages, and perform other significant actions which must eventually be dealt with. Liberation for the girl also means being able to make the ill-fated decision. Many felt, for example, that they should be free to decide whether or not they wanted to become involved with a male who was held in ill repute in the community or to decide if they wanted to have premarital sex without being told by parents that they could or could not. They frequently complained that their parents refused to allow them to exercise their own judgment in these affairs.

A certain degree of rebelliousness was required if one

[1] The child-centered culture will be discussed more fully in the section in this chapter which deals with "Becoming a Mother."

was set on being released from the constraints of parental
dictates. It meant that the girl had to decide that she was
going to go against some of the wishes of her parents if
she felt she should do so. The source of this rebellious
attitude was sometimes rooted in a concern that she was
not getting all out of life that she should be getting, that
she was missing out on some of the fun that some of
her peers were having. It also came from a feeling that
perhaps parents don't always know what is best because
they are "old-fashioned" and do not know what is in vogue
with the current generation. These are age-old problems
that are not peculiar to these girls. Indeed, many of their
own parents experienced the same problems when they
were growing up.

There were varying degrees to which parents allowed
their daughters this desired liberation. Sometimes parents
conceded to their daughter's wishes in one area but main-
tained control over other areas of her life. An example of
this discontinuity was in the life of Ruby, a sixteen-year-old
mother, who resided with her mother in the housing proj-
ect. Ruby became pregnant by a Mexican-American boy
(Black mother and Mexican father) who was about eight-
een. She took a job as a file clerk in a factory and returned
to night school. Her mother accompanied her to the local
Planned Parenthood office for a prescription of birth con-
trol pills after her child was born, allowed her to smoke
openly and to entertain her boyfriend in her bedroom. She
and her boyfriend ritually took the baby to visit his mother
each Sunday, and in many ways Ruby's behavior was very
grown up. One got the impression that she and her mother
were, on occasion, peers because of the strong rapport they
shared and the laxity of her mother's regulations over cer-
tain facets of her life. This was very superficial, however,
because as I came to know Ruby I began to understand the
discontinuities that existed in her mother's controls. She
was very rigid in a number of important areas. For example,
she was very insistent, and uncompromising, on Ruby re-
turning to school. (After the birth of the first child, many

parents don't expect the daughter to return to school.)
She was equally insistent upon knowing Ruby's where-
abouts at all times. (Ruby reported that she became preg-
nant while engaging in premarital sex in her home and
would have found little time outside her home to spend
with her boyfriend in that way.) The rationale Ruby's
mother offered for being strict on her movements was that
of wanting to keep her from associating with the wrong
people and of protecting her from the harmful environ-
ment. In my initial visit with Mrs. Barnes she said:

Ruby has to be in by 10 P.M. She doesn't come in any later than
ten. . . . I'm really afraid to let them [her niece and nephew in-
cluded] stay out that long. . . . The teen-agers don't have any
place to hang out except in the halls and all sorts of things go
on in those halls. I don't like living here and I'd like to get out
as soon as possible but I just don't know when that will be.

I suppose Mrs. Barnes saw no discontinuity in her child-
rearing patterns since she viewed the outside environment
in such a hostile manner. Her own home, she probably
felt, was a better place for her daughter to entertain her
boyfriend, even if she made the mistake of premarital
pregnancy, than the hostile outside world. Ruby is caught
in midstream between becoming a woman and remaining
a child. For many parents, the line of demarcation is much
clearer. Having a child is a sufficient prerequisite for ac-
ceptance into womanhood.

The autonomy girls sought from their parents was based
upon the assumption that they were indeed ready to as-
sume much of the responsibility for their lives. This as-
sumption was not always carried out because many of
them were not yet able to function in the world alone.
They still needed some of the resources their parents pro-
vided. This was especially true for the girls who remained
in the home with their parents after declaring that they
were grown and should have the privileges that are af-
forded adults. Perhaps one of the signs of one's ability to

make it in the world without the aid of parents is when
the girl leaves home. Only a small number of girls are in
this category because this meant that they were, realisti-
cally, able to cut themselves off from parental support.
(This support sometimes included very few tangible re-
sources but was more recognizable in the non-material
form it assumed.) Many girls talked about leaving home,
getting their own apartments and jobs and, in effect, set-
ting up their own households. But few of them ever real-
ized these goals because they were unable, physically and
psychologically, to cut the ties at age sixteen and seventeen.
(One fourteen-year-old mother attempted the same by
apartment and job hunting, but to no avail. She was forced
to remain at home with her parents. However, I do feel
that she would have been able to "live alone," independ-
ently, had she been able to overcome the two major
obstacles of finding a job and a house, because of her
maturity.) This is evident also in the number of girls who,
after having their first child, remain in the home of their
parents instead of setting up their separate households.
Thus, the final symbol of one's liberation from parental
controls is the ability to leave home and take care of one-
self. This does not include those girls who leave and at
some later point are forced to return because of unex-
pected hardships.

PREMARITAL SEX

An important way of understanding how womanhood is
perceived and attained is by comprehending the meaning
premarital sex holds for these girls. Premarital sex, in con-
ventional society, has always been a controversial topic.
Traditionally, American society has prescribed certain reg-
ulative norms that govern sexual behavior. Reiss outlines
four premarital sexual standards that are predominant in
this country: (1) ancient double standard, (2) permissive-
ness without affection, (3) permissiveness with affection,

and (4) formal single standard of abstinence.[2] In commenting on the ancient double standard that exists in many parts of the world Reiss writes:

The double standard in premarital sexual behavior is obvious in our norms which state that premarital coitus is wrong for all women, and thus women who indulge are bad women. Premarital coitus, however, is excusable, if not right, for all men, and thus men who indulge are not bad men.[3]

The double standard, although not so widely accepted now as in former times, is still accepted among a sector of the population, and is practiced in other areas as well. For example, much of the concern of the feminist movement is directed toward abolishing the barriers that produce inequality between men and women in the various professions. The weakening of the double standard has been attributed to the revolution that has taken place in America through progress made in science, technology, religion and through man's re-evaluation of his ideas about his role in the society.[4] In part, as a response to the double standard, two other premarital standards emerged: (1) permissiveness without affection and (2) permissiveness with affection. In the former, few people have traditionally subscribed to the norm because it places strong emphasis on "body-centered coitus" and because "it would require giving up completely our code of abstinence."[5] On the contrary, the permissiveness with affection standard has gained widespread support since the turn of the century because it makes the strong assumption that if individuals hold affection and love for each other, then premarital coitus is acceptable. Reiss suggests that this standard has perhaps

[2] Ira L. Reiss, *Premarital Sexual Standards in America*, New York, Free Press, 1960.

[3] Pp. 91–92.

[4] Robert R. Bell, *Premarital Sex in a Changing Society*, New Jersey, Prentice-Hall, 1966, see Chapter 1.

[5] Reiss, p. 124.

gained such widespread practice in this century because it rules out body-centered coitus, especially among the middle and upper classes. More important, it gives females justification for engaging in premarital sex.

The fourth premarital sexual standard that Reiss describes is that of the formal single standard of abstinence. This sexual standard applies for male and female, and frequently is practiced by adolescents and engaged couples who have "moral" hang-ups about engaging in premarital sex.

In recent years, we have observed a revolution in attitudes and behavior in the area of premarital sex. This does not simply imply that more unmarried couples are engaging in sexual activity, but it also symbolizes a frankness and openness on the part of such couples that is unprecedented in modern times. At no other point in American history has there been such candid discussion of sex, including contraception, abortion and premarital sex. This is evidenced in the largely middle-class movements for abortion reform, the widespread dispensation of contraceptives (which even involves politicians advocating their distribution in the Black community) and the movement to teach sex education to school children.

A major problem that has always been associated with these reforms has to do with the moral-immoral dichotomy in which the topic of sex has been framed. Premarital sex should never have been placed in the context of morality because this is not the central question involved. Sex is only one of the many normal, vital functions of everyday life and is as normal and human as eating and sleeping. It is conceivable that the American middle class could have had the same kind of hang-ups about eating and other vital functions as are held toward premarital sex. The premarital sexual codes are changing in the dominant society, in part, because of the recognition of the non-human quality of sexual abstinence. Another source of the rebellion against conventional sexual codes comes from the awareness that the double standard and the code of abstinence are sym-

bols of hypocrisy. So many young middle-class people are realizing that the conventional morality they are taught by their parents, and which the society *theoretically* adheres to, is not practiced. They observe the adultery and other forms of sexual permissiveness that take place among the advocates of conventional morality, and rebel against this "morality" because of the contradictions involved. The questioning of traditional values toward premarital sex only symbolizes the revolution that is occurring in other areas of American life that involve similar contradictions—such as religion, war, racism and the like.

Many of the conventional codes regarding premarital sex have little significance for the girl growing up in the Black community. The low-income Black community has always been stereotyped as having "loose morals" and "promiscuous" behavior in the area of sex. The frequency of so-called illegitimate births and the boyfriends and common-law husbands with whom these women engage in sexual relations are usually cited as proof of sexual promiscuity. (Social scientists commonly refer to the so-called illegitimacy rates of Blacks being almost ten times those of whites.) What is not taken into consideration in these assertions is that a different set of moral codes regulates the sexual behavior of Black people. While they are influenced, to some extent (especially the middle class), by conventional morality, it does not dictate their attitudes and sexual practices. Thus, premarital sex is not regarded by the majority of low-income Black people as an immoral act. It is viewed as one of those human functions that one engages in because of its natural functions. The sex revolution involves the changing of attitudes and practices in the larger society that have never been considered problematic to the same extent in the Black community. Perhaps the greatest problem of premarital sex in the Black community has been its consequences (pregnancy) rather than the act itself.

There are basically two types of responses these girls held toward premarital sex: indulgence or non-indulgence.

The polarization in sex behavior reflected the same atti-
tude that was involved in the dichotomy I made between
those girls who acted mature in their relationships with
boys and those who did not. Girls whose behavior was di-
rected toward upward mobility were less likely to engage
in premarital sex than those whose behavior was not so
directed. Also, the indulgence or non-indulgence in pre-
marital sex was rooted more in practical considerations
than in moral ones. That is, many girls who abstained
from such relations were concerned with avoiding preg-
nancy and frequently did not condemn girls who did not
abstain. There were a few girls, however, who did adhere
to sexual abstinence because of the morality question.

One of the areas I was interested in (when conducting
this study) was understanding the role sex played in the
life of Black teen-age girls. Therefore, this discussion will
focus upon those who engaged in premarital relations.
Girls who engaged in premarital relations were usually
distinguishable from those who did not because of their
sophisticated knowledge and maturity in sexual matters.
There was much preoccupation and interest in the area of
sex. As a group, they took a much livelier interest in their
associations with males, and they were more prone to dis-
cuss men and sex in forthright and concrete terms.

In their everyday conversations with peers there were
many expressions dealing with sex that indicate this ma-
turity. Girls often gave their peers advice (usually upon
request) about sexual matters. Much of this revolved
around courtship problems. The advice from peers was of-
ten the most available and, according to some girls, the
most valuable source. Girls of all ages engaged in this be-
havior. The fourteen-year-old often imparted advice that
could have been mistaken for that coming from someone
several years older. An illustration is taken from an inter-
view with a fourteen-year-old unwed mother.

Interviewer: How do you feel in general about girls who have
   sex before they get married?

Respondent: Well, I feel that it's something that they are all go-
ing to do at least once before they get married. I feel there
are some things they should know before they get married
where they wouldn't be totally inexperienced when they get
married. . . .

Interviewer: Do you ever offer advice to any of your friends about
sex?

Respondent: Well, there was this one girl. She asked me if it
was all right . . . how did it feel to have a baby before you
get married and would it be better if she had one before she
got married. I told her no, that I would recommend it to no
girl to have a baby before she got married. It was just some-
thing that happened to me. If I could go back, I'm not going
to say I wouldn't have had the sexual relationship but I would
have tried to prevent having a baby.

Another important area in which maturity stands out
has to do with the obligatory demands girls made on boy-
friends once they began engaging in premarital sexual rela-
tions. At this point the level of intensity in the courtship
was usually heightened. Frequently the couples saw more
of each other and the relationship became more emotional
and oftentimes serious. The girl often made demands of
her boyfriend that she felt he was obligated to fulfill be-
cause of the sexual involvement with him. In most cases,
the decision to begin having sexual relations automatically
placed strong obligations on the male. These obligations
took several forms. One form was that the girl felt that
she should be the only female with whom her boyfriend
had close (or any) associations. The case of eighteen-
year-old Susan is an illustration:

Interviewer: Susan, why do you have sex with your boyfriend?
[He was eighteen also.]

Susan: For many reasons, I guess. I love him and it makes me
feel closer to him. Also because he wanted me to.

Interviewer: Does it make you angry to think he might break off
   with you and go with another girl?

Susan: Yes it does. I get very upset if I think about that. Be-
   cause although he is very nice to me I get mad when I think
   about having sexual intercourse with him and then he might
   turn around and start going with some other girl.

Interviewer: Why?

Susan: Well, I don't want to have sex with every boyfriend I
   have because it is not nice. He is the first and I want to keep
   it that way. . . . I don't think he ought to go with anybody
   else since I have relations with him. He wouldn't be doing me
   right.

Clearly, there is no "promiscuity" involved in Susan's
behavior.

Many of the girls felt that the obligations the boy must
fulfill included marriage if pregnancy occurred *and if the
girl wanted marriage.* Some girls felt that they possessed
abilities to choose boyfriends very discriminately on the
basis of whether or not they were likely to offer marriage
in the event of pregnancy. Although marriage was usually
preferred, it was desired only in those cases of mutual
consent between partners. Eighteen-year-old Melba, who
dropped out of school in the tenth grade (no children)
because she lost interest, indicated that a primary concern
in selecting a boyfriend had to do with her evaluation of
him as a potential husband. Melba's childhood had been
economically insecure, owing to the fact that her mother
had been, except for intermittent periods, the sole provider
for the family. Melba had worked intermittently after leav-
ing high school but had been unable to find a permanent
well-paying job. Thus, her strong concern for a boyfriend
who would assume responsibilities for marriage should
pregnancy occur was an outgrowth of her desire for the
economic security that she had never known. Melba com-
mented on her ideas of these expected obligations:

Interviewer: What do you think would make you decide upon
   having sex with one particular boy and not with another?

Melba: A boy like Tim, now if something like that happened to me . . . he wouldn't even care. But John, I believe he would do his part, as far as I am concerned; if he didn't marry me, he would take care of me or something like that.

Interviewer: If you got pregnant, would you expect the boy to marry you?

Melba: I want him to.

Interviewer: And if he didn't marry you, what would you expect of him?

Melba: To take part as far as the baby is concerned.

The attitude that Melba expressed was very common among these girls when questioned about obligatory demands they felt they should make of their boyfriends.

The discussion of obligatory demands is only an illustration of one aspect of the way in which maturity operates. The intensity of the courtship usually heightens and loses its air of semicasualness when sex is introduced. Girls are compelled to engage in more advanced strategies in order to meet the demands of the complex relationship. Consenting sexual involvement, at any point in an unmarried female's life, often encourages and dictates that she become further involved in a more complex and extended relationship. Personal considerations that are related to what course of action she will take should pregnancy occur, hopes for eventual marriage and so on force many girls who engage in premarital sex eventually to deal with these issues. A girl might begin having sexual intercourse in her courtship in a less serious manner, but often this somewhat casual relationship develops into one that is more complicated. In sum, very often sexual involvement in courtships encourages maturity because of the heightened intensity and complexity the relationship assumes once sexual involvement takes place.

Girls who engaged in premarital sex were more inclined to be critical of parental controls and to feel that adults did not understand the needs and problems of adolescents.

The fact that they engaged in premarital sex was a strong indication of defiance, because in doing so they frequently acted against parental desires—parents did not encourage premarital relations owing to the problems involved. Sometimes girls who felt their parents were too strict defied them by flaunting their activities or information about their activities before irate parents. One example is that of eighteen-year-old Janice, who got married during the course of this study. She often referred to herself as rebellious because of her mother's strictness. At one point her defiance took the following form:

Interviewer: Before you got married where would you usually go to have sexual relations? [She had indicated that she had done so.]

Respondent: Motel.

Interviewer: Did you ever feel at any point that when you'd come back home your mother would look at you as though she knew?

Respondent: Yes. At first I thought that. But before I ever thought of having a relationship with a man she always accused me of something like that. I got used to it.

Interviewer: As far as your mother was concerned when you got married you were a virgin?

Respondent: No. She knew that I wasn't a virgin. See, my sister was different. She never sat down and talked to Mama and she always said that we should sit down and talk. Like I told you before no matter how much she argued and fussed I just went on and told her [that she had had sexual relations]. She was very angry but she accepted it.

Interviewer: Did she ask you whom you had sex with?

Respondent: No.

Interviewer: You just walked in and told her?

Respondent: [Yes], I'm very bold.

Her act of voluntarily telling her mother that she had been engaging in premarital sex may be viewed as a way

of declaring to her mother that she was no longer a child and that she was no longer complying with her regulations. There is a strong element of the above subject's actions to be found in the entire group.

In addition to attempting to break the close ties with parents in the area of sex, they also engaged in other forms of prohibited behavior. Smoking, drinking and breaking curfews were some of the problematic areas. They seemed more willing to be rebellious against their parents and to engage in those activities which, to them, symbolized being a mature woman. Sexual involvement just happened to be one of such means of self-expression.

The decision that girls made to begin having sexual relations often came after much discussion with their peers and boyfriends. The pattern appears to have been that the boyfriend asked them on several occasions before they finally consented. During the interim period, when the girl had been approached but had not made a decision, she underwent a great amount of pressure—both external (from the boyfriend) and internal (strong feelings of ambivalence about whether or not she should do so). This process of decision making was often prolonged over long periods of time, sometimes months. In those situations where the boyfriend had to wait several months without the girl consenting to engage in sexual relations, he usually either took on additional girl friends who would do so, got tired of waiting and broke up with the girl, or maintained the relationship but continued to ask her to engage in sex. In one situation, where the girl made a positive decision about sexual indulgence after having been first asked weeks prior to her participation, we are able to observe and understand the processes and ambivalence that she experienced. The illustration below is taken from an interview with a fifteen-year-old girl, Candice, who was dating an eighteen-year-old high school senior:

Interviewer: What kind of reaction did you have when Shelton first asked you to have sex with him? What did you say?

Respondent: I told him to let me think about it at first.

Interviewer: How did he approach the subject with you?

Respondent: Well, just like . . . I'll say for instance you know how people on television approach a girl or something like that and say they love them and all that. He'd go all through that.

Interviewer: How long had you been going with him the first time he asked you?

Respondent: It was about four months.

Interviewer: Were you surprised when he asked you that?

Respondent: No, I wasn't surprised. That's what the average boy now expects.

Interviewer: And you told him that you'd think about it?

Respondent: Yes.

Interviewer: How long was it before he asked you again?

Respondent: He didn't ask me that time. He just said are you going to do it or not, and I said yes.

Interviewer: You said you told him you had to think about it. Did you really sit down at home or someplace else and really think about it?

Respondent: I'd think about it at night and at school. It hit me all of a sudden and I had to think about it.

Interviewer: What kinds of things did you think about?

Respondent: I was thinking would I have a baby and all that.

Interviewer: What do you think made you decide to do it?

Respondent: I just don't know what made me decide. The first word I could think of was yes.

Interviewer: Did you ever think that maybe you wouldn't do it? Did you think at one point that maybe you shouldn't do this?

Respondent: Well, the average boy today, when they want to do something like that they tell you they won't get you a baby so since you've known him for so long and trust him, you just decide to trust him.

Interviewer: How long was it between the time you told him to let you think about it and you decided to do it?

Respondent: Two weeks.

The result of this fifteen-year-old's sexual involvement was pregnancy. The boyfriend to whom she referred denied paternity and she has not been friendly with him since she first became pregnant.

Most of the girls spoke about the pressure they experienced as a result of their boyfriend's constantly asking them to engage in sex. Sometimes they said that the only reason they submitted was because the boyfriend pleaded with them, as illustrated in the interview with an eighteen-year-old mother below:

Interviewer: Is this John's baby?

Respondent: Yes.

Interviewer: Do you know why you decided to have sex with him?

Repondent: No.

Interviewer: No particular reason at all? [She nodded no.] Did you want to . . . or did he beg you?

Respondent: He begged me to.

Others talked about being in love and wanting to please their boyfriends by submitting. They frequently talked about their boyfriend's considerate ways, the companionship he provided, his handsome build and the general romantic aura surrounding their courtship.

Interviewer: Why did you decide to have sex? What broke your resistance? [The respondent had talked about her habit of teasing boys until she reached eighteen, when she had her first sexual experience.]

Respondent: It just happened. I don't know. I guess I'm in love with him. I tell him that it's got to be love because all the other boys I went with and I thought I was in love with them

too; that's why I think this is love because I say, "I have not
ever had anything to do with no other boy so you are the first
one."

The "being in love" aspect appears to underlie the reasons
many of the girls gave for engaging in permarital sex. They
often expressed the opinion that the sexual relationship
provided them with the opportunity to feel closer and be
possessed by their boyfriends. It further served as a me-
dium through which they could express the heights of their
caring for their boyfriends.

Typical responses that bear on this point were:

Interviewer: Why do girls have sex with boys?

Respondent: Because they love them so much and they don't
    want to say no. At first the girl probably won't do it and just
    lets the boy quit her. But the first time you're scared and you
    don't really enjoy it but as it goes on you begin to enjoy it.
    If you really love a boy you'll enjoy it and get as much pleasure
    as he would out of it. [Fifteen-year-old]

Another girl in the same peer group as the one above:

Respondent: Some boys will quit you and some boys keep on
    going with you hoping that you will give in someday. Some-
    day you will give in. If he loves you enough he'll keep on
    going with you and you will give in if you love him.
    [Seventeen-year-old]

A small number of them were curious about sexual in-
volvement. They had heard from girl friends various ac-
counts of what the relationship was about, so they wanted
to find out for themselves.

Interviewer: Why did you at age fourteen have sex?

Respondent: Well, the first reason is I wanted to see what it was
    like. The second is that he wanted me to.

Interviewer: Why were you curious?

Respondent: I wanted to know how it felt because most of my associates had different stories about it. . . . I wanted to know for myself.

Another girl, who was expecting a child when the interview took place:

Interviewer: Why did you decide to have sexual relations?

Respondent: Because I never had any before. Some girls used to say that when you first try you probably will like it, but if you don't like it don't do it no more.

Thus, there are a variety of reasons for sexual indulgence. One of the more prominent reasons observed was the function it served as a substitute for other areas of gratification that could not be fulfilled through ordinary channels. Specifically, some girls engage in premarital sex because it provides them with a sense of belonging, of feeling needed by their boyfriends. It is a common experience which provides a sense of identity and utility. In a sense, it can be viewed as a system of exchange. Often in the absence of material resources (such as money to purchase gifts for a boyfriend's birthday, etc.) sex becomes the resource that is exchanged. Sex becomes the medium of exchange for a boyfriend who shows that he cares by providing small gifts, taking the girl out on dates, etc. While these small considerations of gifts, dates and the like might strike one as trivial, they are sometimes extremely important sources of gratification for these young women, who might need the emotional security the boyfriend provides. Her involvement in sexual behavior is only an attempt to respond to his concern for her by attempting to fulfill his needs in the only way she can. It is here that sexual involvement transcends any conventional analysis because the standards that the individuals apply to their actions are created out of their particular situations.

Sexual experience was not without its problems. Al-

though many girls found it to be a means of expression in
a variety of ways, they were still influenced by the con-
ventional codes of morality. Some of them were more in-
fluenced by conventional modes of morality than others
and experienced conflict and sometimes trauma over
whether or not they should defy these codes. The sharp
conflict between strict non-indulgence taught by many par-
ents and the desire to experience premarital sex sometimes
had a profound effect upon their lives. A fourteen-year-old
who had engaged in premarital relations about three or
four times over a period of several months with her steady
boyfriend was plagued with guilt feelings over her be-
havior. She said she had always been disappointed with
the relationship and did not know why she had bothered
to do it. Although she and her boyfriend had often talked
about eventual marriage (after they finished college) she
was not quite sure if she was good enough for him to marry
because she felt boys, justifiably, cared less for girls once
they engaged in sex.

Interviewer: Is Marty a boy you hope to eventually marry?

Respondent: We talk about marriage sometimes. We were going
    to marry each other. One time I asked him, "What would
    your children think if they knew about your wife?"

Interviewer: What do you mean?

Respondent: I mean if I had sexual relations with him before
    we got married. He said the children shouldn't know about it
    and what we had done.

Interviewer: Did that make you feel better?

Respondent: Yes it did, because, well, I think the children should
    not know.

These conflicting pressures were so stong in some cases
that girls attempted to resolve them by not having re-
lations for long periods of time and vowing to themselves
they would never have them again until marriage. In dis-

cussing guilt feelings and changing premarital sexual standards, Ira Reiss maintains that:

Although very few females stop engaging in sexual activities because of guilt feeling, it may be that those most prone to strong guilt feelings are least likely to engage in such behavior.[6]

Sometimes, amid all the conflicts, these girls were able to rationalize their behavior on grounds they felt their parents should accept.

Interviewer: How do you feel about having sex in terms of whether or not you should have done it?

Respondent: I think about it a lot. I think about the ten commandments; I think about what Mama has said. I've thought about it a lot. Then I say, I don't know, *if it's all that wrong then why am I here?* . . . At first I was so ashamed that I couldn't even think about it. I would just sort of go off. [Emphasis added]

Interviewer: Do you think you'll do it again?

Respondent: I don't know. If I have to go through that again, I don't know.

There is no single and uncomplicated explanation that can be given for the reasons girls engaged in premarital sex. The need to belong, to be loved, to satisfy curiosity, to please one's partner and to "be a woman" were the primary reasons expressed. In all of these, however, one observes the fact that premarital sex is considered a "womanly" activity. It is the point when girls cease to be girls and begin to become women. Indeed, for some, it is a sign of womanhood. This level of involvement with males, as illustrated, tends to increase maturity and actually aids in the process of achieving womanhood because these girls

[6] Ira L. Reiss, *Social Context of Premarital Permissiveness*, New York, Holt, Rinehart & Winston, 1967, p. 113.

are filling the roles of women. Still, their attitudes and behavior toward premarital sex emerge out of a value context within the Black community. At early ages they are taught that sexual indulgence is frequently costly because of the possibility of pregnancy, etc. They are also informally socialized in a tradition that places high value on the positive features of sexual involvement—within or without marriage. The moral stigma is not nearly so strong as in middle-class society because sex is considered a very human act, and the guilt that is attached to it in conventional terms is not always predominant. Indeed, many of them probably experienced very little guilt, because by the time they began having premarital sex, they had already worked through whatever conflicts they might have had. Others probably never experienced deep conflict at all because they always had an understanding of the very human quality of sexual involvement and accepted it on these terms. The current sexual revolution is addressing itself to some of the values that have always been present within broad segments of the Black community. This emphasis is also taking place in other areas of human behavior, as will be illustrated in the section below on "Becoming a Mother."

BECOMING A MOTHER

If there was one common standard for becoming a woman that was accepted by the majority of the people in the community, it was the time when girls gave birth to their first child. This line of demarcation was extremely clear and separated the *girls* from the *women*. This sharp change in status occurs for a variety of reasons. Perhaps the most important value it has is that of demonstrating the procreative powers that the girl possesses. Children are highly valued and a strong emphasis is placed on one's being able to give birth. The ultimate test of womanhood, then, is one's ability to bring forth life. This value underlying child bearing is much akin to the traditional way in which the same behavior has been perceived in African culture. So

strong is the tradition that women must bear children in most West African societies that barren females are often pitied and in some cases their husbands are free to have children by other women. The ability to have children also symbolizes (for these girls) maturity that they feel cannot be gained in any other way. Rainwater writes:

It would seem that for girls pregnancy is the real measure of maturity, the dividing line between adolescence and womanhood.[7]

There is something about the child-bearing experience that they feel enhances maturity. It is the time when the girl learns firsthand the same things that her mother has experienced. Thus, there is no longer the sharp line that separates her from her mother because both of them have engaged in sexual relations and both have had children. Similarly, she has encountered the same experiences during the period of pregnancy and has learned its profound meaning for her as a Black woman. The problems that pregnancy and childbirth pose for the unmarried low-income girl are dealt with, as well as the status and gratification many of them receive from motherhood. It is during pregnancy that they are forced to think about the multitude of problems that must be overcome. Such factors as having to drop out of school, supporting the child, hurting one's family, etc. are very real for these girls and most of them struggle with them, sometimes agonizingly, for the entire period of pregnancy and after the child is born. Yet this represents only one side of the ambivalence they hold toward child bearing. To have a child represents fulfillment of the womanly tradition in the Black community and, as such, is not viewed entirely in the realm of stigmatization.

It is also within this context that we can understand the high value that is placed on the child and the lack of stigmatization. There are no "illegitimate" children in the

[7] Rainwater, "Crucible of Identity: The Negro Lower-class Family," *The Negro American*, Talcott Parsons and Kenneth Clark (eds.), Boston, Houghton Mifflin Company, 1965, p. 187.

low-income Black community as such because there is an inherent value that children cannot be "illegally" born. There are, however, "unauthorized" births because these children are not born within the limitations and socio-legal context defined by legislators and other people in the majority group who *create* and *assign* labels to the minority group. Children are conceived in love relationships, and in those cases where they were conceived under less fortunate circumstances (such as rape) they are never blamed for their existence. Also, they are rarely felt to be the result of their mother's "promiscuous" activities. Girls most often stated that these pregnancies resulted from their involvement with a boyfriend with whom they were in love or cared for a great deal. Children are always spared their mother's "mistake" or "sin" because they are considered innocent and, in effect, do not ask to be born.

It is unfortunate that social scientists always use the term "illegitimate" to refer to Black children born out of wedlock. Illegitimacy is a stigmatizing label that acts to degrade the mother and the child, but no such degradation as is common in the white middle class can be found to exist with low-income Blacks. This will be illustrated in the many case studies that will be addressed to the subject of child bearing by single girls in this study. A wholly different value context exists for them and runs counter to the myth of illegitimacy. The so-called illegitimate rate for Blacks, being almost eight times that of whites, has been used as an index of social problems and is always singled out as one of the major factors associated with "family disorganization." These figures, which are so often the source of alarm, are irrelevant because they emerge out of a white middle-class value context and actually say very little about the way "illegitimacy" is viewed by Blacks.

These are some of the major emphases that will be dealt with in this section. Becoming a mother, as the data will show, emerges out of a very strong set of cultural traditions and a value context that are perhaps peculiar to the Black community.

The adolescent Black girl who became pregnant out of

wedlock changed her self-conceptions from one who was approaching maturity to one who had attained the status of womanhood. In a similar manner, individuals with whom she was associated changed their conceptions of her to fit the same role. Mothers were quick to say that their daughters had become grown, that they have "done as much as I have done," that is, have had a baby. Because giving birth was regarded as the pinnacle of femininity and womanness (even if it was interpreted as a mistake to have a child), the girl who became a woman at thirteen was often accorded differential treatment. Rarely did parents attempt to disregard this fact by continuing to treat their daughters exactly the same as they had before the birth. This change in status occurred in those situations where parents continued to be the sole providers for the child and grandchild, as well as in those circumstances where other sources of support were received (Aid to Dependent Children, employment, aid from father) for the young mother and child. Because parents perceive the sharp change in status, it is often they who initiate the more mature kind of relationship. Thus, mothers begin to respond, in many instances, as co-equals. They assume the duty of telling their daughters those facts which they do not understand about womanhood, such as the actual procedures of childbirth, how to take care of themselves during pregnancy, how to care for the child when it is born; also, their attitudes about the man involved change. That is, in their discussions of the father of the unborn child, he is no longer viewed as a "boyfriend" but as a man who is about to assume a certain responsibility in life because of the impending birth. Maturity is also bestowed on him for having fathered the child, because it is a test of his manhood. Thus, the relationship for all parties involved is raised to a more mature level as parents begin to perceive their daughters as mothers and their daughters' boyfriends as fathers.

Parents become more accustomed to treating the girl differently by allowing her more privileges (sometimes unlimited), such as going out as frequently as she wishes

to any place she wishes and entertaining boyfriends in absolute privacy, and by allowing her more responsibility in the home, such as caring for younger siblings, etc. In turn, the girl gains a stronger bargaining position for her rights. When parents refuse to permit her to carry out an act because of her age, she usually reminds them that she is grown and they have so much as told her so in the past. Inevitably conflicts emerge from time to time because the girl remains in the parents' home, and parents sometimes revert back to the parent-child routine. It must also be stated that some parents refuse to surrender the control and continue to treat their daughters as children. Indeed, they sometimes refuse to accept this symbol of womanhood (as will be illustrated in the case of Candice).

There is much ambivalence over the birth of children outside marriage. This is shared by the young mother and the child's grandparents, but these ambivalences are not weighed in terms of morality-immorality so much as they are within the context of economic realities. It is exceedingly difficult for parents to think of supporting a grandchild on an already insufficient income, and perhaps more difficult to accept the fact that their daughter's life has already come to a sudden halt insofar as her educational and economic progress are concerned. The first premarital pregnancy is perceived as a "mistake," more than a sin, and the girl is entitled to forgiveness. A very general attitude of acceptance of one's mistakes prevailed among the majority of the girls and their parents. That is, while they maintained that one should not become pregnant with a child before marriage if the situation could be avoided, there was yet a strongly expressed feeling that since one did not always have ultimate control over this process (this emanated in part from an almost total lack of use of contraceptives, which will be dealt with in the next chapter) the necessary adaptation to the pregnancy and birth should take place with as much ease as possible. Fifteen-year-old Judith stated:

I wouldn't try to get nothing to get rid of a baby. I would just go head and have it. . . . I wouldn't see any sense in trying to

get rid of it. If you knew you didn't want it you should not have had the sexual relationship.

A paradoxical situation existed for those girls who were engaging in premarital sex between the ideological and the behavioral. I met only two girls who expressed a forthright desire to give birth to a child without the security and protection that usually comes with marriage. There was a strong desire among all of them for "protected motherhood." However, there was often expressed a somewhat resigned acceptance of the fact that they did not feel that they could, without question, always avoid premarital pregnancy. Their feelings of powerlessness in this area stemmed from their feeling that they had but two alternatives: either (1) to engage in sexual relations and accept whatever consequences might follow; or (2) to abstain from premarital sex. With this attitude, when pregnancy did come one had, to some degree, already been prepared for it and could justify its occurrence because of the fatalism which they felt guided them into participating in such behavior. Or, since they had a stark awareness that they could get pregnant by engaging in premarital sex, they simply prepared themselves to accept the consequences. When Jane, a fifteen-year-old, was asked about the possibility of becoming pregnant, she replied:

Well, I take a chance. If you get pregnant, you're pregnant and there's nothing you can do about it. . . . I feel that if a person wants to have sex before they get married then go ahead because you can marry a boy and that's all you're worried about then. . . . I don't have anything against girls who get pregnant before they're married as long as they've got a way to support their baby without going out on the corner picking up everybody they meet—as long as the boy is going to help support it.

Although this fatalistic attitude was fairly common, strong feelings were also expressed that to have a child outside marriage would be a *mistake*. They felt that each girl was entitled to *one mistake*, but beyond that girls often earned

the reputation for being promiscuous, immoral and some-
times emotionally unstable.

The idea of a girl having made a mistake was held
strongly by parents and was adopted by adolescent girls
who had experienced premarital pregnancies. A sixteen-
year-old girl related the story of her mother's response to
her pregnancy:

Interviewer: What did your mother say when you got pregnant?
How did she take it?

Respondent: She was hurt, really . . . she cried, she was hurt.
And she told me that because I made one *mistake* don't wallow
[i.e., don't continue to make the same mistake].

Sixteen-year-old Ruby held a similar view:

If I had to give teen-agers advice about sex I would tell them
that dating is all right but never have sexual intercourse—you
never know what's going to happen. . . . After I made the first
mistake I would tell them not to do it before they made their
first mistake.

The belief was that a pregnancy outside marriage was a
"mistake" (that is, that one had been unlucky) that could
be viewed as being both a wrongdoing and an act for
which the doer should receive compassion. On the one
hand, the girl had committed an act that was completely
against the *morals* of the larger society which became
problematic for her because she was, to some extent, af-
fected by these societal rules, etc. However, she was also
viewed as having borne a child who had the right to live
and be cared for and reared in the community of his par-
ents without stigmatization. If there is any norm that is
*unmistakably clear*, it is precisely the conception of the
child's relationship within the family.

The topic of stigmatization of the unwed mother and
her child is a very important one. It involves a different
conception from that which dominates middle-class think-

ing on the subject, as was indicated.[8] While the great majority of girls regretted having become pregnant, there was an absence of long-term overt shame for committing the act. The accommodating attitude of the community aided in relieving them of long-term embarrassment and guilt over their behavior. In a taped discussion group with fifteen-year-old Scarlet and eighteen-year-old Edith and three of their peers, the girls talked about their ideas regarding shame and stigmatization for having a child outside marriage.

Interviewer: Would any of you be ashamed to have a baby without being married?

Respondent 1: I wouldn't.

Respondent 2: I wouldn't.

Respondent 3: I wouldn't.

Respondent 4: I wasn't ashamed. (This girl had a miscarriage.)

Respondent 5: It's really no reason to feel shame because there are a lot of people walking around here unmarried and you'll just be one more in the crowd. You shouldn't feel inferior or anything because there are a lot of people in your class.

Respondent 2: And then too if there were no others and you're the only one and there wasn't any crowd I don't think that's anything to feel ashamed of. Everyone has needs that they have to satisfy. I don't really think it's a big sin. Everybody makes mistakes.

Respondent 3: I think if I was the only one or one of a few then I would be ashamed. Now girls don't be ashamed and you just expect a girl to get pregnant now because so many girls do. But before 1960 it was something for everybody around the corner to talk about and everything. Now somebody will

[8] Leontine Young, *Out of Wedlock*, New York, McGraw-Hill, 1954, deal with the differences in attitude of acceptance of the child born out of wedlock in the lower class and in the middle class. She maintains that the lower-class Black child is spared the stigmatizing labels of "child of sin" that the middle-class child experiences.

say So-and-so is pregnant and everybody will say "oh" and go on about their business.

Interviewer: Do the babies who are born out of wedlock get stigmatized?

Respondent 2: The other little children are illegitimate too, most of them, so they don't laugh at each other and say those kinds of things.

Respondent 4: That doesn't matter. They don't care whether you have one parent or two parents. It just doesn't matter as much as it did when my mother was coming up, when everybody had a father and their father's name. Children are more mature than our parents were.

Respondent 3: The only time this question would arise is when people have arguments and start calling each other names. They do it a lot of times. But they don't mean it because they're probably illegitimate themselves. They'll call you that if you've got two daddies and mothers. They say that anyway so you can't tell the ones who are illegitimate from the ones who have parents.

To these girls, the question of "illegitimacy" was not of primary importance because stigmatization of the mother and child are not serious problems for them.

The problems of having a child outside marriage are many, but this is not one of them.

The idea that the child has the right to live an unscarred life and should not be punished for his mother's mistake is deeply entrenched in the culture of the community. No matter how unfortunate circumstances become, and no matter how hurt the girl and her parents are over the impending birth, the mother and/or her family keep the child and rear it. Sometimes the child might be "given" to an aunt or grandmother, but seldom does it leave the extended family. Hylan Lewis, in commenting on this norm, states:

Some low-income mothers pray for boys in order to avoid "trouble" for their daughter, and when trouble comes there is

grief and anger, even though you "stick to your own, take care of your own, and never turn them away."[9]

Adoption and abortion are generally held in disfavor and are not available (especially adoption) to poor Blacks. (These topics will be discussed later.) When the child remains in the family and is reared as the child of the natural mother, or grows up in the three-generational household with very close contact with the mother, there is a great opportunity for the young mother to play the motherly role. Since she usually has to assume certain responsibilities for the child's welfare, she has little opportunity to suppress her experience with giving birth. Perhaps this dissociation would be less difficult to manage if the mother and child were physically separated at birth. Even when she does not assume responsibility for the care of the child, she must live with it as it grows up and is, therefore, unable to dissociate herself from this part of her past. (Most girls expressed no desire to forget this experience.)

Pregnancy was most often received with surprise. Although many girls were not engaging in their first pre-martial sexual experience, they were unprepared psychologically for having a child. Parents usually reacted negatively at first to the pregnancy of their daughters with hurt, shame and sometimes shock. None of the girls in this study reported having been abused (beaten) or severely berated. Most often the parents were surprised and hurt. After the initial response, there was a resigned acceptance of the pregnancy. As time passed the girl and her parents adjusted to the idea that a child was expected and parents became concerned about their daughter's welfare during the pregnancy. Girls in this study infrequently reported knowing other teen-agers whose parents mistreated them because of pregnancy and became very strict on them, often not allowing them to go any place alone except to

[9] Hylan Lewis, "Agenda Paper No. V: The Family: Resources for Change," Planning Session for the White House Conference "To Fulfill These Rights," November 16–18, 1965, Washington, Government Printing Office.

school. In such families parents usually became stricter on
their younger daughters in an effort to avoid the same
problems of unwed pregnancy as were posed by the elder
daughter. Although girls are able to adjust to a premarital
pregnancy, it was rarely a welcomed event. Whenever the
girls who were not pregnant (in this study) spoke of want-
ing children, it was always referred to as something they
wanted to occur within the marital relationship they ex-
pected to have in their early to late twenties. Such com-
ments as "I want a boy and a girl *when I get married*"
were expressed by a majority of the girls. Premarital
pregnancies were viewed by those who had or were about
to experience having a child as the cause for imposing
restrictions upon their lives. Some of them spoke of the
changes that had already occurred or were expected to
occur in their lives as a result of having a child. Fifteen-
year-old Ethel talked about these changes:

Interviewer: Did you regret getting pregnant?

Ethel: Not to me, I didn't; yet it looks like I did because now
I can't go skating and swimming and to other places I used
to like to go. . . . After I have the baby I think I'll change;
I don't know; I might do the same things, go skating, danc-
ing and act jivey like I used to do with my other friends.

A girl who had not yet had a baby was more decisive in
her beliefs about the restraints having a baby can place
on a young unwed mother. Seventeen-year-old Josetta
commented:

I didn't want to have relations with my boyfriend because I
might end up pregnant with a baby which I don't want at this
time. I haven't finished school; I haven't any way to support it or
myself now. . . . I don't want to have a baby until I have fin-
ished all of my schooling, have a real nice profession and then I
think I'd be ready to settle down. . . . I think I am doing the
right thing because self-preservation comes before anything.

Perhaps the comments made by sixteen-year-old Eileen are closest to the point under discussion:

Interviewer: Does the fact that a girl has a child change her life very much?

Respondent: Yes, it changes her life a lot. First of all, they consider themselves grown and then they just start acting like grown women. They don't think they're children any more. They won't listen to anybody.

In other situations girls commented about the conflicts of having a child and not really wanting a baby this early in their lives, but yet not wanting to surrender the child to someone else who would assume the task of mother. The exception, of course, is giving the child to their mother and sometimes to another close relative.

There are indications that having a child changes the girl's life considerably. She might not be ready for motherhood and/or womanhood but is forced to accept many of its responsibilities. That is, as long as the child is acknowledged as hers, she must care for its physical needs to whatever extent possible (this might include getting welfare support for it, getting a job and taking care of it, securing support from its father, etc.) and contribute in part or full to the socialization of the child in all aspects of its life. Rarely were young mothers who remained in the home of their parents expected to take complete charge of these responsibilities. Most of them could always get their mothers and grandmothers to baby-sit for them and to take care of many of the major tasks associated with child rearing. In a sense, this reflected the deep complexity of what it meant, on every level, to have a child when one could theoretically still be considered a child. While some girls were able to assume the responsibilities for becoming a parent, others were almost totally incapable of doing so. Much of this was associated with age because obviously the fourteen-year-old could not be expected to handle these duties and responsibilities as well as the seventeen- or

eighteen-year-old. Having a baby for a very young girl must necessarily have a different psychological impact than it does for the older girl. She is just entering the age of adolescence and has only begun to experience many facets of this developmental process (regardless of how precocious she is). I observed on some occasions very young mothers who treated their babies more like dolls than children. A number of girls often played with their child, dressed up the child and took it out for a walk or a visit and showed it off as though it were a beautiful doll. There was little indication that the concrete meaning of motherhood had penetrated their minds. For these girls, the acceptance of the role of mother comes through maturing in other areas (such as chronological years).

Parents are rarely the first to learn of their daughter's pregnancy. She usually confides her problem to her peers and then to her boyfriend. Her peers are usually able to console her and offer suggestions on what she should do. This advice might range from them suggesting that she tell her parents immediately to advising her to wear a coat and full dresses to conceal the pregnancy. Most of these girls are several months pregnant before their parents discover it. Thus, sixteen-year-old Alice states:

I was five months before she [her mother] knew it. I didn't tell her then but she kept on looking at me funny and finally she asked me, "Alice, are you going to have a baby?" and I said, "Yes."

The boyfriend is usually unable to offer the kind of physical security the girl needs (marriage) because he is often unemployed and frequently too young to settle down and provide a home for her. He is relied upon, however, for emotional security, warmth and understanding during the pregnancy. There is frequently a maintenance of the relationship with the child's father as it was before the pregnancy, depending, of course, upon how the child's father reacts to the pregnancy (i.e., whether he owns or dis-

owns the child; he usually acknowledges paternity). This is also contingent upon whether she wants to maintain the relationship (she usually does). In some cases the couple remains together and makes plans to get married in the future. It is not uncommon for couples to marry after the child is born.

Because of the "accepting" attitude of the community, the girl is seldom preoccupied with being pregnant once it has become known to the people in her community. Except for the restraints placed on her life mentioned earlier, she asserts herself almost as much as before and often engages in "new" relationships with boys. It is not at all uncommon for a girl to break off with the child's father and take another boyfriend. This is a very important aspect because it is a good indicator of her relatively high status in that she is still considered physically attractive. If she breaks up with the child's father, either after pregnancy is discovered or before, she rarely experiences a profound sense of mistrust of him and rejects all men. Nor does she experience deep trauma because the relationship ends without the boy marrying her. (A minority of girls do become embittered toward men after their pregnancy.) This occurs because she does not perceive her relationship with him in those terms. Although he is important in her life, she attaches a significant amount of importance to other people as well, including peers, her family et al. She therefore learns early in her life that it is perhaps best to spread out the relationships and depend upon various individuals for fulfilling different needs instead of making a costly or potentially costly investment with a single individual: her boyfriend. (This will be taken up more fully in a discussion of marriage in Chapter Seven.)

There are many complexities and serious problems involved in attaining womanhood through having a baby. Julanne, who became a mother after she turned fourteen, and who wanted to become a neurosurgeon, can be used as a case study. She and her seven siblings (she was the

second oldest) were supported by their father, who no longer lived with them, and from the small earnings their mother received as a part-time cook. She was a brilliant girl, probably the most intelligent fourteen-year-old I ever met. When she was twelve, she was selected from her school district to participate in a summer enrichment program at a prominent Midwestern private college. Julanne considered this the most outstanding event in her life and spoke freely about writing book reports, living in a dormitory and socializing with students from other parts of the United States. She became a pen pal to one of these students and frequently corresponded with her. She was also a very precocious girl with firm ideas about what she wanted her life to be like, but yet she realized there were barriers that could present themselves unless she received certain breaks. At fourteen she dropped out of school and had her child. She was forced to adopt the characteristics of a woman and became the most mature fourteen-year-old I ever met.

She talked about the changes that have occurred in her life since she became a mother.

Interviewer: Julanne, how old are you?

Julanne: Fourteen.

Interviewer: Now I'd like for you to think back and try to recollect any important things that have happened to you or any event that occurred, whether it was someting that you were glad happened or that you would rather not have happened. Or to your family.

Julanne: Well, I just had a baby recently, but in a way I'm sort of glad I did and in a way I'm not.

Interviewer: How is that?

Julanne: Well, I feel that after having this baby I've learned a lot of things that I feel I might not have learned. And then again . . . I don't know. I just feel like . . . well . . . I don't really know.

Interviewer: What kind of things do you think you've learned in your experiences with having a child?

Julanne: Well, I learned how to take care . . . I always did know how to take care of a baby but not my own. *Now I have someone to love for myself that I can have all to myself.*

Interviewer: Do you feel that having a baby makes you more a woman than you were before you got pregnant?

Julanne: Yes it does.

Interviewer: In what ways do you feel more mature?

Julanne: Well, I feel that I know a little more than a girl who doesn't have a baby. I feel that I can tell her some things. I wouldn't advise nobody to go out and have one. Myself, I sort of resented having this baby but it's too late for that now.

Interviewer: Why do you resent it?

Julanne: Well, my not being married or anything and after I had the baby, the baby's father acted real funny towards me.

Interviewer: How old is the father?

Julanne: Eighteen.

Interviewer: Do you see the father now?

Julanne: Yes, I see him very often. He comes around a lot, takes the baby over to his mother's.

Interviewer: Is he still your boyfriend?

Julanne: Yes, he is.

Interviewer: Do you have any plans for ever marrying him?

Julanne: No I don't, because he is supposed to be going into the Army. He's in the reserves. He got a notice. They're supposed to call him back. They want him to go to Vietnam. I just don't think I would marry him, at least not in the near future anyway.

Interviewer: Why?

Julanne: Well, because I want to go back to school and I feel if I get married I'll have too many responsibilities and I

wouldn't be able to go to school. I'm not old enough to go to night school. Maybe after I graduate from high school, maybe I can marry him then.

Interviewer: How long had you been going with him before you got pregnant?

Julanne: Two years.

Interviewer: So he's been your boyfriend since you were twelve years old?

Julanne: Yes.

Interviewer: Do you think you have always been a rather mature girl for your age?

Julanne: Maybe not mature but I've always been . . . yes, maybe I have been a rather mature girl for my age. Nobody seems to believe I'm fourteen.

Interviewer: Have you always gone around with girls your age, younger than you, or older?

Julanne: Well, they're usually two years older than I am because they feel I'm just telling them I'm fourteen but not really. They feel I'm sixteen or seventeen.

There are several important themes in Julanne's comments that reflect the complexity of the phenomenon. A fourteen-year-old becomes pregnant, has feelings of shame and pride that she is a mother but not a wife; she finds security in having a child because she has something of her creation, and, although she is still friendly with the father (who rejected her when she first became pregnant), she has only very vague intentions of ever marrying him. And she feels that having a baby was a learning experience that enhanced her maturity.

These themes also suggest that there is no single clear-cut solution to this fourteen-year-old's problems. At such a young age her choice of alternatives was severely limited. Marriage was not altogether desirable because it would have prevented her from fulfilling her goal of becoming a

neurosurgeon and caused her to worry about the marriage working out or not. Going back to school would not necessarily alleviate the problem either, because proper care for the child might be the sacrifice that has to be made. Julanne's mother was unable to take complete charge of the baby because of her heavy responsibilities. Whatever the choice of alternatives, there would probably be a great cost to Julanne and her child. Becoming a woman often has considerable disadvantages. Julanne's case was not unusual.

It must be recognized that although motherhood is a strong symbol of womanhood, there are some parents who refuse to accept this as a *rite de passage*. In these situations parents usually exert a very protective attitude toward their daughters and tend to view the pregnancy as a severe "mistake" for which others (peers, boyfriends, etc.) are quite often held responsible. Sometimes they blame themselves for having been negligent in their responsibilities as parents. Girls who become pregnant in such families continue, with their parents' insistence, their normal routines as much as possible. The baby becomes the primary responsibility of its grandmother, while its natural mother returns to school and tries to forget that part of her past. The recognition of the importance of chronological years as an index of maturity is the major factor involved. For parents maintain that teen-age girls cannot be effective mothers and should not begin to fulfill this role before they are prepared to handle it responsibly.

Another factor is that some of these parents want to provide their children with a carefree period of adolescence, without major burdens and responsibilities. Many parents work hard to give their children what they never had—adolescence. Thus, a pregnancy has the potential of disrupting hard-worked-for plans for the child's future and all measures are used to counteract its possible damaging effects. All of these behavioral reactions to pregnancy must also be understood from the pregnant girl's perspective. She usually accepts her parents' decision about the basi-

cally unchanged course her life is to take because she ha
accepted their values and attitudes about this area of he
life. Having a baby does not mean the same thing t
this type girl as it does to others I have described becaus
she is not allowed to nor does she insist upon practicin
motherhood. She accepts her status and attempts to pro
long the period of adolescence because she feels it is t
her advantage to do so.

Candice, a fourteen-year-old only child, became pregnan
at thirteen and had a son a few months after she turne
fourteen. Her father was disabled and the family depende
upon his Social Security and disability pension for thei
livelihood. Her mother was a housewife, and probabl
fifteen years her husband's junior.

The father of Candice's baby was an eighteen-year-ol
high school senior who denied paternity and, although h
had tutored her in her home several times a week, im
mediately stopped coming to her house when she told hir
she was expecting his child. Her parents were very stric
and carefully guarded her movements; in fact, Mrs. Evan
said that Candice "got pregnant between home an
church," because she could only go to church and schoo
alone. Actually, Candice became pregnant after church in
her boyfriend's home, according to the account she relate
to me.

When the child was born, the Evans family decide
that they wanted no support from the child's father if h
had to be forced to give it. Candice returned to school t
pursue her high school work with the hope of eventuall
becoming a secretary or a nurse. Her parents began t
rear her son as though it were their own. I talked to he
about her attitude toward motherhood, etc.:

Interviewer: How do you feel about rearing the baby withou
    being on speaking terms with his father? Do you ever thin
    your baby might eventually ask you about his daddy?

Candice: We won't tell him until he gets grown that I'm hi
    mother. . . . He might know. . . . We might tell him . .

but you see, he won't call me mother. He will call my mother
mother.

Interviewer: Did you and your mother decide this is what you
are going to do?

Candice: Yes.

Interviewer: Do you think the people in your neighborhood
might secretly tell him that your mother is not his mother?

Candice: Well, if they do it wouldn't matter because he will
know I'm his mother, but he won't call me mother. He'll call
me by my first name.

Interviewer: How did you feel when your mother decided that
might be best?

Candice: I think it is right instead of putting him up for adop-
tion.

Interviewer: Did you and your parents discuss adoption?

Candice: No. My mother said it wouldn't be right because it's
my baby and I should suffer the problems of having it and I
didn't want him put up for adoption anyway.

Candice's case is an example of one whereby pregnancy
did not permanently interrupt her childhood. Her young
son, in real life, became a little brother to her. Like many
girls, she did not regret that she had been spared from
playing the role of a woman before she was ready in other
vital ways. Unfortunately, many girls do not have this
opportunity.

A girl was sometimes challenged to "prove her woman-
hood" by submitting to sexual relations with the male who
called her womanhood into question. Sometimes this chal-
lenge was made by the girl's peers and adults. A conversa-
tion with an eighteen-year-old is an illustration:

Interviewer: Do you think that many girls that you know have
sexual relations because they enjoy it?

Respondent: Some of them do and some of them don't. Some
do it for kicks and some do it because somebody tells them
that if you don't hurry up and have a relationship you'll get
too old and it will hurt or it will run you crazy and stuff like
that and they do it.

Success in this endeavor, or being able to affirm that one
has become a woman, depends upon one's interpersonal
resources (peers, male friends, role models), clothes,
money and a variety of other resources,[10] depending upon
the inclinations of the individual. While all of these are
significant prerequisites, they have varying degrees of im-
portance with different girls. That is, womanhood can be
achieved without one indulging in fashions, hair styles and
cosmetics, engaging in premarital sex, having a baby and
so on. But, in some way, all of these are important sym-
bols for different individuals in their quest for womanhood.
   As a broader commentary on Black womanhood, and
how various individuals go about achieving it, one must
note that Black women are now beginning to serve as "role
models" for many white women. This can be observed in
the growing numbers of white women who have decided
to have children outside marriage, two of the most well-
known examples being those of actresses Mia Farrow and
Vanessa Redgrave. However, it is interesting that the
children of middle-class white women are not referred to
as "illegitimate" or "bastards," but are called "love chil-
dren," i.e., babies conceived and borne out of "love."
   We can also observe the emulation of Black woman-
hood in the area of premarital sex, where the young
middle-class whites are openly defying the "sacred" moral
codes of their parents, who, in fact, have always practiced
the double standard; and the young are challenging the
basic assumptions upon which these ethics were founded.

[10] Money and other material resources aid the girl in her quest
for womanhood but are not indispensable to this process. One
can become a woman without possessing great quantities of these
resources.

As a result, parents, counselors, ministers, educators and a variety of other individuals are attempting to *listen* to their children, and many are subjecting themselves to re-valuation. Thus, sex education is being taught in the public schools, middle-class women are arranging abortions for their daughters and the "sexual revolution" is becoming an institutionalized part of mainstream American life. Although this is a very healthy sign, it only mirrors the fact that the majority group had to sanction this behavior before it became legitimate.

These are some of the most blatant examples of the way in which the *deviant perspective* is applied or with-drawn very discriminately when it affects the behavior of the majority group. Conceivably, there will be no "illegitimate" children and "promiscuous" women in ten years if there are enough middle-class white women who decide that they are going to disavow the societal canons regarding childbirth and premarital sexual behavior. But this has to occur before the stigmatizing labels that are now attached to Blacks are destroyed.

This does not mean that Blacks accept these labels *in toto*, or that we are powerless in other ways to resist them. The point I am making is that institutional racism is so profound, even in the area of motherhood, that the larger society can subjugate, oppress and assign a priority to any behavioral act to suit its best interest, and *change the definition which governs that same behavior* whenever it desires to do so.

*Black womanhood* has always been the very essence of what American womanhood is attempting to become on some levels.

## Becoming a Woman: Part II

In the previous chapter I discussed the various symbols of womanhood, or how low-income Black girls go about the actual task of becoming women. The focus of this chapter will also relate to the same general area, except I will describe some of the alternatives that girls take to those discussed in Chapter Six. These alternatives, while suggesting that girls have become mature, are to be viewed as ways some girls avoid some of the consequences dealt with in the previous chapter. Marriage, contraception and abortion will be the topics of discussion. Because of the girls' youthfulness and the opposition to contraception and abortion many of them expressed, the discussion will be relatively short. The same applies to marriage, for, again because of adolescence, a very small number of these young ladies had experienced marriage. Therefore, a considerable amount of this discussion will rely heavily upon their attitudes and impressions about these topics, as opposed to their actual involvement.

### MARRIAGE

It has been mentioned that marriage was an ideal goal to which all these girls aspired in later life. Their idealized conceptions of the "good life" included being married to a "good man" who was a stable provider and an understanding and protective husband and father. Because of a scar-

city of such ideal mates in their environment (because of the inability of the majority of men to obtain the highly skilled and professional jobs), they frequently do not obtain the desired choices in a mate, and must settle for someone less than they hoped for. Even when this is the alternative to which they must resort, the marriage is often a happy one, in spite of the economic hardships the couple must suffer. Black people have been forced to adjust to these harsh economic realities, and young married couples make the adjustment in a similar manner. Marriage for the girls in this study was, therefore, viewed with ambivalence. They viewed future marriage in a very positive manner if it took place under the ideal circumstances, but at the same time, marriage was viewed as very tenuous because they knew that the odds were stacked up heavily against this kind of ideal arrangement working out. Unemployed and underemployed men do not make ideal husbands and this is a fact that many Black girls learn early in their experiences with fathers, brothers and other men in their families who undergo these difficulties. While Black women understand the nature of such difficulties, and frequently blame the society (instead of their husbands) for them, they still contribute to the instability and breakup of marriages.

These girls do not realistically expect to be able to marry a doctor, engineer or lawyer. A few of the more upwardly mobile ones remain steadfast to this goal and are successful, providing they are able to expand their network of associates and to move into the middle-class-oriented occupational areas.

Another consideration that weighed heavily in one's choice of a mate was one's ability to follow the strict sexual codes that would assure avoidance of the pitfalls of a premarital pregnancy and an unplanned marriage. The most obvious way to maximize the chances for marrying a professional man is to avoid relations (especially serious) with men who are not oriented toward upward mobility.

In accordance with this norm, there was a firm attitude prevailing among girls who had not had sexual experiences that if one's boyfriend was indeed concerned with her welfare, he would not expect her to make this great "sacrifice." Moreover, they reasoned, when a girl gives her body to a male she takes a great chance (risk of pregnancy), and the "boy should be ready to marry you." In stereotyped language, this type girl would be classified as a "prude," or more reasonably, one who is guided by logic after weighing the risks, costs and payoffs involved. Cynthia, a sixteen-year-old, adhered strongly to these views:

I think girls who have sex before they get married are cheating themselves. You know, like if they get married and they will be thinking about what they did back in their girlhood days and maybe their husband would be thinking the same thing. . . . They would feel guilty about this. . . . My girl friends tell me, "You don't know what you're missing," and I tell them, "No! no! no dice!" . . . They say, "You're jive [square]."

Other girls talked about sex being "right" only within the marital relationship. Sixteen-year-old Gwen held very strong views on the subject:

My mother always told us that if someone asks you to have something to do with them ask if they're ready to get married. So I don't think I'd appreciate it and I don't think I'd like it. . . . I feel if they want to do it they should get married first and then do it. People talk about a lot of these girls. I wouldn't say it is morally wrong but I'd say to feel right and for it to be nice they should be married. . . . Some girls don't know how to tell the boy no.

The idea that the sexual relationship would be better, more fulfilling and "right" within the marital relationship stems from a very traditional view in the dominant society

that this experience should be a very valuable one for the persons involved. Therefore, girls tend to link it to ideas of the "good career and success," emotional love and romance, and feel that this can perhaps only take place within marriage.

But for the vast majority of low-income Black girls, these dreams of the "good life" that is void of problems never materialize. Thus, they settle for what is available in their immediate environment, which is usually far less attractive to them. With such limited alternatives, marriage is often approached negatively and women do not put forth as much effort as they would otherwise to make it successful. Marriage is even more tenuous with men because they are often unable to provide for wives and children even at the minimal level. They cannot assure their families the kind of economic stability that the larger society has declared a man must give his family, but yet they are forced to live in and be judged by that society which has relegated them to inferior social statuses. It is no wonder that Black men are expressing the kind of rage that we observe in the urban rebellions, and remarkable that their frustrations did not erupt on a broader scale sooner. Of course, Black rage has been in existence as long as Blacks have been on the North American continent. It has never devoloped as intensely as it did in most of the major cities in the 1960s. But these recent eruptions are repeats of past performances in Black history—those of Denmark Vesey, Nat Turner and scores of others. The problem Black men have in the area of fulfilling economic responsibilities in marriage is only one symbolic representation of the perpetual tensions they must endure.

Marriage should also be analyzed in the context of the community's traditions and attitudes toward it. Although it is an ideal choice of alternatives for women, it is not held to be the *only* viable alternative to pregnancy, etc. Because they know the difficulty of finding a husband who

can adequately provide for them, there is often no great amount of anxiety to get married. The kind of pressure that middle-class girls experience to be married after they reach a certain age is not experienced in the same manner with these girls. It is not that marriage is devalued but rather that women are often unwilling to enter into a marital union that is economically bankrupt from its inception. To remain single is sometimes less problematic.

There is also a tendency by some low-income Black women and men to view the legal contract that binds couples in marriage with less importance than members of the larger society hold it. What is referred to as common-law marriage often resembles legal marriage in duration and other responsibilities and obligations that the couple carry out for each other. Part of this attitude results from the tenuous nature of marriage (described in the preceding paragraphs); it also results from long-held community traditions that hold common-law marriage as a legitimate union that is sanctioned by the people in the community. This probably had its origins during slavery, when couples were denied the legal right to marry and devised an alternative adaptable form to cope with this situation. Many couples also separate without obtaining a divorce because they cannot afford the costs. As Blacks become more assimilated into the economic market, common-law marriages will decrease in the degree of their functional importance. Already they are far less common with young people than they were with their parents a generation ago.

One of the ways marriage (as a reality instead of the idealistic dream) was dealt with was in the context of a premarital pregnancy. All of the girls in this study who had begun to engage in premarital sex at some point addressed themselves to the question of marriage in the event of pregnancy. Marriage was the ideal choice of alternatives in the event of an unwed pregnancy, but there was a range of qualifying conditions for marriage. In only one case did

parents refuse to allow a daughter to marry after marriage was offered by the father of the expected child. In this situation the mother of sixteen-year-old Ruby felt that her daughter was too young to marry (pregnant at fifteen) and instead took her to the public health clinic in the community for a prescription of birth control pills. (As mentioned in the previous chapter, Ruby returned to night school after the child was born, took a job as a clerk-typist and continued courting the child's father, who took the mother and child to visit his parents each Sunday.)

The most frequent qualifying condition for marriage was that of consent (especially from the male) between both partners. Forced marriages were not only disapproved, but held in strong disfavor. The attitude "you can make them marry but you can't make them live together" was quite common among parents and daughters. Marriage was considered far too serious a proposition to enter it without mutual consent. This attitude also reflected a strong sentiment that a real marriage could not be forced or legislated by outside parties (e.g., parents).

In a survey conducted with 159 adults (male and female) in the community where these girls lived (most of them parents of the girls in the study) 29 per cent suggested that the alternative of marriage for a girl who had become pregnant was entirely up to the young couple involved. Some of the typical responses the parents gave are listed below:

If they cared enough for each other they should marry.

They shouldn't be forced to marry but if they want to it would be okay.

She would marry him if they both want to; otherwise, no, because he will throw it back in her face later.

If they both are willing to marry. I wouldn't force them, because the boy might be mean to her.

If they felt that they could make a good marriage, yes; but I don't

think they should marry just because she is pregnant. But only if they both want to.[1]

Although mutual consent was expected in these situations, it was usually the female who was more willing to marry than the male. Sometimes the males who had been named as fathers of children denied it, and in many situations where paternity was acknowledged they refused to contribute to the support of the child. Again, the analysis of the survey data indicates that about one fourth of the sample felt that the decision to marry may depend more on one of the parties than the other. Twice as many persons said it depended on the boy as said it depended on the girl. Some typical responses were:

Depends on the boy. Often getting married is not the answer. If he doesn't want to, they shouldn't.
If he wants her, she should; if he doesn't want her, shouldn't force them—no getting along.
If he wants to marry her, they should, but they shouldn't be forced to marry.
If she felt like he wanted her and would work and take care of her. I don't feel she would marry him just because she is pregnant.
Only if the boy wants to marry her. A lot of times you can force somebody to do something they don't want to do and it's bad.[2]

In an unusual situation a fourteen-year-old mother in this investigation refused to consider marriage because of the reasons below:

I told Bill [the baby's father] first that I was pregnant. He had been asking me all along if I would marry him and I told him

[1] Jerome S. Stromberg, *Private Problems in Public Housing: A Further Report on the Pruitt-Igoe Housing Project*, Occasional Paper 139, Social Science Institute, Washington University, St. Louis, Missouri, February 1968.
[2] Ibid., p. 99.

no. . . . I felt if I married him then somebody would say, "She doesn't really like him. She's just marrying him because she's fixing to have his baby." . . . My baby needs a father but I felt that he'd feel that I didn't marry him all that time and now that I am getting ready to have a baby I feel that I'm entitled to marry or he just has to marry me or something. I didn't want him to feel like that so I felt that maybe if I waited awhile to see how things worked out after I had the baby, if he's still feeling the same way that maybe I'd marry him. In a way I want to marry him and in a way I'm just not ready for marriage.

This is an atypical situation that illustrates a reverse position from that usually experienced by the pregnant adolescent. Rarely do girls have the opportunity to decline marriage because of the kind of considerations this fourteen-year-old made, because men do not always offer marriage. Males more often than females seem to decline marriage as a solution to pregnancy. But it is important to remember that both may decline marriage or refuse to consider it altogether. If stronger stigmas were attached to having a premarital pregnancy, the pressures to marry and legitimize the child would be greater.

Moreover, marriage, although desired under the proper circumstances, was sometimes refused by girls who considered themselves "too young" or "not ready" to marry. The decision not to marry because of one's youthfulness and lack of preparation for the marriage role was made by two of the girls who were pregnant when the study was conducted. Carol, a seventeen-year-old girl who was eight months pregnant when I interviewed her, expected to go to night school after her baby was born. Her ideas about marriage to her expected child's father are expressed below:

My boyfriend hasn't asked me to marry him because he'd like to wait longer. . . . I think this is best because I think I'm too

young. I think I should be twenty-three when I marry because when you are grown and you'll find a job easier and rent a house. I don't know if I'll keep on going with him. . . . I don't know if he is the kind of person I want to marry. In a way he is and in a way he is not.

The attitude that Carol took was a sophisticated but unrealistic one. It could also be argued that Carol's attitude was a defensive reaction to the fact that her boyfriend *had not* asked her to marry him. Sometimes the question of not being ready to settle down to the role of wife and full-time mother becomes a factor in deciding not to marry. Girls felt that their autonomy and freedom would become limited should they decide to marry. But if they remained home with their parents they would have more mobility.

The considerations that pregnant girls gave to marriage were varied. Although there was a desire to give birth within the protective marital relationship, marriage was not automatically sought under any conditions. It has been emphasized that the most important consideration made was the mutual consent required of both partners. Because marriages in this environment are often assumed to have a precarious character, and have not always proved to offer the economic and emotional security that the pregnant girls desire, decisions not to marry are based upon such considerations. The unattractiveness and potential inability of the marriage to offer a considerably better life than one already has are important factors related to this very rational decision.

Also, the logistics and economics of early marriage weighed heavily in these decisions. Girls who had not yet reached the legal age to marry had to obtain parental consent. Males who were below the legal age had to do the same. On at least one occasion I observed a situation in which a mother refused to sign for her eighteen-year-old

son to marry a girl whom he had impregnated because she felt he was too young to marry. When these young couples do marry, the problem of financial instability is a serious one from the outset. Young males in these girls' age range find it even more difficult than older Black males to find employment. Consequently, many young married couples frequently depend upon both sets of parents for financial assistance. The intense strain placed upon the marriage because of this problem causes many young marriages to dissolve after a very short period of time. Others, though filled with strain and problems, last for many years and sometimes are never broken. Still others somehow manage to overcome the economic hardships and the family miraculously moves from abject poverty to the middle class.

Two of the girls in this study who were married will be used as case studies to illustrate some of the points under discussion. Cassandra was married at fifteen, two years prior to the time of this investigation, and was in the process of obtaining a divorce. Her marriage resulted from a premarital pregnancy and lasted less than a year. She owed the failure of the marriage to the fact that her husband (three years older than she) refused to maintain a job and refused to accept the general responsibilities of husband-father. At the time of the interviews and observations with her, she was contemplating marriage with another young man whose child she was expecting and whom she described as "the type of man who would make a good home for me and my son." This young man regularly contributed to her support, acted as the real father of her son and talked eagerly of marrying her when she received her divorce. She neither had nor desired contact with her former husband. As far as she was concerned, she would have been better off had she never known him.

In the second case, seventeen-year-old Janice married during the course of this investigation. She was not pregnant but reported that she married because she was in love,

and because her boyfriend was on his way to Vietnam and she felt that marriage would be a good way of demonstrating how much she cared. She remained in school and lived at home with her mother. She took a room with a family for a short while but soon moved back to her mother's home. She wrote her husband each day and talked of him constantly. Although she admitted that she primarily married him because she loved him, she also owed her early and non-pregnant marriage to her rebellion against her mother's authority. Her father had died several years before. Her mother was very strict, which was often the source of bitter conflicts between the two. After Janice married, her mother considered her "grown" and no longer attempted to exercise the same strict controls over her behavior. Janice's marriage was not characterized by the same tensions as Cassandra's because it did not occur as a result of pregnancy. However, because one of her reasons for marrying was rebelliousness against parental authority, there is a strong possibility that the marriage will become unattractive because of this same reason. When her husband returns from the Armed Forces, he could attempt to exercise the same type of authority as did her mother. Should this become the case, she might again choose to rebel. On the other hand, the chances for the marriage succeeding are greater and the costs less to both parties because there are no children involved. Neither of them is forced at this point to settle down completely and accept the responsibilities that would be demanded of them as parents.

It should be carefully noted that girls do not have any uniform conceptions of what one should be like as a woman and individual girls have conflicting ideas about which role model is best to emulate. The diverse role models who are drawn on as sources of identification represent the entire gamut in their environment (mothers, sisters, aunts, teachers et al.) and a fairly large cross sec-

tion of female types outside their immediate environment (nurse, surgeon, professional athlete, entertainer).

It has been observed that the majority of these girls held expectations for marriage that represented what is typically the stable working- and middle-class female's expectation: a husband who can provide them with a very comfortable life, two children; in reality such ideal expectations often have slim chances for being realized. Beyond the superficial screen of ideal expectations exists with many of them the knowledge that perhaps these expectations might not be fulfilled; nevertheless, one can still maintain incentive toward this end. Once girls begin to experience deep emotional involvement with males, they become more prone to recognize the difficulty for becoming the nurse or teacher they say they want to be. With the recognition that few females whom they know find it possible to attain the goal of marrying a professional man and having only two children, as girls in this environment grow older they are less inclined to maintain strong incentive to try to fulfill whatever larger societal obligations are demanded of them.

On the other hand, girls who do not succumb to the strong peer and boyfriend influences to engage in premarital sex and eventually marry their ideal choice of a mate are usually able to do so because of the wider variety of secondary associations, material resources and individual strength from which they are able to derive satisfaction and support. As stated in an earlier part of this work, girls who had experienced premarital sexual relations usually appeared to be more mature than those who had not. While this appears to be true of a wide variety of situations, it could also be argued that perhaps there is a great degree of maturity that allows one to be able analytically to arrive at the conclusion that premarital sex can only produce detrimental consequences.

A more important consideration toward marriage is that

many of these girls reject the larger societal expectations of them, and *realistically* adapt to as well as create their own alternatives and norms. Therefore, marriage is engaged in after a more realistic cold assessment of the chances of it succeeding. It is based more upon rationale than upon emotions. Love, emotional security, etc. are actually "luxury" reasons for getting married. Thus, Black females and males are using more sophisticated and more rational reasons for entering the marital contract. It could be that when Blacks fall into the "trap" of using the dominant society's reasons for marriage, they become *ipso facto* prone to failure, because in this kind of environment, emotional love cannot always counteract joblessness and the multitude of tensions which are frequently present.

On the contrary, white middle-class girls can usually wait for marriage until the ideal or traditional reasons occur. They are more carefree, their "illegitimacy" rate is lower than that of Blacks and their economic statuses are more secure. Yet they have a high divorce rate and the stability of their marriages can be questioned because of this and other factors. Thus, traditional reasons for marriage (emotional love and security, etc.) do not always work well for those who invented the institution and purport to live by it.

CONTRACEPTION

In recent years the subject of contraception has assumed a controversial nature in the low-income Black community. Basically, there are two arguments surrounding its usage. Some argue that all women, regardless of race and class background, should have the alternative means at their disposal to prevent unwanted pregnancies. Within the context of the low-income Black community, proponents of this position maintain that perhaps hundreds of thousands of Black women would like to have these alternative

means; that to expect them to continue to have a multitude
of children that they cannot adequately support is unfair
to the parents and children. Thus, the quality of life for
each individual child as well as for parents increases when
careful planning of pregnancies occurs. The more contro-
versial position regarding the use of contraceptives came
into prominence in the past two years or so when the Black
revolt had its impact upon almost all sectors of life, in-
cluding the area of contraception and family planning.
Militant and revolutionary Blacks argue that the dispensa-
tion of contraceptives through public health clinics and
private agencies such as Planned Parenthood is a genocidal
tool that is designed to decrease the Black population.
The reason is that it would be advantageous for the ad-
versary (usually characterized as the "power structure")
to attempt to "wipe out" the Black population because
it would decrease the problems he has to deal with that
have been posed by the Black revolt. With a smaller Black
population, the current trend toward full equality could
be reversed because the political strength of Blacks would
be reduced with the decrease in numbers.

Both of these arguments appeal to large segments of
the low-income Black population because they make sense.
It is obvious that a woman who has had several children
and does not want more would welcome the knowledge
of how to avoid pregnancy if it does not run counter to her
moral beliefs. On the other hand, it also makes sense that it
would be to the advantage of some hostile whites to cut
back the Black birth rate (especially in low-income fami-
lies) in order to make the questions raised by the Black
revolt less problematic. It would also be to the advantage
of the opponents of welfare and other forms of public
assistance because it is most often this segment of the
population that has been forced to depend upon charity for
its livelihood. The genocide argument has gained a consid-
erable amount of support among the young, politically
conscious Black people.

Neither of these arguments relates to a much more traditional position many low-income Blacks take toward the use of contraceptives: the moral opposition based upon the assumption that nothing should be done to prevent conception except abstinence from sexual involvement. There are many deep-rooted sentiments against contraception that are based upon these moral considerations, as well as the absence of knowledge about the safety involved.

Very intricately involved in the process of the adolescent girl making the necessary adaptations to her future role of wife and mother is the area of contraception. Her knowledge and usage of contraceptives could act to facilitate the acquisition of her ideal marital relationships. If girls hold positive attitudes toward the usage of contraceptives, they can enhance their opportunities for achieving their future expectations of a comfortable middle-class life-style because they can control the number of children they will have, and only have those they feel they can afford. It is very important to explore the question of contraception among these girls and the general attitudes of the community, and to assess the degree to which their successful adaptation to the future marital relationship is contingent upon present practices with contraceptives and their attitudes about possible usage in the future.

It has long been argued that the poor are the most benefited by contraceptives but also the most apprehensive to make use of them. Much of this apprehension, as we will later see, comes from an inadequate education concerning their usage. The problem of inadequate and non-usage of contraceptives has been discussed by Lee Rainwater in *And the Poor Get Children*:

In this country, the problem of having more children than are wanted or can be adequately supported is largely confined to persons of one social group—a fact immortalized in the hyperbolic phrase, "The rich get richer and the poor get children." As

family limitation has become an increasingly rational process, the middle class has been able to limit family size quite effectively in terms of whatever goals its members set for themselves. Traditionally and in reality, it is the poor people—the "working class", the "lower class"—who have too many children.[3]

The inadequate usage of contraceptives by the poor is primarily caused by an insufficient amount of information about the availability, costs and safety of these items. Also of great importance is the belief among some poor that child bearing is a natural process that should not be interfered with by the use of contraceptives or abortions.[4] Although the availability of contraceptives for the poor is increasing, there still exists a scarcity of information about the usage and source of supply for many people.

In the community in which this study took place, many of the people I knew held strong folkloric beliefs about contraceptives. Contraceptives were feared by many women because of beliefs that they caused deformity and stillbirth, prolonged illness and sometimes death to the female. Moreover, there was an attitude among the population against the practice of contraception because it conflicted with religious beliefs. Some felt that contraception was synonymous with abortion, which was often considered murder. Thus, it is not unusual that these adolescent girls had, to some extent, assumed some of the attitudes and beliefs that adults held. However, their opinions were more positive toward contraceptives than those of adults.

They held a strong existential base for their beliefs about contraception. They felt that through nature certain things were meant to be as they are and were not to be interfered with. This existential base also served to facilitate the rationalization process which many of them used

[3] Lee Rainwater, *And the Poor Get Children*, Chicago, Quadrangle Books, Inc., 1960.
[4] Ibid., pp. 53–56.

to explain their disbelief in contraceptives. This will be discussed further below.

A majority of girls were familiar with some method of fertility control. That is, most of them had heard of the pill and condom and a smaller number of them were familiar with some type of suppository (invariably Norform) and foam (usually Emko). The source of their information was usually relatives and friends who used contraceptives. In the mid and late sixties (when most of this data was collected) the pill was synonymous with birth control. When asked, "What do you know about the way in which women keep from having children?" the reply was often, "I know about birth control [the pill]." A very small number of them could list the pill, foam, condoms, diaphragms, suppositories, intrauterine device and rhythm. Usually the girls who had such a vast amount of knowledge about these various methods of contraception held a positive approach to their usage. That is, they were inclined to express a desire to practice family planning once they were married. However, one of the great problems for these girls who were interested in doing so was their general unawareness of how to secure contraceptives. Although some of them had read pamphlets and books they had obtained from friends, older sisters, mothers and high school teachers, and had been informally educated about the positive effects of contraception, there was still a general lack of concrete information about the ways in which this material could be obtained. Occasionally, there was the knowledge that a girl friend or relative had secured pills from the local Planned Parenthood clinic, the local Maternal and Child Care Clinic or an unknown doctor. But this information appeared to be an abstraction to most of them, perhaps because a prerequisite for obtaining contraceptives at the two above-mentioned agencies was parental consent if under eighteen or to have already given birth to a child. This is a vivid example of the hypocrisy of social

agencies that dispense contraceptives. To require a woman to have given birth to a child (or to be married) before providing her with contraception resources is similar to "rewarding" her after she has made a mistake (had a baby). Needless to say, she should be given this information before she gets pregnant. The problems involved with obtaining contraceptives from a private physician stemmed from the lack of financial resources and a considerable amount of shame and fear about approaching the physician. A typical example of their attitude toward the problem of securing contraceptives was expressed by Ruth, a fifteen-year-old who had not had premarital relations.

I know a little about birth control. My sister takes it, and some girls at school take it [the pill]. You can get them from the clinic. You have to be eighteen or over but your mother can sign for you. . . . These girls' mothers signed for them.

The problem of availability of contraceptives was acute for those few girls who did not share the usual folkloric beliefs about the ill effects one could suffer from their usage and the moral and religious opposition.

With the majority of girls, however, there was still a strong fear of using contraceptives. All of the young women I knew gave personal accounts of individuals they knew or had heard of who suffered physically from using contraceptives. Some of their accounts were alarming enough to deter them from engaging in the usage of these items in the future. A typical story was told by sixteen-year-old Cynthia, who had not had premarital sex:

At the neighborhood station where I work [recreation center] they had some books on birth control. I read one and it was telling about how birth control works. It said it will help you from getting a baby if you take them right and if you don't it will form an deformed baby inside you. . . . I know this lady

who went to the hospital. She thought she was pregnant for six months, and a black round ball came out of her. She was taking birth control [the pill].

For fifteen-year-old Ethel, who was six months pregnant at the time of the interview, contraceptives only produced negative consequences:

I don't think the girls should take birth control pills. They should have the baby, because it will be worse if you take the birth control pills. . . . If you take the birth control pills and have the baby, you don't know what you're doing, you will probably die, or the baby might die and you live. . . . A girl in my class had her baby and she said that birth control pills are no good because they make you sick and if you have one baby and take them you can't have another child.

Other girls related stories of women having given birth to infants that resembled "monsters" because they had taken the pill. These accounts of the ill effects of contraceptives were informally circulated throughout the community to the extent that several girls related the same story. They are also passed from one generation to other: Girls had heard certain stories via their *mothers* and *grandmothers*. This folk tradition acts to perpetuate the process of misinformation and consequent non-usage of contraceptives. It also serves the purpose of perpetuating the values of the community regarding what is considered "life" and "non-life." For a great many older women there is little or no difference between using artificial methods to avoid conception and destroying life once it has been conceived. This belief might appear to be nonsense but it is very real for them. More simply, it is a strong reflection of how they perceive the existence of life. That this perception differs markedly from the views of the dominant society is relatively unimportant except insofar as the prac-

tical aspects are concerned, because their beliefs and tradi-
tions are part of an autonomous subculture.

The misinformation associated with contraceptives was
rarely countered with the dissemination of accurate and
adequate information. Only rarely did girls find it possible
to discuss this topic with individuals who were equipped
with factual information. Infrequently, a high school
teacher, an older sister, a mother or a peer passed this
information on to the adolescent girl. However, these oc-
currences were so rare that only a small proportion of girls
benefited from them. The majority of girls who had sexual
experience had not engaged in any regular practice of con-
traception. Most of them either relied solely on their boy-
friends to apply the condom or withdrawal (this appeared
to occur on an irregular basis, perhaps depending upon
whether or not the condom was available at the time of
intercourse) or they never considered using contraceptives
at all. About four girls had very irregularly used Emko foam
and Norform suppositories, which they either purchased at
a drugstore or borrowed from friends or relatives.

Of great importance was a belief among some of these
adolescents that fertility should not be controlled because
it had an important function (that is, childbirth) to per-
form. This also implied a strong religious belief that noth-
ing should be done to prevent either conception or
childbirth, short of abstinence. Miriam, a seventeen-year-
old who had engaged in premarital sex, adhered to this
belief:

Women shouldn't take birth control pills. It is not right. If they
don't want to get pregnant, they shouldn't do it.

For sixteen-year-old Marilyn, the problem was similar:

Birth control and all that other stuff, I don't believe in it. If
you're going to do it don't be using no protection or nothing. You

ould go on and get married. If you have to use some protection
r something, don't do it. . . . I go to church every Sunday. I go
• confession. I just don't believe in birth control. When they
rst came out I didn't believe in it. It wasn't because the Church
id it or nothing. I just don't believe birth control is right.

larilyn's attitudes reflect, as do those of other girls, an
pposition to the usage of contraceptives for mixed and
ometimes unclear reasons, except that it is unethical.
It should be noted that a small number of girls had
bsolutely no knowledge of contraceptives. They were
otally unaware of any method to prevent conception,
eyond abstinence. These girls (about three teen-agers)
ere also the most sheltered among the entire group. Their
arents were both strict and selective about the peers
ith whom they allowed them to associate, the places to
hich they allowed them to go and the activities in which
hey permitted them to become involved.
When this research was conducted, the political argu-
ents about the use of contraceptives as a method of geno-
ide against Black people had not been raised among
hese young ladies. They raised none of the questions that
re commonly raised by large numbers of women in the
lack communities today that reflect their heightened
olitical consciousness. The advent of the hundreds of
rogressive autonomous groups that have emerged
hroughout the country since I did the original study is
esponsible for the increased awareness of the various
amifications involved in the issue of contraceptives. Yet
his heightened social and political awareness affects only
 small segment of the population and perhaps the vast
ajority of low-income Black women are still unaware of
any of these issues. The impact that the small numbers
as could eventually become a great force among the
asses.
The primary issue is whether or not Black women

(teenagers and adults) are able to obtain the desired in
formation regarding contraceptives. I feel that the availa
bility of such information should be present and the
should not be forced either to use or not use contrace
tives. At this stage, it seems to be more important that th
individual choice can be exercised. Of course, wome
should be aware of the arguments for and against con
traceptives and make their decisions based on these issues
It is legitimate to assume that it is a question of genocid
that is involved in conservative political officials' can
paigns to "peddle" pills and other contraceptives in th
Black community. But it is ludicrous to assume that Blac
women who have had all the children they care to hav
and can afford should be denied information on ways t
cease giving birth. Obviously the quality of life for th
children and parents increases when poor people are abl
to practice family planning. But in our attempts to inte
vene in these very delicate areas of family life, we mus
take into serious consideration the feelings of the people
which are based upon centuries of beliefs and a clearl
defined way of perceiving and responding to the world
The other consideration is that the quality of life for poo
people should be improved without using contraceptio
as a final recourse. If the larger society were to assume it
responsibility in eliminating poverty, discrimination an
disease, contraception would not be sought as the mos
viable alternative.

ABORTION

The same negative attitudes which were held toward con
traception were held toward abortion, but to a stronge
degree. Males and females held the attitude that onc
conception occurred the unborn fetus had life that shoul
be preserved. There was a strong value placed on life, es
pecially that of the young and "innocent" child. The re

lts of a survey conducted in this community indicated
at a majority of the residents were opposed to abortion.[5]
:om a total of 158 respondents (male and female
lults) 90 per cent of the males and 94 per cent of the
males disapproved of abortion as an alternative to a
pothetical teen-age premarital pregnancy. However, the
obing question "Under what conditions would you say
e should try to get an abortion?" did elicit certain con-
tions under which abortion would be approved. The
ly sizable category of responses allowing abortion was
or health reasons" and included the following com-
ents:

nly if the doctor says so and it bothers her health. I don't be-
lieve in abortion.
health were threatened.
nder the conditions where a person has been taking some kind
of drugs, and has reason to believe that the baby might be de-
formed.
you have any reason to believe that the child one is carrying
may be abnormal, or for health's sake.
nly if it's against her health.
it's against her health, but that's up to the doctor to decide.
nder no conditions, unless health is involved.
e should get an abortion only if the two parents have some
kind of mental or physical defect.
she was in bad health, I advise that she should.
nly if she were a sickly kind of girl.

Other persons gave conditions under which abortion
ight be acceptable or made other comments on abortion.
ll of their responses are quoted below:

abortion was legal as in some other countries and done in a

[5] Taken from Jerome S. Stromberg, *Private Problems in
ublic Housing: A Further Report on the Pruitt-Igoe Housing
oject*, Occasional Paper 39, Social Science Institute, Washing-
n University, St. Louis, Missouri, February 1968.

clean hospital and not by quacks like it is here, then may
she should try it. But I don't really believe in it, because i
taking a human's innocent life even if the baby hasn't be
born yet.

If she thinks there is nothing wrong with it. You're saved by yo
own belief. I couldn't afford another one myself. Can't ta
care of the three I have.

I suppose that if she isn't too far gone she could go see a doc
about it. I'd be kind of scared myself.

I think that abortion could be okay, but I really don't know.

Under no conditon; that's murder.

If he isn't suitable to marry and this wouldn't be the best thir
then she should get an abortion.

If she weren't getting married—but it's not a good idea.

If it's her first child, no. If it's her second pregnancy, she shou
or shouldn't depending on the kind of fellow the guy is.

If she's had more than one.[6]

One of the prominent reasons for opposition to abortio
among the adolescents was a strong fear of the physic
consequences. Because abortions for them are most ofte
performed by non-medical persons, the possibilities
medical complications and sometimes death are qui
realistic. The strong emphasis on danger stemmed fro
the "quackery" methods with which they were acquainte
These included various forms of self-induced abortio
(taking "black mustard," quinine, drinking red pepper
steaming water, placing one's feet in a concoction of stea
ing water and mustard) and other quasi-medical metho
performed by older women and peers whereby improvise
unsterile instruments were used to detach the fetus fro
the womb.

Girls reported the same types of frightening stories a
sociated with abortions as with those previously mention
in connection with contraception, such as "flushing t

[6] Ibid., pp. 106-7.

fetus down the commode," "dying from gangrene poisoning" and so on.

In the absence of more qualified medical personnel to perform low-risk abortions, and with the absence of more liberalized abortion legislation, their attitudes toward them will probably not undergo radical change in the near future. The various legalized abortion committees are still very white-middle-class-oriented and rarely involve and affect poor women, who are least financially able to afford additional children. Moreover, the prevailing attitude that equated abortion with murder will perhaps continue to exist until these people redefine "life" and "non-life." At present a predominant feeling they hold is that abortion is no different from murder because once "life" has been *conceived* it has the right to be *born*. The fetus is considered life, and it is considered just as wrong to destroy it as it is to kill a person outside the womb. For indeed, a fetus is a person. Again, one observes the high regard for the preservation of life, especially for that which is young, innocent and has not had the opportunity to live and become a productive member of society.

Perhaps because of this high regard for life in its extended forms (and even a different concept of what life is) and the feeling that it is a "sin" to destroy "life," very few of these girls had any direct knowledge of what is involved in abortions. Most of their information was gained from secondary sources that were almost always filled with the sordid stories of the misfortunes one had suffered at the hands of an abortionist, or by the self-induced abortions. None of them knew of the "legal" methods and the ultrasterile conditions under which thousands of abortions are performed annually. They were aware, however, that there were probably ways to "get rid" of an unwanted baby if one had the proper connections. Most of them did not have such connections.

It would be erroneous to say that all of them were op-

posed to abortions, because one of the girls whom I knew best attempted a self-induced abortion without success. She obtained a chemical substance which she called "black mustard" from an elderly lady in her community. She was to insert this substance into the vagina but became too frightened to go through with it. A few other girls who were not opposed to abortion did not express as much opposition to abortion based on reasons associated with morality, as they did opposition based on fear of possible physical consequences. The recognition that this could be a fatal act was a strong and effective deterrent. Still, however, many low-income Black women have abortions but there is no way of knowing exactly how many do so.

There is no evidence that these girls were adverse to the use of contraceptives and abortion because they preferred having children. Rather their opposition stemmed from the popular folkloric beliefs about the harm contraceptives caused and from the conflict the use of contraceptives raised with some of their religious beliefs. Abortions raised more serious questions for the possible physical danger to the individual, and because it was believed that one destroys life by doing so. Therefore, if problems of insufficient and incorrect information surrounding contraceptives were corrected and they were made available to these adolescents, they would probably utilize them. In the absence of a more positive approach to the use of contraceptives, the girls' opportunities for enhancing their positions as attractive potential marital partners become more limited. The frequency of unwed pregnancies that often occur as a result of premarital sexual intercourse weigh heavily when marriage is considered.

Many of the attitudes expressed on family planning can be analyzed in terms of the function they serve for the individuals who hold them. The function of folk beliefs is one important aspect of this. Here, individuals have come to hold certain beliefs that can be considered superficial

even though they are highly functional—yet they have not been challenged with counterformulas and prescriptions. In many developing countries the same kinds of adverse attitudes toward the use of contraceptives are held until programs are introduced successfully in this area to dispel all of the popular folklore surrounding contraceptives. Frequently individuals use folklore in a defensive manner because there are no other mechanisms to deal with the situation.

Sexual participation is more problematic for these adolescents than for some teen-age girls in the middle-class society who are able to engage in premarital sex without being confronted with the problems that arise from the non-usage of contraceptives. There are increased tensions and pressures that girls usually experience when they engage in premarital sex without the advantage of contraceptives. In addition to the conflicts, feelings of guilt and so on that are experienced by many girls in American society who engage in premarital intercourse, there is the imminent possibility of pregnancy. In the middle class, it is generally assumed that girls engage in sexual relations at a later age. If pregnancy occurs, it is often within the engagement period and abortion or marriage usually follows. Even when the couple is not engaged, marriage more often follows premarital pregnancy in the middle class than in the lower class. The high rate of marriage acts to reduce the number of out-of-wedlock births in this group. Also, pregnancy for adolescent girls in this environment poses more serious long-term problems than it does for their middle-class counterparts because the frequently used alternatives of abortions and adoption in the middle class are very rarely chosen by them as promising alternatives. Adoption centers for non-white children (especially the poor) are virtually unknown.

It is rather common for middle-class whites to be aware of homes for unwed mothers and adoption facilities which

can be utilized in the event of premarital pregnancy. These homes and agencies are sponsored by numerous charitable organizations and other private concerns. Moreover, there is a sizable market for children born of white middle-class unwed mothers. Thus, if white girls become pregnant, they are not forced to keep the child and rear it, because of the availability of adoption facilities. Such avenues are not open to the Black poor because of many factors. The adoption market's demands do not generally include Black children. Whites, who do most of the adopting, do not usually adopt Black children, although there is a recent small trend for whites to adopt Black babies. It is also difficult to place these children in the homes of Blacks, either because they are financially unable to afford them or because they already have children of their own. Therefore, teen-age pregnancy in this environment leads either to children born out of wedlock or to marriage under frequently unfavorable conditions. If the former is the outcome of the pregnancy, the security and welfare of the child and mother are often inadequate.

Contrariwise, when marriage is the outcome of a premarital pregnancy, the girls' opportunities for still being able to fulfill some of their ideal expectations for marital success and happiness are more favorable than with non-marriage. However, as has been pointed out, many of these marriages lack stability from the beginning for the variety of reasons already given.

It must be recognized that any programs designed to provide contraceptives and legalized abortions to low-income Black women should take into consideration the strong value context that is applied by these girls who are approaching womanhood, as well as by the whole community. Both share a common set of cultural ethos and are prone to respond in the same manner. There does exist a different concept of "life" and "non-life," and these differences must be weighed carefully in any types of intervention programs.

Another important factor to realize is that all poor Black girls do not grow up with such limited chances for marrying the ideal partner, being adverse to the use of contraceptives and abortion, etc. Unfortunately, these opportunities are still too limited and the barriers must be overcome before a substantial number of young women are able to realize their dreams and goals.

*Conclusions*

I have attempted to depict the intricacy of Black womanhood as a sociohistorical phenomenon and as it relates to largely low-income adolescent Black girls growing up in the large metropolitan centers. It is difficult to capture the *essence* of this complex period of psychosocial development because of the peculiar historical backdrop against which this process occurs. Therefore, I have endeavored to analyze their present lives as they emerge out of these historical forces, for they have been involved in a strong reciprocal relationship in that they have been shaped by the forces of oppression but have also exerted their influence so as to alter certain of these patterns.

What has come to be popularly referred to as *institutional racism* has exerted the strongest impact upon all facets of the Black woman's life. Institutional racism has been defined as:

. . . the operating policies, priorities, and functions of an ongoing system of normative patterns which serve to subjugate, oppress, and force dependence of individuals or groups by: (1) establishing and sanctioning unequal goals; and (2) sanctioning inequality in status as well as in access to goods and services.[1]

[1] Walter Stafford and Joyce Ladner, "Comprehensive Planning and Racism," *Journal of the American Institute of Planning,* Vol. 35, No. 2, March 1969, p. 70.

The dynamics of institutional racism have been responsible for both the strengths and weaknesses of Black womanhood. The weaknesses are obvious and have been almost exclusively focused on in the social science and popular literature. The work of E. Franklin Frazier[2] and the infamous Moynihan Report[3] are representative of the "disorganization perspective" although they appeared twenty-five years apart. The dominant intellectual perspective on the Black family and the Black woman is still one which views them as pathological and an aberrant of the white middle-class model. However, it has been the overt and covert malignancy of institutional racism which has produced the alleged deviance and pathology. The behavioral characteristics of Black women which assumed these negative dimensions (when judged by the larger society) emerged as adaptations to a pathological society. It was the institutionalized structures and processes of racism which caused the so-called family disorganization, matriarchal society, high rates of juvenile delinquency, "illegitimacy," violence and homicide.

One of the peculiar aspects of racism in this country is that it has structured the *dominant* and *subordinate* roles and relationships between Blacks and whites, and placed Blacks within a relatively closed system; yet it has blamed the alleged *deviant* behavioral adaptations on its victims. In this kind of social system the most pervasive form of neo-colonialism with all its subtle manifestations becomes apparent and destructive. The most destructive of these manifestations is the ability of the oppressing class to indoctrinate the oppressed to believe in their alleged inferiority. Carter G. Woodson addresses this effective psychological tool in his work *The Miseducation of the Negro.*

[2] *The Negro Family in the United States*, Chicago, University of Chicago Press, 1939.
[3] *The Negro Family: The Case for National Action*, Government Printing Office, March 1965.

No systematic effort toward change has been possible, for taught the same economics, history, philosophy, literature, and religion which have established the present code of morals, the Negro's mind has been brought under the control of his oppressor. The problem of holding the Negro down therefore is easily solved. When you control a man's thinking you do not have to tell him not to stand here or go yonder. He will find his "proper place" and will stay in it. You do not need to send him to the back door. He will go without being told. In fact, if there is no back door, he will cut one for his special benefit. His education makes it necessary.[4]

The serious problem which Woodson addresses is one which requires an alternative system of formal and informal socialization. This socialization process is referred to by some scholars as "decolonization," or the refusal to allow the oppressor to define the problems and solutions of the oppressed.[5]

The normative patterns that exist in the white middle-class society are considered by its adherents as rational, justifiable and an *ideal* model. If one accepts the legitimacy of this model, any deviations from it would be considered within the realm of aberrant behavior. However, if the model is considered illegitimate, there should be no concern that one is obligated to conform to it because the value and behavioral system which undergirds it would be considered irrelevant. This seems to be the core of the white versus Black culture thesis. It is simply a question of whether or not the values, attitudes, behavior

[4] Carter G. Woodson, *The Miseducation of the Negro*: Washington, D.C., Association Publishers Inc., 1969 edition, p. xxxiii.

[5] This concept has been used as it relates to the problems of social research among minority groups. See Robert Blauner and David Wellman, "Towards the Decolonization of Social Research," Paper delivered at the "Workshops on Problems of Research with Low Income and Minority Groups in the United States," sponsored by the National Institute of Child Health and Human Development, March 8–10, 1970. It has also assumed popular usage by progressive Black scholars and activists.

and systems of belief which govern the dominant white middle class should be the criteria by which Black people, most of whom have never been allowed to assimilate into the American mainstream, should be evaluated.

This raises another fundamental question relating to the validity of the middle-class model. The structure of American institutions is, inherently, closed to Black participation except on the most minimal level. The blatant discriminatory practices have been historically documented through unemployment statistics, deteriorated housing conditions, inferior educational standards, minimal political participation, police repression, etc. But at the same time that these oppressive conditions exist (and seem to be worsening in the 1970s), the demands are being made by middle-class whites that Blacks conform to the same ethic which allegedly guides their lives. Two things seem apparent in this regard. First, even if Blacks wanted to conform to the white middle-class life-style it would be very difficult because of their inability to garner the necessary resources to accomplish these goals. Second, one must question the validity of the white middle-class life-style from its very foundation because it has already proven itself to be decadent and unworthy of emulation. The obvious symbols of this bankruptcy are to be observed in the "generation gap"; the problems of drug abuse among white youth; the "tuning out" by thousands of young whites into hippie communes instead of actively engaging in the struggle to initiate social change in the larger society; suburban "swingers" (sex clubs); the absent father who spends so much time away from his home that it, according to the classic definition, becomes a "matriarchal" society; the inability of many whites to accept the very basic humanist value that is attached to having children—in or out of wedlock; liberalized abortion laws; the destruction of the natural resources through the pollution of the rivers and the destruction of the land; the creation of ignorance, poverty and disease manifested by the callous disregard for the preservation of life in its fullest extension. This includes a refusal to become

involved in eliminating readily preventable diseases and combating hunger among the poor, a refusal to use the full resources of the middle class to destroy every vestige of neo-colonialism that exists within American society and abroad.

If this model is felt to be the ideal by which the values and behavior of Black people ought to be judged, we must seek other alternatives and more viable standards because that which purports to be the exemplary one is in the process of internal destruction, and there is little within it which seems worthy of being salvaged. The very fact that white society could produce and perpetuate institutional racism for over three centuries raises a serious concern for its validity, even for its adherents. The Black writer James Baldwin has prophetically analyzed the problem:

If we, who can scarcely be considered a white nation, persist in thinking ourselves as one, we condemn ourselves, with the truly white nations, to sterility and decay, whereas if we could accept ourselves *as we are*, we might bring new life to the Western achievements, and transform them. . . . Hence the question: Do I really *want* to be integrated into a burning house? . . . there is certainly little enough in the white man's public or private life that one should desire to imitate.[6]

His observation raises a fundamental question about the basic values of the dominant society and their relevance to the needs of Black people. Also, the question should be raised as to whether or not the dominant middle class should continue to adhere to a system of values which is in a rapid process of deterioration. Perhaps they too should seek to devise a value system which can save the entire society from ruination. On this point, we again turn to Baldwin:

White people cannot . . . be taken as models of how to live. Rather, the white man is himself in sore need of new standards

[6] James Baldwin, *The Fire Next Time*, New York, Dial Press, 1963, pp. 108–9.

which will release him from his confusion and place him once again in fruitful communion with the depths of his own being.[7]

Black people should reject these values and work toward strengthening those which have emerged out of the Black experience.

I raised the controversy over the existence of a distinct Black culture in Chapter One, and pinpointed some of the specific arguments *for* and *against*. I am proposing now that there does exist a strong Black culture that is separate from that of the dominant white middle class, and it is comprised of primarily two elements: (1) it is a result of certain Africanisms which survived slavery; and (2) it grew out of the adaptive responses which Blacks were forced to make to the slavery system and the systematic discrimination after slavery. Black culture has been referred to as a subculture, subsociety, the Black experience, "soul," etc. Regardless of the name which has been applied, it exists as a fairly autonomous entity within the larger social system and functions to meet the needs of Black people. As this relates to the lower class, Rainwater has suggested that:

. . . lower-class groups have a relatively high degree of functional autonomy vis-à-vis the total social system because that system does little to meet their needs. In general the fewer the rewards a society offers members of a particular group in the society, the more autonomous will that group prove to be with reference to the norms of the society. Only by constructing an elaborate repressive machinery, as in concentration camps, can the effect be otherwise.[8]

The functional autonomy which characterizes much of the Black community allows for the sustenance and strength-

[7] Ibid., pp. 110–11.
[8] Lee Rainwater, "Crucible of Identity: The Negro Lower-class Family," *The Negro American*, Talcott Parsons and Kenneth Clark (eds.), Boston, Houghton Mifflin Company, 1966, p. 200.

ening of Black culture. Black music, dance, art and spirituality are generally recognized to have strong African roots. It is not difficult to imagine how these cultural elements could be transmitted throughout the generations when one takes into consideration the fact that assimilation of Blacks into the mainstream has rarely been possible. As Hannerz notes:

Black people are not moving into mainstream society as individuals *and* as a group—they are only trickling into it one by one on white people's terms, while most of them remain in the ghettos.[9]

All of this is changing as Blacks demand the recognition of the validity of a highly functional culture which is not to be measured against the standards of the middle-class norm. The Black nationalist movements are advocating the rejection of the American value system, and pointing out the dangers of "integrating into" the society on terms already dictated by the oppressing group. Indeed, some reject integration altogether, while others only view it as a goal which should be accomplished only when Blacks are able to negotiate their demands from a basis of power. It is assumed that once the power base has been established, Blacks can set their own terms for *integration* or *equality*. Of equal importance, however, is the fact that the various repressive measures which seem to be forecast for Blacks during the decade of the seventies will make the "trickling" of individuals into the mainstream even more difficult.

The concept "soul" symbolizes the foundation of Black culture. Black culture can be viewed as a non-material culture, and can be more clearly observed in the emotive responses of Black people than in their artifacts; more poignantly in their spirituals and jazz than in their crafts-

[9] Ulf Hannerz, *Soulside: Inquiries into Ghetto Life and Community*, New York, Columbia University Press, 1969, p. 197.

manship; more lucidly in the strong bond between
mother and child than in the ability to provide that child
with all of the *material* luxuries life can afford. Indeed,
the ultimate nature of this culture can be made with a
simple distinction between Aretha Franklin singing the
blues, and her imitator the late Janis Joplin. Aretha Frank-
lin has lived the oppressed life—the blues—and Janis Jop-
lin had not. Hence, Miss Joplin *never* comprehended this
highest form of reality. Our gift to American society has
been spiritual and cultural and has, at various times in
our history, acted to forge basic humanistic values which
this society greatly needed. Lerone Bennett, historian,
articulates the meaning of soul and its implications for
Black culture in his essay "Ethos: Voices from the Cave":

The whole corpus of the tradition . . . is compressed into the
folk myth of *Soul,* the American counterpart of the African
*Negritude,* a distinct quality of Negro-ness growing out of the
Negro's experience and not his genes. *Soul* is a metaphorical evo-
cation of Negro being as expressed in the Negro tradition. It is
the feeling with which an artist invests his creation, the style with
which a man lives his life. It is, above all, the spirit rather than
the letter: a certain way of feeling, a certain way of expressing
oneself, a certain way of being.

From the womb of this non-Puritan, nonmachine, nonexploi-
tative tradition have come insights, values, and attitudes that
have changed the face of America. The tradition is very def-
initely nonmachine, but it is not anti-machine; it simply rec-
ognizes that machines are generative power and not soul, instru-
ments and not ends.[10]

It is this spiritual, aesthetic quality of Black culture that
offers this society the basic humanistic values which have
disappeared through the process of neo-colonialism and its
rapid technological advancements. These mechanized proc-

[10] Lerone Bennett, *The Negro Mood,* New York, Ballantine
Books, 1964, p. 89.

esses came to value efficiency over the basic spiritual qualities of life. Perhaps this Black humanism has the capacity to counteract the prevailing destructive forces within the society, if it is given the opportunity to do so. This already seems to be a realization among some middle-class whites who tend to view the "soul ideology" as their personal salvation and seek to emulate the Black life-style whenever possible.

It must be emphasized that, although there are very positive qualities within Black culture, one must not romanticize these to the extent that they become an opiate and an end unto themselves. No matter how much we celebrate our culture and its heroes, we must still do the necessary *activist* work to eliminate oppression. Cultural nationalism can never be a total substitute for direct political involvement.

In spite of the observations made by Baldwin and other Black thinkers about the devaluation of American middle-class culture, and the definitions which have been provided for an authentic Black culture, the fact is that Black people have been strongly influenced by the dominant society. Growing up in America, and being exposed to the normative patterns of the dominant group, one could expect to be shaped by what W. E. B. DuBois has referred to as a "double consciousness."

In 1903 he wrote in *The Souls of Black Folk* that:

The Negro is a sort of seventh son, born with a veil, and gifted with second-sight in this American world,—in a world which yields him no true self-consciousness; but only lets him see himself through the revelation of the other world. It is a peculiar sensation, this double-consciousness, this sense of always looking at one's self through the eyes of others, of measuring one's soul by the tape of a world that looks on in amused contempt and pity. One ever feels his twoness,—an American and a Negro; two souls; two thoughts, two unreconciled strivings, two warring

ideals in one dark body whose dogged strength alone keeps it from being torn asunder.[11]

This twoness to which DuBois refers characterizes the majority of Blacks, who find the influences of the dominant culture inescapable. Thus, it is strongly reflected in the lives of the girls in this study through their ambivalence, guilt and general tensions and struggles to define their lives as Black women. Although they were very realistic about their opportunities, statuses and goals, they nevertheless lived from day to day with this "double-consciousness." The "dogged strength" to which DuBois refers is the same as the "inner resourcefulness" which I described to be a major component of their lives, and which accounted for their highly creative ability not only to devise the most ingenious ways to adapt to oppression, but also to develop immense creativity within this process. Perhaps it is through oppression and bountiful suffering that one's creative abilities reach their zenith.

The nature of this dualism—"double-consciousness"—has had a major imprint upon Black women throughout our history, and in recent years has reached a new peak because of the current revolution in women's rights in the larger society. Many Black women who have traditionally accepted the white models of femininity are now rejecting them for the same general reasons that I have proposed we should reject the white middle-class life-style. Black women in this society are the only ethnic or racial group which has had the opportunity *to be women*. By this I simply mean that much of the current focus on being liberated from the constraints and protectiveness of the society which is proposed by Women's Liberation groups has never applied to Black women, and in that sense, we have always been "free," and able to develop as individuals even under the most harsh circumstances. This freedom, as well as the tremendous hardships from which Black

[11] W. E. B. DuBois, *Souls of Black Folk*, New York, Fawcett World Library, 6th Premier printing, August 1968, p. 16.

women suffered, allowed for the development of a female personality that is rarely described in the scholarly journals for its obstinate strength and ability to survive. Neither is its peculiar humanistic character and quiet courage viewed as the epitome of what the American model of femininity should be.

American white women were never allowed the opportunity to develop and become the socially mature beings many of them must have viewed as desirable. The highly pristine image which they were forced to develop during slavery has manifested itself in the most subtle forms even today. During slavery they were protected from Black men at all costs, placed on a pedestal and even protected from their spouses. Sexual relations were ideally confined to the marital relationship, and according to one author, to the act of procreation itself.[12] As part of the white man's creation of the myth of sacred white womanhood and as the perpetuator of racial supremacy, an illusionary world surrounding her chastity came into being. This chastity was manifested not only in the sexual sense, but it pervaded all areas of her life. Hernton notes that:

Not only did the southern white woman push sex out of her life as a shameful thing never to be mentioned; not only did she silently give up her husband to illicit, backyard love affairs—she also gave up her children to "black mammies" to suckle and nurture, because, according to the myth of sacred white womanhood, the white woman was above such "nasty" things as attending to the biological functions and needs of child-rearing. And in time these poor abandoned white "ladies" lived to witness their sons and daughters turning away from them in times of stress and strain toward the Negro mammies for affection, solace, and human understanding.[13]

[12] See Oscar Handlin, *Race and Nationality in American Life,* New York, Doubleday Anchor Books, 1957 edition, p. 122.

[13] Calvin Hernton, *Sex and Racism in America,* New York, Grove Press, 1965, p. 18.

The tragedy of this situation is manifested today by the pathological hang-ups which almost inevitably emerge within Black male-white female relationships. It is also reflected in the myths which surround the racist assumptions regarding the alleged animalistic sexual tendencies of the Black female. One must note that very often it is the white woman who makes the sexual advances toward Black men. Many Black men have been lynched because they refused to engage in intimate relations with white women who cried "rape" because they could not bear the idea of being refused by a Black man. When Black men violated the "sacred" laws governing white womanhood they were punished severely, oftentimes with lynching. Even today severe penalties are imposed on Black men who are accused of raping white women. At the same time, however, Black women became the objects of the most debased sexual passions of white men. They were raped, forced to bear children by their masters, denied the right to keep their offspring if the master wanted to sell the child, and most importantly, their very *femininity* and *humanity* were denied them because they were considered to be neither feminine nor human. In all of this suffering, Black women bore a remarkable and perhaps unprecedented courage, not to be paralleled in human history. They adjusted to all of these conditions, fought them with vigor and emerged with fewer scars than seems normal. All of these devastating influences actually caused them to become stronger, and to transmit the art of survival to subsequent generations. This is why I feel that the most viable model of womanhood in the United States is the one which Black women symbolize. At the same time, certain features in this model pose problems and should be given serious re-evaluation and alteration. (These will be dealt with more fully below.)

One of the major characteristics which define the Black woman is her stark realism as this relates to her resources. Instead of becoming resigned to her fate, she has always sought creative solutions to her problems. The ability to

utilize her existing resources and yet maintain a forthright determination to struggle against the racist society in whatever overt and subtle ways necessary is one of her major attributes. Perhaps more than in any other way, the Black woman has suffered from the institutional racist impact upon her role in, and relationship to, her family. It has been within the family that much of her strength has developed because it was here that she was forced to accept obligations and responsibilities for not only the care and protection of her own life, but for that of her offspring as well. Still, under the most rugged conditions she has managed to survive and to offer substantial contributions to the society as well.

The Black woman suffers from the twin burden of being *Black* and *female*. Her life is shaped by the subjugated statuses which are assigned to being a woman and being Black, both of which carry with them a double jeopardy. On the surface this would imply that Black women should be at the forefront of the Women's Liberation movement. Yet the problems to which members of Women's Liberation groups are addressing themselves are far less relevant to Black women. The movement is led largely by white middle-class women whose problems are basically different from those of Black women, regardless of class. The protective shelters which the society has imposed on white women have never been problematic to Black women because the society has refused to offer them the same protectiveness. One of the most blatant symbols of institutional racism has historically been the society's refusal to allow Black men to protect their women. As a result, Black women have always been "liberated."

Another major difference is that the "battle between the sexes" which characterizes the Women's Liberation groups—struggles over equalization of power in interpersonal relations—is the kind of luxury which Black people as a race can ill afford. Black women do not perceive their enemy to be Black men, but rather the enemy is consid-

ered to be the oppressive forces in the larger society which subjugate Black *men, women and children*. A preoccupation with the equalization of roles between Black men and women is almost irrelevant when one places it within the context of total priorities related to the survival of the race. All of the energies and resources of males and females are necessary to obliterate institutional racism.

Many of the tensions and conflicts which the girls in this study experienced are reflected more profoundly in the interpersonal relations between adult males and females. The advent of the civil rights movement brought into being an assertion of Black masculinity that could be felt in practically all walks of life. Their demands for the right to provide for and protect their families, to compete equally with men of other races in the job market, in politics and in education were expressions of their refusal to continue to abide by the illegitimate laws governing their lives. Thus, the urban rebellions, the rise of revolutionary and cultural nationalism and the other outward signs of revolt against the American system are manifestations of this adamant rejection. The bold assertion of Black masculinity has required that Black women redefine their roles, especially as these relate to Black men.

The strong roles which Black women have traditionally played are now coming into sharp focus amid the controversy over whether or not she should basically be a *passive supporter* of Black men or should continue to *assert her individuality* and make the contributions to the Black community that she has always proved capable of making. Many Blacks have already redefined the woman's role to be that of the *passive*, non-assertive individual, whose major function is to be supportive of her spouse (defined in this context as husband or boyfriend). The justification for this position is that manhood is defined in terms of strength and it is assumed that Black men cannot find their places at the top of the family hierarchy if women continue to maintain the aggressive roles which many of them fulfill. Some base this on the African polygynous

model, in which women assume the more passive roles. Others maintain that all of the Black institutions will eventually have to change if they are to remain relevant to its people and this redefinition of the male-female relationship is only one such change to anticipate. The counterposition is that Black men must assert their masculinity in spite of the traditional role Black women have played. The assumption is also made that the full resources of both sexes are vitally needed and women must not, unfairly, be asked calculatedly to submit themselves to all the demands of Black men. The proponents of this viewpoint state that manhood will not be gained at the calculated expense of womanhood, but that men must discover their assertiveness through their own inner resourcefulness, with the compassionate *support* of Black women.

What is clear, however, is that an alteration of roles between Black males and females must occur. The traditional "strong" Black woman has probably outlived her usefulness because this role has been challenged by the Black man, who has demanded that the white society acknowledge his manhood and deal directly with him instead of using his woman—considered the weaker sex—as a buffer. The cowardice which characterized the relationship between the larger society and Black women has come to an abrupt end. I am not suggesting that the distinctive positive character of Black womanhood forged by centuries of oppression should be abolished. Obviously there is much to be preserved from this model because of its highly functional as well as humanistic value. I am proposing, however, that the stereotyped "Sapphire" ("Sapphire" is the name applied to the typical *strong* Black woman) cannot continue to operate in the traditional manner but must make the necessary adjustments that will allow for the full development of *male and female*. Black women must utilize those survival techinques in the larger struggle for the liberation of Black people. Even the middle-class Black woman must redefine her role. No

longer must she view herself as an independent profes-
sional woman devoid of the burdens of race prejudice and
discrimination, simply because she had the opportunity to
be socially mobile. Her destiny is intricately related to
those of poor women, and her commitment to survival
must also be the same.

Black women must join all Black people in the process
of defining who they are, what their goals are to be, who
their prophets and heroes—past and present—are and what
the strategies of survival will be; whether we will allow
ourselves to become assimilated into the mainstream on
the oppressor's terms or whether we will fight the omi-
nous extermination that is already taking a toll on the lives
of college students, political activists and anyone else who
defies the social system in ways which have been forbidden.

The decade of the seventies will be a period when the
priorities of Blacks—adequate living wage, standard hous-
ing facilities, elimination of poverty, disease and ignorance,
political participation—will be reordered. The current
trend will be for the issues relating to ecology, popu-
lation control, the creation of an elitist corps, Women's
Liberation (white middle-class) and a variety of issues
that are secondary to the survival of Black people. This
calculated reordering of priorities is manifested in the
United States Government's appropriating more resources
to combat the pollution of the land and rivers than to
eliminate hunger.

Many of the gains which were realized through massive
protest demonstrations, the loss of lives, jailings and other
forms of brutal assaults on individuals who sought to make
the United States Constitution a reality are now becom-
ing nullified. This is evidenced by the attacks by govern-
mental officials on intellectuals, students and Blacks; in
the refusal of the government to enforce school desegrega-
tion guidelines which were based on the 1954 Supreme
Court Decision (Brown *vs.* Topeka Board of Education);
in the police repressive tactics which are granting them
*legal* rights to arrest, fingerprint and detain "suspects" for

long periods of time; and in the wholesale slaughter of innocent students and Blacks throughout the country. There is also a design to incarcerate "political" prisoners so that they will not be free to disturb the equilibrium of the society. The confiscation of these fundamental rights forecasts a bleak era, and can only be counteracted by the most aggressive assertion of unified power by Blacks against these forces.

In many ways the Black woman is the "carrier of culture" because it has been she who has epitomized what it meant to be Black, oppressed and yet given some small opportunity to negotiate the different demands which the society placed upon all Black people. Thus, she can be considered an amalgam of the diverse components which comprise Black culture: the pains and sorrows as well as the joys and successes. Most of all, it was she who survived in a country where survival was not always considered possible. As we return to the lives of the adolescent girls presented in this study, we must be aware that their lives cannot be viewed in an isolated context—in the context of a slum area in St. Louis, Missouri—but rather within the national and international context of neocolonialism and its disastrous effects upon oppressed peoples. Their conditions and life chances are necessarily interwoven with the status of the oppressed all over the world. As this broader context changes, so will their lives. It is no accident that when I revisited the same community in the spring of 1970 (the community in which they lived from 1964 to 1968, during the period when most of the data was collected), the environmental conditions had actually worsened. The unemployment rates were higher; the public housing project in which the majority of them lived had a vacancy rate of over 60 per cent, owing primarily to the unsuitable living conditions; and very few positive changes were apparent. This revisit only mirrored the worsening conditions that are occurring in every metropolitan center in the United States, and unfortunately, Blacks are the most severely affected by these.

These girls, like Black girls throughout America, will enter womanhood in an era when the demands for commitment to the fight for survival will be more necessary than at any other time in recent history. They will be forced to engage themselves in those serious tasks which will ensure the survival of Black people against extermination. Unfortunately, they will not have the luxury of living the carefree life of many of their middle-class counterparts. Perhaps it will be the strength of their forebears which will allow them to triumph!

# Bibliography

Alkalimat, Abd-L Hakimu Ibn, "The Ideology of Black Social Science," *Black Scholar*, December 1969.

Anonymous, *God Struck Me Dead: Religious Conversion Experiences and Autobiographies of Negro Ex-Slaves*. Nashville: Fisk University Social Science Institute, 1945.

Aries, Philippe, *Centuries of Childhood: A Social History of Family Life*. New York: Random House, 1962.

Baldwin, James, *The Fire Next Time*. New York: Dial Press, 1963.

Barbour, Floyd, *The Black Power Revolt*. Boston: Porter Sargent Publishers, 1968.

Becker, Howard S., *The Outsiders*. New York: Free Press, 1963.

Bennett, Lerone, "The Challenge of Blackness," *Black Paper Series*, Institute of the Black World Publishers, April 1970.

———, *The Negro Mood*. New York: Ballantine Books, 1964.

Bernard, Jessie, *Marriage and Family Among Negroes*. Englewood Cliffs, N.J.: Prentice-Hall, 1966.

Billingsley, Andrew, *Black Families in White America*. Englewood Cliffs, N.J.: Prentice-Hall, 1968.

Blauner, Robert, "Internal Colonialism and Ghetto Revolt," *Social Problems*, Vol. 16, No. 4, Spring 1969.

———, "Negro Culture: Myth or Reality," in *Black Experience: The Transformation of Activism*, Trans-action publication, 1970.

Blauner, Robert, and David Wellman, "Towards the Decolonization of Social Research," paper delivered at the "Workshops on Problems of Research with Low Income and Minority

Groups in the United States," sponsored by the National Institute of Child Health and Human Development, March 8–10, 1970.

Braithwaite, Lloyd, "Sociology and Demographic Research in the Caribbean," *Social and Economic Studies*, VI. Jamaica: University of the West Indies.

Broderick, Carlfred, "Social Heterosexual Development Among Urban Negroes and Whites," *Journal of Marriage and the Family*, May 1965.

Brown, Claude, *Manchild in the Promised Land*. New York: New American Library, Inc., 1966.

Carmichael, Stokely, "What We Want," *New York Review of Books*, September 22, 1966.

Clark, Kenneth, *Dark Ghetto*. New York: Harper & Row, 1965.

——, *Prejudice and Your Child*. Boston: Beacon Press, 1963 enlarged edition.

Clark, Kenneth B. and Mamie P., "Emotional Factors in Racial Identification and Preference in Negro Children," *Journal of Negro Education*, 1950.

Clarke, Edith, *My Mother Who Fathered Me*. London: Allen and Unwin, 1957.

Coleman, James S. et al., *Equality of Educational Opportunity*. Washington: U. S. Government Printing Office, 1966.

Coles, Robert, *Children of Crisis*. New York: Little Brown, 1964.

David, Jay (editor), *Growing Up Black*. New York: Pocket Books edition, 1969.

Davis, Allison, *Social Class Influences upon Learning*. Cambridge, Mass.: Harvard University Press, 1962.

Davis, Allison, and John Dollard, *Children of Bondage*. New York: Peter Smith, 1964.

Dollard, John, *Caste and Class in a Southern Town*. New York: Doubleday Anchor Books, 1957.

Drake, St. Clair, and Horace R. Cayton, *Black Metropolis*. New York: Harper Torchbooks, 1962. (First edition 1945, Harcourt, Brace.)

DuBois, W. E. B., *Souls of Black Folk*. New York: Fawcett World Library, 1961.

——, *Darkwater*. New York: Shocken Books, 1969.

Ellison, Ralph, "A Very Stern Discipline," *Harper's Magazine*, March 1967.

Erikson, Erik, "The Concept of Identity in Race Relations: Notes and Queries," *Daedalus*, Winter 1966.

Fanon, Frantz, *The Wretched of the Earth*. New York: Grove Press, 1965.

———, *Black Skins, White Masks*. New York: Grove Press, 1963.

Finestone, Harold, "Cats, Kicks, and Color," *Social Problems*, Vol. 5, July 1957.

Fortes, Meyer, "Kinship and Marriage Among the Ashanti," in *Africa Systems of Kinship and Marriage*, A. R. Radcliffe-Brown and Daryll Ford (editors). New York: Oxford University Press, 1950.

Franklin, John Hope, *From Slavery to Freedom*. New York: Alfred A. Knopf, Inc., 1956.

Frazier, E. Franklin, *The Negro Family in the United States*. Chicago: University of Chicago Press, 1966 edition. (First edition 1939.)

———, *Black Bourgeoisie*. New York: The Free Press, 1957.

Gans, Herbert, "The Negro Family: Reflections on the Moynihan Report," in Lee Rainwater and William L. Yancey, *The Moynihan Report and the Politics of Controversy*. Cambridge, Mass.: MIT Press, 1967.

Garfinkel, Harold, *Studies in Ethnomethodology*. Englewood Cliffs, N.J.: Prentice-Hall, 1967.

Gaughman, Earl E., and Grant Dahlstrom, *Negro and White Children*. New York: Academic Press, 1968.

Glazer, Nathan, and Daniel Patrick Moynihan, *Beyond the Melting Pot*. Cambridge, Mass.: MIT Press, 1965.

Goode, William, *The Family*. Englewood Cliffs, N.J.: Prentice-Hall, 1964.

———, "Illegitimacy in the Caribbean Social Structure," *American Sociological Review*, XXV, February 1960.

Goodman, Mary Ellen, *Race Awareness in Young Children*. New York: Collier Books, 1964.

Gottlieb, David, and John Reeves, *Behavior in Urban Areas: A Bibliographic Review and Discussion of the Literature*. New York: Free Press, 1963.

Gottlieb, David, and Charles Ramsey, *The American Adolescent*. Homewood, Illinois: The Dorsey Press, Inc., 1964.

Gouldner, Alvin W., "Anti-Minotaur: The Myth of a Value-Free Sociology," *Social Problems*, Winter 1962.

Gregory, Dick (with Robert Lipsyte), *Nigger: An Autobiography.* New York: Dutton, 1964.

Grier, William, and Price Cobbs, *Black Rage.* New York: Basic Books, 1968.

Hammond, Boone, and Joyce A. Ladner, "Socialization into Sexual Behavior," in *The Individual and Sex: Background Readings for Sex Education*, Carlfred Broderick and Jesse Bernard (editors). Baltimore: Johns Hopkins University Press, 1969.

Handlin, Oscar, *Race and Nationality in American Life.* New York: Doubleday Anchor Books, 1957.

Hannerz, Ulf, *Soulside: Inquiries into Ghetto Culture and Community.* New York: Columbia University Press, 1969.

Hare, Nathan, *Black Anglo-Saxons.* New York: Marzane and Munsell, 1965.

Harrington, Michael, *The Other America.* New York: Macmillan, 1962.

Henriquiz, Fernando, *Family and Colour in Jamaica.* London: Eyre and Spottiswoode, 1953.

Henson, Josiah, *Father Henson's Story of His Own Life.* New York: Corinth Books, 1962.

Hernton, Calvin, *Sex and Racism in America.* New York: Grove Press, 1968.

Herskovits, Melville, *The Myth of the Negro Past.* Boston: Beacon Press, 1958 edition.

Herzog, Elizabeth, "About the Poor: Some Facts and Some Fictions," Washington: Government Printing Office, 1968.

Jones, LeRoi, *Home: Social Essays.* New York: William Morrow and Co., 1966.

Kardiner, Abram, and Lionel Ovesey, *The Mark of Oppression: Explorations in the Personality of the American Negro.* New York: Norton, 1951.

Keil, Charles, *Urban Blues.* Chicago: University of Chicago Press, 1966.

Killens, John Oliver, *Black Man's Burden.* New York: Pocket Books, 1969 edition.

King, Martin Luther, address delivered at Abbott House, Westchester County, New York, October 29, 1965.

Kituse, John, "Societal Reaction to Deviance: Problems of Theory and Method," *Social Problems*, Winter 1962.

Komarovsky, Mirra, *Blue Collar Marriage.* New York: Random House, 1964.

Kriesberg, L., *Mothers in Poverty: A Study of Fatherless Families.* Chicago: Aldine Publishing Co., 1970.

Lemert, Edwin, *Social Pathology.* New York: McGraw-Hill, 1951.

Lester, Julius, *Look Out Whitey! Black Power's Gon' Get Your Mama!* New York: Dial Press, 1968.

——, *To Be a Slave.* New York: Dial Press, 1968.

Lewis, Hylan, "Agenda Paper No. V: The Family: Resources for Change, Planning Session for the White House Conference to Fulfill These Rights," Washington: Government Printing Office, 1965.

Liebow, Elliot, *Tally's Corner.* Boston: Little Brown, 1967.

McBroom, Patricia, "The Black Matriarchy: Healthy or Pathological?" *Science News,* Vol. 94, October 19, 1968.

McCarthy, John D., and William L. Yancey, *Uncle Tom and Mr. Charlie: A Review of the Negro American's Self-Esteem.* Nashville: Vanderbilt University, 1970 (mimeographed).

Maier, "Adolescenthood," *Social Casework,* Vol. 46, January 1965.

Mead, George Herbert, *On Social Psychology,* Anselm Strauss, (editor). Chicago: University of Chicago Press, 1964; and "The Genesis of the Self and Social Control," from *The Philosophy of the Present,* Arthur E. Murphy (editor). Chicago: Open Court, 1932.

Mead, Margaret, *Male and Female.* New York: William Morrow and Co., 1949.

Meier, August, and Elliot Rudwick, *From Plantation to Ghetto.* New York: Hill and Wang, 1966.

Merton, Robert K., *Social Theory and Social Structure.* Glencoe, Illinois: Free Press, 1957.

Miller, Walter B., "Lower Class Culture as a Generating Milieu of Gang Delinquency," *Journal of Social Issues,* No. 14, 1958.

——, "Implications of Urban Lower-class Culture for Social Work," *Social Service Review,* No. 33, 1959.

Moore, Clark D., and Ann Dunbar, *Africa Yesterday and Today.* New York: Bantam Books, 1968.

Moynihan, Daniel, *The Negro Family: The Case for National Action.* Washington: Government Printing Office, March 1965. (Reprinted in Rainwater and William Yancey, *The Moynihan Report and the Politics of Controversy.* Cambridge, Mass.: MIT Press, 1967.

Musgrove, F., *Youth and the Social Order*. Bloomington: Indiana University Press, 1964.

Myrdal, Gunnar, *An American Dilemma*. New York: Harper & Row, 1944.

Northup, Solomon, *Twelve Years a Slave*. Baton Rouge, Louisiana: Louisiana State University Press, 1968.

Orshansky, Mollie, "Who's Who Among the Poor: A Demographic View of Poverty," *Social Security Bulletin*, July 1965, Vol. 28, No. 7.

Perinbaum, Marie, lecture delivered at Spelman College, Atlanta, Georgia, Spring 1969.

Pettigrew, *A Profile of the Negro American*. Princeton, N.J.: D. Van Nostrand Co., Inc., 1964.

Polsky, Ned, *Hustlers, Beats, and Others*. Chicago: Aldine, 1967.

Porter, Sylvia, "Negro Women and Poverty," San Francisco *Chronicle*, August 5, 1969.

Poussaint, Alvin, "The Negro American: His Self Image and Integration," reprinted in *The Black Power Revolt*, Floyd Barbour (editor). Boston: Porter Sargent Publishers, 1968.

——, "The Special Position of the Black Woman," *Essence Magazine*, April 1970.

Powdermaker, Hortense, *After Freedom*. New York: Viking, 1939.

Quarles, Benjamin, *The Negro in the Making of America*. London: Collier-MacMillan Ltd., 1964.

Rainwater, Lee, *And the Poor Get Children*. Chicago: Quadrangle Books, Inc., 1960.

——, "The Crucible of Identity: The Negro Lower-class Family," in *The Negro American*, Talcott Parsons and Kenneth Clark (editors). Boston: Houghton Mifflin Co., 1965.

——, *The Problem of Lower Class Culture*. St. Louis: Social Science Institute, Washington University, 1966 (mimeographed).

——, Marital Sexuality in Four Cultures of Poverty. *Journal of marriage and the Family*, No. 26, 1964.

——, "Work and Identity in the Lower Class," in *Planning for a Nation of Cities*, Sam Bass Warner, Jr. (editor). Cambridge, Mass.: MIT Press, 1966.

Reiss, Ira L., *Premarital Sexual Standards in America*. New York: Free Press, 1960.

——, *The Social Context of Premarital Permissiveness*. New York: Holt, Rinehart and Winston, 1967.

Rose, Arnold, *The Negro American*. Harper & Row, New York, 1964.

Rosenberg, Morris, *Society and the Adolescent Self-Image*. Princeton, N.J.: Princeton University Press, 1965.

Sawyer, Ethel, "Some Methodological Problems in Studying Socially Deviant Communities," unpublished paper presented for a Ph.D. Colloquium in the Department of Sociology and Anthropology, Washington University, St. Louis, Missouri, May 9, 1967.

Schulz, David, *Coming Up Black: Patterns of Ghetto Socialization*. Englewood Cliffs, N.J.: Prentice-Hall, 1969.

Smith, Ernest A., *American Youth Culture: Group Life in Teenage Societies*. New York: The Free Press, 1962.

Smith, Jean, "I Learned to Feel Black," reprinted in *The Black Power Revolt*, Floyd Barbour (editor). Boston: Porter Sargent Press, 1968.

Smith, Lou, in *Lay My Burden Down, A Folk History of Slavery*, B. A. Boykin (editor). Chicago: University of Chicago Press, 1945.

Smith, M. G., *West Indian Family Structure*. Seattle: University of Washington Press, 1962.

——, *Kinship and Community in Carriacou*. New Haven, Conn.: Yale University Press, 1962.

——, Introduction, in Edith Clarke, *My Mother Who Fathered Me*. London: Allen and Unwin, 1966.

——, "Culture and Social Structure in the Caribbean: Some Recent Work on Family and Kinship Studies," *Comparative Studies in Society and History*, No. 6, 1963.

——, *The Plural Society in the British West Indies*. Berkeley: University of California Press, 1965.

Smith, R. T., *The Negro Family in British Guiana*. New York: Grove Press, 1956.

Stafford, Walter, and Joyce A. Ladner, "Comprehensive Planning and Racism," *Journal of the American Institute of Planners*, Vol. 35, No. 2, March 1969.

Staples, Robert, "The Myth of the Black Matriarchy," *Black Scholar*, January–February 1970.

Stromberg, Jerome S., "Private Problems in Public Housing: Further Report on the Pruitt-Igoe Housing Project," Occasional Paper No. 39, Social Science Institute, Washington University, St. Louis, Missouri, 1968 (mimeographed).

Tannenbaum, Frank, *Crime and the Community*. New York: Columbia University Press, 1938.

The Text of the Confessions of Nat Turner as reported by Thomas R. Gray, 1831, reprinted in John Henrik Clark, (editor), *The Confessions of Nat Turner: Ten Black Writers Respond*. Boston: Beacon Press, 1968.

U. S. Census of Population, U. S. Summary Detailed Characteristics table 186, 1960.

U. S. Department of Commerce, Bureau of the Census (CPR.—60, No. 66).

Valentine, Charles A., *Culture and Poverty*. Chicago: University of Chicago Press, 1969.

Vital Statistics of the United States, Volume 1, *Natality*, Department of Health, Education and Welfare, 1963.

Washington, Booker T., *Up from Slavery*. New York: Bantam Books, 1963 edition.

Whitaker, Barbara, "Breakdown in the Negro Family: Myth or Reality?" *New South*, Vol. 22, No. 4, 1967.

Whitten, Norman E., Jr., *Class, Kinship, and Power in an Ecuadorian Town*. Stanford, California: Stanford University Press, 1965.

Wirth, Louis, *The Ghetto*. Chicago: University of Chicago Press, 1928.

Woodson, Carter G., *The Miseducation of the Negro*. Washington, D.C.: Association Publishers Inc., 1969 edition.

Wright, Richard, *Black Boy*. New York: Harper, 1937.

Young, Leontine, *Out of Wedlock*. New York: McGraw-Hill, 1954.

# Index

Abortion, 256–63
Adolescence, 111–24 *passim*
Adoption, 261–62
African background, 12, 18–23, 49
family, role of, 18–22
motherhood, role of, 212–13
women, role of, 20–24
Alkalimat, abd-L Hakimu Ibn, 35
American value system
Blacks influenced by, 123–24, 273
validity of, 268–70
Aries, Philippe, 56
Assimilation, 271

Baldwin, James, 269–70
Barbour, Floyd, 31, 82
Becker, Howard, 2
Bell, Robert R., 197
Bennett, Lerone, 6–7, 272
Bernard, Jessie, 127

Billingsley, Andrew, 17
Birth control. *See* Contraception
Black Anglo-Saxons, 51. *See also* Middle class
Black community, defined, 4
Black consciousness, self-image and, 42–43, 81–83
Black culture, 5
and entry into womanhood, 11–12
nature of, 270–73
origins and development of, 32–39
Blake, Judith, 37, 38
Blauner, Robert, 7, 36, 267
Blues, 35, 272
Botkin, B. A., 29
Boyfriends, 130–31, 180–89. *See also* Sex
Braithwaite, Lloyd, 38
Broderick, Carlfred, 126–27
Brown, Claude, 57, 64–65
Brown *vs.* Topeka Board of Education, 77

Caribbean Black society, 37–39

Caste system, effects of, 79–80. *See also* Institutional racism

Charm clubs, 120–22

Childbearing, 163, 165–67, 171–72, 211–33
    attitudes toward, 127–30, 144–45
    out of wedlock, stigmatization of, 217–20
    in precolonial Africa, role of, 21–22

Childhood
    absence of, 58–60, 61–62, 64–65, 74–75
    case study, 65–67, 69–70
    extended family, role of, 60–61, 70–75
    hope for future, 75
    peer group, role of, 61, 70–75
    protected, case study of, 67–70
    self-concept, development of, 77–95, 107–8
    self-defense, 58–59, 75
    socialization into womanhood, 60ff., 110–11
    survival mechanisms, 58
    white *vs.* Black, 55–56, 72, 74, 83–84, 106–7
    *see also* related entries

Child-labor laws, 56–57

Civil rights movement, personality and development, and, 81, 278, 280

Clark, Kenneth B., 8, 77–78, 174, 213

Clark, Mamie P., 77–78

Clarke, Edith, 37

Clothes, 118–20, 121–24, 164–65

Cobbs, Price, 43, 80, 84, 85

Coleman, James S., 83

Coles, Robert, 58, 59, 81–82

"Colonial analogy" in social research, 6–7

Contraception, 114, 247–56, 261, 262–63

Dahlstrom, W. Grant, 83

David, Jay, 57

Davis, Allison, 60, 70

Deviant perspective in study of Blacks, 1–7, 16–17, 79, 233, 266ff. *See also* Institutional racism

Dollard, John, 79

"Double consciousness," 4, 273–74

Douglass, Frederick, 25–26

Drug addiction, 157–59

DuBois, W. E. B., 4, 273–74

Education, role of, 140, 145, 146

Environment, images of, 94–106

Erikson, Erik, 40

Family
    African, 18–22
    as disorganized, 15–16
    extended, 60, 70–75
    importance to Blacks, 16–17
    as matriarchal, 15–16, 33, 39–50 *passim* (*see also* Deviant perspective in study of Blacks)

Family (*cont'd*)
   slavery, effects of, 24–39
   and socialization of child,
      61
   *see also* Female-headed
      households; Parental con-
      trols, liberation from; re-
      lated entries
Fanon, Frantz, 80
Farrow, Mia, 232
Fathers. *See* Men
Female-headed households
   median family income of,
      147
   number of, 39–40
   *see also* Family
Femininity, 118–24
Ford, Daryll, 21
Fortes, Meyer, 22
Franklin, Aretha, 272
Franklin, John Hope, 19
Frazier, E. Franklin, 15–16,
      31, 34, 35, 39, 51, 140,
      169, 266

Garfinkel, Harold, 110–11
Gaughman, Earl E., 83
Ghetto, redefined, 4
Glazer, Nathan, 35
Goode, William, 37, 41
Goodman, Mary Ellen, 78
Gottlieb, David, 112
Gouldner, Alvin W., 8
Grandmothers, 71–72
Grier, William, 43, 80, 84, 85

Hammond, Boone, 127
Handlin, Oscar, 275
Hannerz, Ulf, 38–39, 271
Hare, Nathan, 51
Henriquez, F. M., 38

Henson, Josiah, 27
Hernton, Calvin, 275
Herskovits, Melville, 23, 34,
      35, 36, 38, 39
Herzog, Elizabeth, 46

Identity, 77–94, 106–8
Illegitimacy, 213–14, 219–21,
      232–33
Infanticide, 28–29
Institutional racism
   defined, 265–66
   role of, 5–6, 16–18, 265–
      68, 277
   *see also* Deviant perspective
      in study of Blacks

Johnson, Charles S., 16
Joplin, Janis, 272

Kardiner, Abram, 78
Keil, Charles, 35
King, Martin Luther, 17
Kituse, John, 2
Kriesberg, Louis, 52

Ladner, Joyce A., 127, 265
Lemert, Edwin, 2
Lewis, Hylan, 16, 221
Liebow, Elliot, 116
Love, 207–8, 247

McBroom, Patricia, 48
McCarthy, John D., 84
Manson, Roberta, 32
Marriage, 24, 40, 235–47
   attitudes toward, 144–45,
      146–47, 184–86
Materialism, 123–24
Matriarchy
   defined, 41

Matriarchy (*cont'd*)
  *see also* Family
Mead, George Herbert, 77
Mead, Margaret, 41
Meier, August, 20, 22
Men
  emasculation, theory of, 41–49
  in precolonial Africa, 18–19, 21, 22
  role of, 134, 142–43, 152, 181–89, 277–79
  slavery and, 24, 31
Menstruation, 178–80
Method of study, 7–14
Middle class, Black, 51–52, 53, 72, 279–80
  aspiration toward, 140–60
Miscegenation, 97–98, 275–76
Monogamy, 136–39
Motherhood. *See* Childbearing
Moynihan, Daniel Patrick, 7, 35, 40, 50, 266
Murphy, Arthur E., 77
Musgrove, F., 112

Northup, Solomon, 28

Oppression. *See* Institutional racism
Orshansky, Mollie, 49
Ovesey, Lionel, 78

Parental controls, liberation from, 189–96, 204–5, 216
Parsons, Talcott, 174, 213, 270
Passivity of women, 46

Pathological nature of Black community. *See* Deviant perspective in study of Blacks
Peer group, 61, 70–75
  and entry into womanhood, 111–18
  and premarital sex, 200
Perinbaum, Marie, 20–21, 22–23
Pettigrew, Thomas, 78–79
Police, attitudes toward, 103–4
Porter, Sylvia, 50
Poussaint, Alvin, 82, 85
Poverty, Black family and, 49–51
Pregnancy. *See* Childbearing
Prejudice. *See* Institutional racism
Premarital sex, 196–212, 237–38, 261

Quarles, Benjamin, 19, 23–25
Queen Mothers and Sisters, 20–21

Racism. *See* Institutional racism
Radcliffe-Brown, A. R., 21
Rainwater, Lee, 50, 173–74, 213, 249–50, 270
Ramsey, Charles, 112
Rape, 62–63, 148
Rattray, R. S., 21
Redgrave, Vanessa, 232
Reeves, John, 112
Reiss, Ira L., 196–97, 211
Repression, 185–86
Rodman, Hyman, 37
Rose, Arnold, 79
Rosenberg, Morris, 83

Rudwick, Elliott, 20–22

"Sapphire," 279
Sawyer, Ethel, 3
Schulz, David, 45
Self-hatred thesis, 77–94, 106–8
Self-image, 41–43, 77–94, 106–8
Sex
  abortion, 256–63
  awareness, development of, 126–28
  boyfriends, 130–31, 180–89
  contraception, 114, 247–56
  love, 207–8, 247
  miscegenation, 97–98, 275–76
  monogamy, 136–39
  premarital, 196–212, 236–37, 260–61
  rape, 62–63, 148–49
  white woman and, 275
Sexual identity. See Womanhood
Slavery, 24–39
  African background and, 23–24, 32–39
  rebellion against, 25, 29–33
  separation of families, 26–30
Smith, Ernest A., 112
Smith, Jean, 85–86
Smith, Lou, 29
Smith, M. G., 37, 39
Smith, R. T., 37
Socialization, 59ff., 111
Social protest, personality development and, 81–82, 278, 280
Social research
  deviant perspective, validity of, 1–7

inherent bias of, 6–7
intervention by researcher, 9
values, role of, 8
*see also* Deviant perspective in study of Blacks
Soul, 35, 271–73
Stafford, Walter, 265
Staples, Robert, 30, 43
Stealing, 99–103, 164–65
Stromberg, Jerome S., 241, 257
Study method, 7–14
Styron, William, 7
Suicide, 106

Tannenbaum, Frank, 2
Truth, Sojourner, 25, 27, 32
Turner, Nat, 25–26, 238

Upward mobility, 139–60
  marriage and, 236–38

Values, in social research, 8–9. *See also* American value system
Vesey, Denmark, 238
Vietnam War, 100, 105
Violence, 62–63
  police and, 103–4

Walker, David, 31
Washington, Booker T., 56, 57
Washington, George, 6
Welfare system, 47–48
Wellman, David, 7, 267
Whites
  attitudes toward, 97–99
  entry into womanhood, 11
  illegitimacy among, 232, 261–62
  marriage, 247

Whites (*cont'd*)
    middle-class life-style, valid-
        ity of, 268–69
    negative self-image among,
        82–84
    suicide rate, Blacks' com-
        pared with, 107
    women, image of, 274–76
Womanhood
    entry into, 1–3
    femininity, 118–24
    future role of, 279–82
    menstruation, onset of,
        178–80
    motherhood, 212–33
    parental controls, liberation

from, 189–96, 204–5,
    215–16
peer group activity and,
    111–18
role models, 125–76
*see also* related entries
Women's Liberation move-
    ment, 46, 274, 277–78,
    280
Woodson, Carter G., 266–67
Working class, Black, 52–53
Wright, Richard, 57

Yancey, William L., 50, 84
Young, Leontine, 219

# ANCHOR BOOKS

### SOCIOLOGY

THE ACADEMIC MARKETPLACE: An Anatomy of the Academic Profession—Theodore Caplow and Reece J. McGee, A440

AGAINST THE WORLD: Attitudes of White South Africa—Douglas Brown, A671

AGRARIAN PROBLEMS AND PEASANT MOVEMENTS IN LATIN AMERICA—Rodolfo Stavenhagen, ed., A718

AMERICAN RACE RELATIONS TODAY—Earl Raab, ed., A318

AMERICAN SOCIAL PATTERNS—William Petersen, ed., A86

ANATOMY OF A METROPOLIS—Edgar M. Hoover and Raymond Vernon, A298

AND WE ARE NOT SAVED: A History of the Movement as People—Debbie Louis, A755

THE ARAB WORLD TODAY—Morroe Berger, A406

ASYLUMS: Essays on the Social Situation of Mental Patients and Other Inmates—Erving Goffman, A277

BEHIND THE SHIELD: The Police in Urban Society—Arthur Niederhoffer, A653

THE BERKELEY STUDENT REVOLT: Facts and Interpretations—Seymour Martin Lipset and Sheldon S. Wolin, eds., A486

THE BROKEN IMAGE: Man, Science and Society—Floyd Matson, A506

CASTE AND CLASS IN A SOUTHERN TOWN—John Dollard, A95

THE CHALLENGE OF YOUTH—Erik H. Erikson, ed., originally published as Youth: Change and Challenge, A438

COMMUNITIES IN DISASTER: A Sociological Analysis of Collective Stress Situations—Allen H. Barton, Foreword by Robert K. Merton, A721

COMMUNITY AND PRIVACY: Toward a New Architecture of Humanism—Serge Chermayeff and Christopher Alexander, A474

THE DEATH PENALTY IN AMERICA—Hugo Adam Bedau, ed., A387

DEMOCRACY IN AMERICA—Alexis de Tocqueville; J. P. Mayer, ed.; George Lawrence, trans., AO5

DRUGS ON THE COLLEGE CAMPUS—Helen H. Nowlis, intro. by Kenneth Keniston, A670

THE DYING SELF—Charles M. Fair, A760

THE EMOTIONALLY DISTURBED CHILD: An Inquiry into Family Patterns—J. Louise Despert, A720

THE END OF THE JEWISH PEOPLE?—Georges Friedmann; Eric Mosbacher, trans., A626

EQUALITY BY STATUTE: The Revolution in Civil Rights—Morroe Berger, A591

THE ETHICAL IMPERATIVE: The Crisis in American Values—Richard L. Means, A735

THE EXPLODING METROPOLIS—Editors of *Fortune*, A146

THE FIRST NEW NATION: The United States in Historical and Comparative Perspective—Seymour Martin Lipset, A597

FREUD: The Mind of the Moralist—Philip Rieff, A278

FROM RACE RIOT TO SIT-IN: 1919 and the 1960s—Arthur I. Waskow, A557

THE GATHERING STORM IN THE CHURCHES: A Sociologist's View of the Widening Gap Between Clergy and Laymen—Jeffrey K. Hadden, A712

THE GUARANTEED INCOME—Robert Theobald, A519

GUILT: Man and Society—Roger W. Smith, ed., A768

THE HIDDEN DIMENSION—Edward T. Hall, A609

HITLER'S SOCIAL REVOLUTION: Class and Status in Nazi Germany 1933–1939—David Schoenbaum, A590

HUSTLERS, BEATS, AND OTHERS—Ned Polsky, A656

IDEOLOGY AND INSANITY: Essays on the Psychiatric Dehumanization of Man—Thomas S. Szasz, A618

INTERACTION RITUAL: Essays on Face-to-Face Behavior—Erving Goffman, A596

INVITATION TO SOCIOLOGY: A Humanistic Perspective—Peter L. Berger, A346

JACOB RIIS REVISITED: Poverty and the Slum in Another Era—Francesco Cordasco, ed., A646

KILLERS OF THE DREAM: An Analysis and Evaluation of the South—Lillian Smith, A339

THE LAST LANDSCAPE—William H. Whyte, A717

LAW AND PSYCHOLOGY IN CONFLICT—James Marshall, A654

LET THEM EAT PROMISES: The Politics of Hunger in America—Nick Kotz, A788

THE LIFE AND WORK OF SIGMUND FREUD—Ernest Jones; Lionel Trilling and Steven Marcus, eds., abridged, A340

MAIN CURRENTS IN SOCIOLOGICAL THOUGHT, Volume I: Montesquieu, Comte, Marx, Tocqueville, the Sociologists and the Revolution of 1848—Raymond Aron; Richard Howard and Helen Weaver trans., A600a

MAIN CURRENTS IN SOCIOLOGICAL THOUGHT, Volume II: Durkheim, Pareto, Weber—Raymond Aron, A600b

THE MAKING OF A COUNTER CULTURE—Theodore Roszak, A697

MAN INCORPORATE: The Individual and His Work in an Organized Society—Carl B. Kaufman, revised edition, A672

MAN IN THE MODERN AGE—Karl Jaspers, A101

THE MAN WHO PLAYS ALONE—Danilo Dolci, A740

MARX IN THE MID-TWENTIETH CENTURY: A Yugoslav Philosopher Reconsiders Karl Marx's Writings—Gajo Petrović, A584

MAX WEBER: An Intellectual Portrait—Reinhard Bendix, A281

MOVEMENT AND REVOLUTION—Peter L. Berger and Richard J. Neuhaus, A726

MY PEOPLE IS THE ENEMY—William Stringfellow, A489

NATION BUILDING AND CITIZENSHIP: Studies of our Changing Social Order—Reinhard Bendix, A679

THE NATURE OF PREJUDICE—Gordon W. Allport, A149

ιE NAVAHO—Clyde Kluckhohn and Dorothea Leighton; revised by Richard Kluckhohn and Lucy Wales, N28

ιE NEGRO AND THE AMERICAN LABOR MOVEMENT—Julius Jacobson, ed., A495

ιE NEWCOMERS—Oscar Handlin, A283

ιE NEW MEDIA AND EDUCATION: Their Impact on Society—Peter H. Rossi and Bruce J. Biddle, eds., A604

 TIME, WORK, AND LEISURE: A Twentieth-Century Fund Study—Sebastian de Grazia, A380

ἱ INTELLECTUALS—Philip Rieff, ed., A733

ιE ORGANIZATION MAN—William H. Whyte, Jr., A117

ᴏLITICAL MAN: The Social Bases of Politics—Seymour Martin Lipset, A330

ᴏPULATION: The Vital Revolution—Ronald Freedman, ed., A423

ιE PRESENTATION OF SELF IN EVERYDAY LIFE—Erving Goffman, A174

ᴀISON WITHIN SOCIETY: A Reader in Penology—Lawrence Hazelrigg, ed., A620

ᴀOTESTANT-CATHOLIC-JEW: An Essay in American Religious Sociology—Will Herberg, revised edition, A195

ᴀYCHEDELICS: The Uses and Implications of Hallucinogenic Drugs—Bernard Aaronson and Humphry Osmond, A736

ᴀCE AND NATIONALITY IN AMERICAN LIFE—Oscar Handlin, A110

ιE RADICAL RIGHT—Daniel Bell, ed., A376

ᴀALITIES OF THE URBAN CLASSROOM: Observations in Elementary Schools—G. Alexander Moore, Jr., A568

ιE REFORMING OF GENERAL EDUCATION: The Columbia College Experience in Its National Setting—Daniel Bell, A616

ιE RELIGIOUS FACTOR—Gerhard Lenski, A337

ᴀVOLUTION AND COUNTERREVOLUTION: Change and Persistence in Social Structures—Seymour Martin Lipset, A764

ᴀRUMOR OF ANGELS: Modern Society and the Rediscovery of the Supernatural—Peter L. Berger, A715

ιE SACRED CANOPY: Elements of a Sociological Theory of Religion—Peter L. Berger, A658

ᴏCIAL AND POLITICAL PHILOSOPHY: Readings from Plato to Gandhi—John Somerville and Ronald Santoni, eds., A370

ιE SOCIAL CONSTRUCTION OF REALITY: A Treatise in the Sociology of Knowledge—Peter L. Berger and Thomas Luckmass, A589

ᴏCIALIST HUMANISM: An International Symposium—Erich Fromm, ed., A529

ᴏCIETY AND DEMOCRACY IN GERMANY—Ralf Dahrendorf, A684

ᴏCIOLOGISTS AT WORK: The Craft of Social Research—Phillip E. Hamond, ed., A598

ᴀRUCTURAL ANTHROPOLOGY—Claude Lévi-Strauss, A599

ᴀUDIES OF LATIN AMERICAN SOCIETIES—T. Lynn Smith, A702

ᴀMING MEGALOPOLIS, Volume I: What Is and What Could Be, Cb

## SOCIOLOGY (cont'd)

Volume II: How to Manage an Urbanized World—H. Wentwor Eldredge, ed., A593a, b

THE TOOLS OF SOCIAL SCIENCE—John Madge, A437

UNION DEMOCRACY—Seymour Martin Lipset, Martin A. Trow, a James S. Coleman, Foreword by Clark Kerr, A296

THE URBAN COMPLEX—Robert C. Weaver, A505

URBAN RENEWAL: People, Politics, and Planning—Jewel Bellu and Murray Hausknecht, eds., A569

VILLAGE OF VIRIATINO: An Ethnographic Study of a Russian Villa from Before the Revolution to the Present—Sula Benet, tra and ed., A758

WALK THE WHITE LINE: A Profile of Urban Education—Elizabe M. Eddy, Ph.D., A570

WHITE MAN, LISTEN!—Richard Wright, A414

WHO DESIGNS AMERICA?—Laurence B. Holland, ed., A523

WHO NEEDS THE NEGRO?—Sidney Willhelm, A789

## DATE DUE

| | | | |
|---|---|---|---|
| JY 11 '94 | | | |
| JUL 02 '95 | | | |
| JAN 18 '96 | | | |
| JY 22 '05 | | | |
| 9/1 | | | |
| | | | |
| | | | |
| | | | |
| | | | |
| | | | |
| | | | |
| | | | |
| | | | |
| | | | |
| | | | |